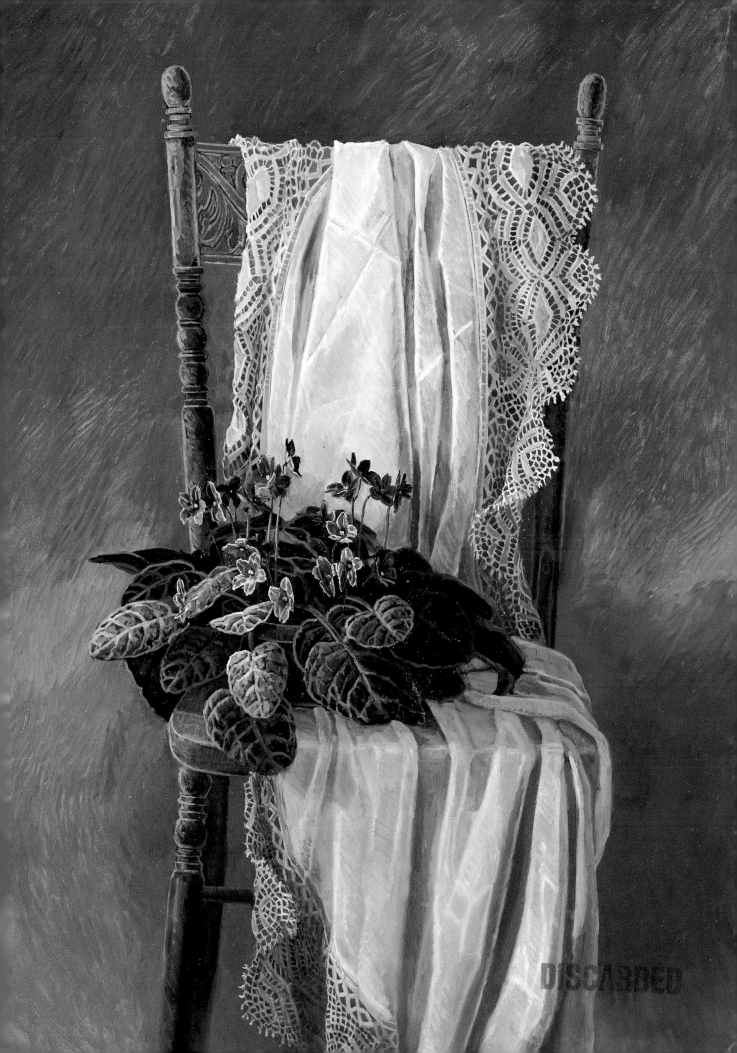

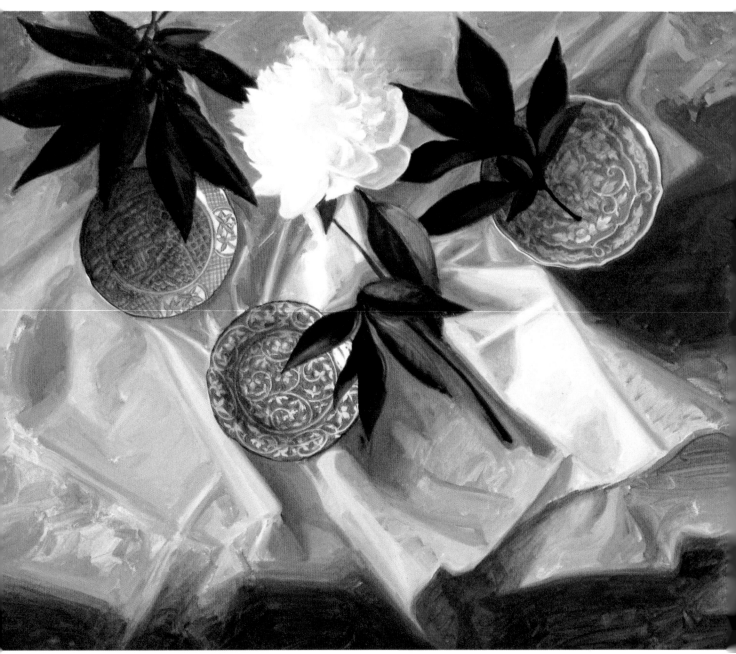

THE PEONY, by Eileen Goodman
28" × 36" (71.1 × 91.4 cm)
Oil on canvas
Collection of A.T.&T. Communications, Philadelphia
Photograph courtesy of Gross McCleaf Gallery, Philadelphia

Preceding page
VIOLETS AND OLD LACE, by Toni Arnett
38" × 34" (96.5 × 86.5 cm)
Oil on Masonite
Collection of Mr. and Mrs. William Sick

Painting the Still Life

Olga Zaferatos

Toni Arnett
Catherine Behrent
Nell Blaine
Barbara E. Bohler
Peter Eichner-Dixon
Robin Eschner-Camp
David Fertig
Iona Fromboluti
Eileen Goodman
Penelope Harris

Polly Kraft
Robert M. Kulicke
Harriet Martin
Jane Piper
Barnet Rubenstein
Valerie Seligsohn
Robert Treloar
Susan Headley Van Campen
Paul Wonner

WATSON-GUPTILL PUBLICATIONS/NEW YORK

To the three people who have taught me a very good deal about seeing:

Michael Karras, whose beautiful music and highly creative ideas have touched me profoundly and invigorated me intellectually;
Nicholas Zaferatos, whose wisdom and vision for a better world have broadened my mind perhaps even more than he can ever know; and most of all
Peggy Zaferatos, whose endless encouragement and magnificent taste and talent for turning everything she touches into beauty, inspired my love for art and for all things beautiful from the very beginning.

First published in 1985 in New York by Watson-Guptill Publications, a division of Billboard Publications, Inc., 1515 Broadway, New York, N.Y. 10036

Library of Congress Cataloging in Publication Data

Zaferatos, Olga
 Painting the still life.

 Includes index.
 1. Still-life painting—Technique. I. Title.
ND1390.Z34 1985 751.4 84-29167
ISBN 0-8230-3860-2

Distributed in the United Kingdom by Phaidon Press Ltd., Littlegate House, St. Ebbe's St., Oxford

Manufactured in Japan

First printing, 1985

1 2 3 4 5 6 7 8 9 10/90 89 88 87 86 85

4-4-88 — MW — 51490

Acknowledgments

My utmost gratitude is extended to the nineteen artists who have given generously of their time and expertise, as well as their wonderful artwork, in order to make this book possible.

Were it not for the talented individuals at Watson-Guptill Publications, notably Mary Suffudy, Senior Editor; Sue Heinemann, Associate Editor; and Areta Buk, the book's designer, there would be no framework in which to display the artist's work and bring it all together so vividly. Mary Suffudy initiated the project and always offered expert advice and direction; Sue Heinemann whipped it into shape and every page bears her insightful contributions; and Areta Buk took all the many pieces and pulled them together in an intelligent design. Grateful acknowledgment must also be made to Bill Scott of the Gross McCleaf Gallery in Philadelphia, who suggested many of the artists in this book.

My deep-felt thanks go as well to two friends who have stood by me and provided enormous support and a great many laughs: Messrs. Teddy Pappas and Paul Truss. I will never forget your kindnesses.

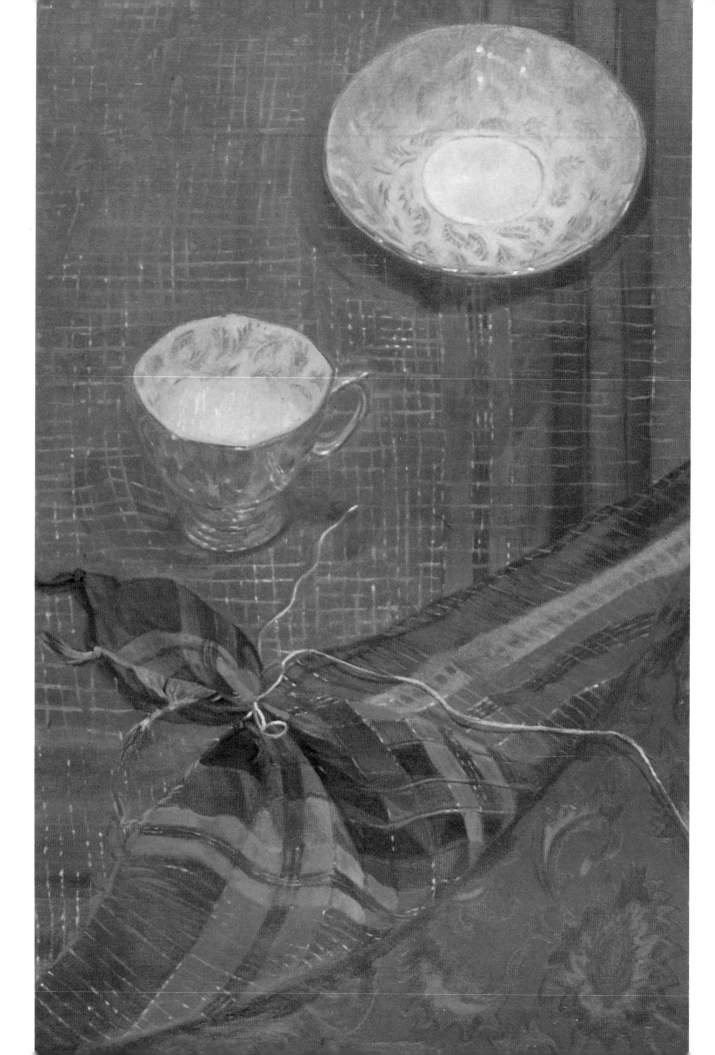

Contents

JILL'S CUP AND SAUCER, by Iona Fromboluti
22" × 14" (55.9 × 35.6 cm)
Oil on canvas
Courtesy of Gross McCleaf Gallery, Philadelphia

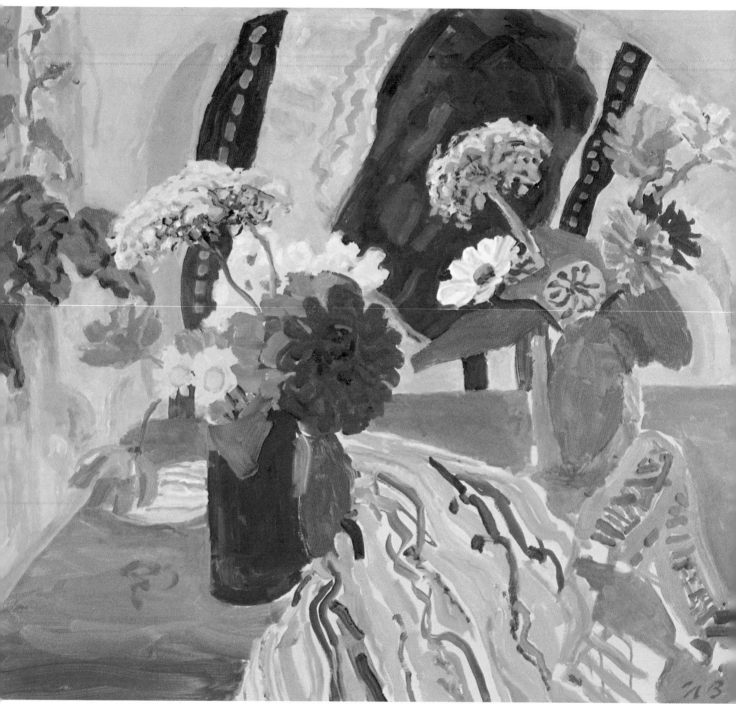

SUMMER'S BOUQUET, by Nell Blaine
26" × 30" (66 × 76.2 cm)
Oil on canvas
Private collection
Photograph by eeva-inkeri; courtesy of Fischbach Gallery, New York City

Introduction

The nineteen painters in this book have all turned their attention to the still life for very much the same reason: the still life lends itself to highly individual expression. With a still life, you can create an environment that you want to paint, with real or imaginary objects. The possibilities seem endless. In choosing and arranging objects, you can focus on such aesthetic considerations as shape or color. Or you may wish to convey the objects' emotional or symbolic significance. More than any other genre, the still life offers freedom in deciding on your subject matter.

Any item can find its place in a still life, as Robert Treloar's plastic cowboys, Penelope Harris's porcelain head, Barnet Rubenstein's cookie jars, Robin Eschner-Camp's paper airplanes, and Toni Arnett's carousel horse clearly illustrate. Even "traditional" still life subjects like bouquets of flowers or baskets of fruit can take on a new aspect, becoming just as alive as any breathing thing. In fact, the very term "still life" is called into question when painted objects being to project energy and active life. Just turn to the paintings of Harriet Martin, Penelope Harris, and Nell Blaine — "stillness" is hardly the word to use in describing them.

Simply put, anything goes if it fits, including quite ordinary objects within easy reach. You might decide, as Catherine Behrent did, to paint the things you see every day on your tabletop. These "familiar" objects can change in a myriad of ways, depending on how you light them, the other objects you surround them with, or your own mood at the moment. All you need is time to concentrate and to look around you and within yourself. Still life

painting is enormously convenient; you needn't wander very far at all for inspiration. It is a genre of painting that you can take up whenever and wherever the inspiration strikes.

Arranging your objects is just as important as choosing them. Here, too, the painters in this book suggest a variety of possibilities. Several artists explore the narrative element, hinting at the "story" of the still life. Barbara E. Bohler, for instance, sets up symbolic relationships; Valerie Seligsohn arranges plants and shells to conjure up exotic landscapes. From a different perspective, Robert Treloar uses the still life as a stage to question our very notions of reality and fantasy. At other times, as in the work of David Fertig and Peter Eichner-Dixon, the relationship between objects expresses a mood or conveys emotion.

Yet another consideration is how the objects link to each other on the painting surface. By connecting seemingly unrelated objects through an intricate linear structure, Paul Wonner creates an almost surreal world, where everything is separate and at the same time together. A different kind of structure emerges in Barnet Rubenstein's canvases, where the repetition of ordinary cookies or cardboard boxes adds up to a whole that is much more than its parts. Indeed, every artist in this book reveals the importance of design in painting the still life. In the work of Polly Kraft or Iona Fromboluti, instance, you will discover how the "background" can play a crucial role in weaving the composition together. Looking at the watercolors of Robin Eschner-Camp, you will see how effective leaving

large areas of white paper can be in providing both tension and relief. And in Catherine Behrent's work, you will find imaginative solutions to the search for balance.

The painting styles of the artists in this book are just as diverse as their subject matter. Each can teach you something different about how to handle your materials and how to achieve the effects you want. Toni Arnett, for example, details her method for depicting the illusion of light, while Eileen Goodman shows us the key role of shadows. Robert M. Kulicke demonstrates the "classical illusion," in which what looks sharply realistic from afar becomes more impressionistic as you move in close. Different possibilities for spontaneous handling and intuitive decision making come out in the work of Nell Blaine and Polly Kraft. On the other hand, how and when to simplify are lessons that can be gleaned from the paintings of Jane Piper and Susan Headley Van Campen.

One of the best ways to learn about painting is by looking at other painters' work. By seeing through the eyes of the artists in this book and by reading about how they work, you will come to understand better what goes into the making of a successful painting. Even more, you will encounter modes of expression you may not have considered before, as well as new ways of perceiving the world around you. *Painting the Still Life* is meant to stimulate you toward developing your own personal style. It will open your eyes to a myriad of potential painting subjects and encourage you to explore a multitude of new ideas.

Toni Arnett
Learning How to Paint Light

There is an immediacy to Toni Arnett's work, a sense of having come across that magical moment when a beam of sunlight transforms the objects in its path. At any moment the light may shift and alter the mood, yet the effect is extremely soothing. It is the light that directs our attention to a certain pattern, a certain flower petal — to those objects that express what is important about the painting. The illusion of shining light does more than emphasize these areas — it gives them life, lending vitality to the inanimate.

Just as light imbues Arnett's work with a certain mood, so too do the many varied colors that her canvases display. Her glowing backgrounds evoke a feeling of atmosphere, of light shining through space. Arnett wants the objects in her paintings to look as though they were surrounded by air, not placed against a backdrop, and so she has found a way to create vibrant settings for the drama she wishes to express.

Like many artists, Arnett has her favorite objects and paints them repeatedly. One favorite is an antique chair, which she often uses as a prop to display other items, especially quilts, which she is drawn to for their colors and patterns. Surprisingly, animals and even people find a place in her still lifes. Never are they the focus, however. Their role is strictly secondary. Arnett includes them as a foil to the objects she places at the center of attention, in order to emphasize how something we usually take for granted can be just as beautiful as the things we deem most relevant. "It all depends on our attitude toward the object we are looking at," she claims. Painting the still life allows Arnett a creativity that she does not find in other genres like landscape painting; through conceiving and arranging her still lifes, she can say something special in her own personal way about everyday objects.

WORKING METHODS

In order to create the illusion of shining light, Arnett carefully controls the values in her paintings, using a scale ranging from 1 (the darkest value possible) to 10 (the lightest). She makes sure that *all* the darker values are at least two jumps darker on the scale than the values in the area bathed in light. It is this clear contrast in values, without transitional steps, that creates the impact of light. To determine a color's value, Arnett uses a set of ten value cards, first created for her by a friend, Mac Carow. Each card represents an even step in value from black (1) to white (10). By comparing a color she has mixed to the cards, Arnett can check its value. (See her Suggested Project for a step-by-step description of how to create these cards and use them.)

The size of Arnett's support is influenced by the subject matter. She usually paints life-size so that she can better portray the essence of the objects, with all their subtleties. She will, however, choose a smaller size if the detail would become too overwhelming on a large scale.

Because Arnett likes to include a wide variety of color in her paintings, her palette is quite full, with more than twenty-five colors. She applies the paint with Langnickel royal sables which give her good control and have an edge that remains sharper longer than most other brushes.

Backgrounds are important in setting the stage for the drama of light in Arnett's paintings and giving a sense of atmosphere. She has two different methods for doing her backgrounds. In one, using opaque paint, she starts at one corner of the top and works her way down, with the values gradually becoming lighter. The top corner, which is closest to the light source, is always the darkest, while the opposite corner (where the light reflects back) is the lightest. After underpainting the background in grays to establish the correct value transitions and letting this dry, Arnett adds vibrancy by crosshatching a variety of color (in the *same* value range) over the underpainting. She may use as many as six colors — dulled versions of red, purple, blue, green, yellow, and orange. But, even though many colors are used, the overall effect is quite neutral.

In the other method Arnett uses for her backgrounds, she mixes her paint with a bit of Grumbacher painting medium to make it semitransparent. This technique gives a luminosity to the background that can't be achieved with opaque color. Again, she keeps the background darker near the light source, letting it get lighter in an even transition as it moves away. In mixing her colors (primaries and secondaries dulled with black), she makes sure to keep all the colors in a particular section the same value—otherwise the background would look spotty. She also keeps the values even as she adds white in moving from dark to light.

CALLEY'S GARDEN
(For caption, see page 12)

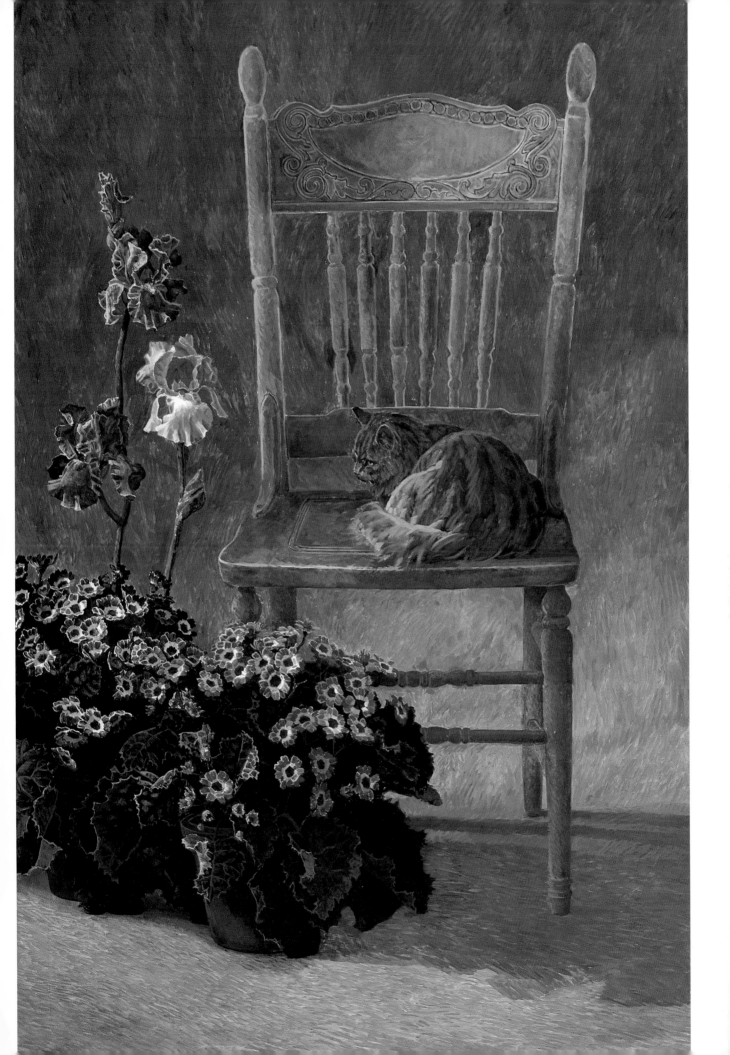

Preceding page
CALLEY'S GARDEN
33" × 51" (84 × 130 cm)
Oil on Masonite

Calley's Garden *stemmed in large part from Arnett's imagination. She had the chair in front of her all the time, but she worked from photographs of the cat and the flowers to get the drawing right. In fact, Arnett often uses photos for the drawing part since it would be impossible to hold onto blooming plants or animals in making such involved paintings. She doesn't use photographs as a reference for color, however, because she believes the color in photographs is inaccurate or distorted. At that point she searches for a real-life model. When it came time to capture the yellow of the cat's coat, for instance, she borrowed a neighbor's cat for several hours.*

Color and the effect of light on color are crucial to the impact of Calley's Garden. *It is through the color harmony that Arnett establishes the painting's peaceful mood. Each object was selected for its color note. The flowers give a range of blues, purples, and reds, with a hint of orange in the iris and a contrast of green in the leaves. The cat adds a touch of yellow, as well as the interest of a living, breathing creature.*

Arnett was very careful to keep all but one of the colors somewhat subdued so that the pink iris would easily catch the viewer's eye as the center of interest. For the background, the chair, and the foreground, she used semitransparent paint (thinning her mixtures with medium) to add luminosity to the color. Then, when she came to the more important objects, she applied thicker paint and employed stronger value contrasts. In order to make the pink iris appear bathed in sunlight, Arnett used her value cards (described under Working Methods). For the iris itself, she chose values running from 10 (pure white) to 3. This large value contrast draws attention to the flower. The background surrounding the pink iris is fairly dark (a value of 5) so that there's a large jump in value to the lit-up edges of the flower. Although there are other areas of strong contrast in this painting — for instance, in the pink and purple cinerarias — they do not command attention to the same degree because the very light areas are quite small.

On the whole Arnett is pleased with the color harmony, value control, and peaceful mood of the painting. Her one criticism is that the overall composition might have been more effective if she had cut the painting off just above the bottom of the flower plants.

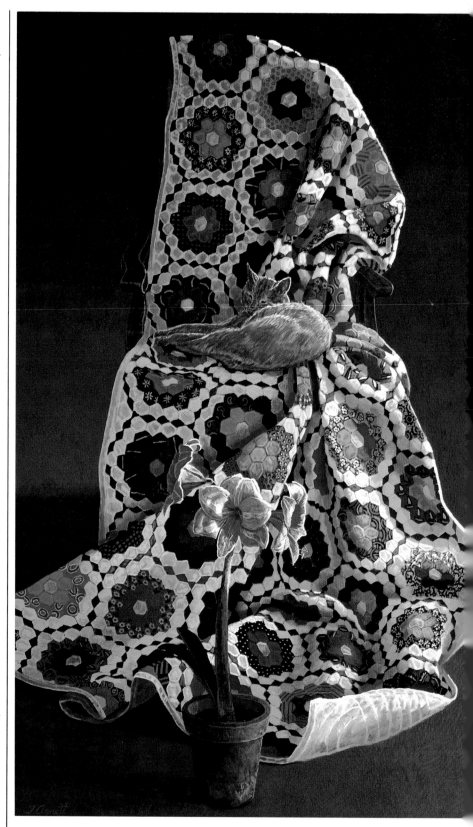

Left

SAINT PETER ON GEORGIA'S QUILT
48″ × 30″ (122 × 76 cm)
Oil on Masonite
Collection of Mr. and Mrs. Bill Armstrong

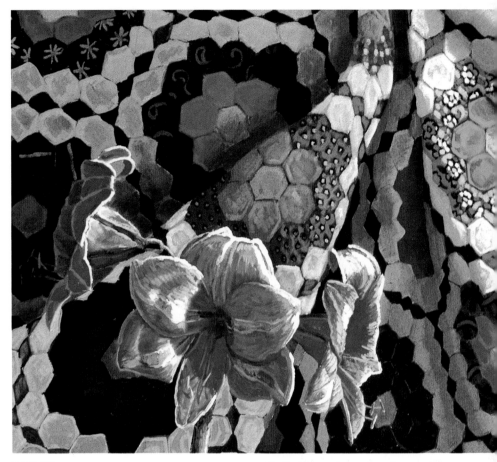

When Arnett saw this quilt, she was intrigued by the variety of effects the quilter had achieved by using different colors and patterns in each hexagon. The design of the quilt is called "Flower Garden," and Arnett decided it would be interesting to contrast the patchwork flowers with a real flower — an amaryllis. She wanted her viewers to feel that they were looking at "life," to sense that the flower was a living thing with its own inner energy. The sleeping cat provides an echo of this theme.

As in all her paintings, Arnett maintained strict control over the values in order to capture the effect of light. She underpainted the background in gray, using values from 2 to 4 on the dark side of her scale. When that was dry, she premixed five colors— all in the same value as the darkest gray in her underpainting. In painting these colors over the gray, she used a crosshatching technique so that the broken color would give the background a certain vibrancy. She worked from dark to light, adding white to her color mixture as she went, making sure she matched the value of her gray underpainting.

Throughout the painting, Arnett keyed all her colors and their values to pure white — the lightest value. Even though the background of the quilt is white, most of it is in shadow so Arnett did not actually paint it white. Instead, she determined how the white would appear if it were in shadow — which turned out to be a light to medium gray.

One thing Arnett learned from this painting was the importance of not being locked into a particular color scheme. Originally the cat was going to be a grayed white. The cat "turned" yellow quite accidentally. She was underpainting the cat in yellow so that when she painted over his coat in a grayed white, a touch of yellow would glow through. But she liked the effect of the yellow underpainting: it added variety to her color scheme and provided a note of warmth in contrast to the cool grays in so much of the painting. Often Arnett will take a piece of canvasette paper and do several quick paintings (in acrylic) of the object in question in different colors. She then cuts her studies out and holds them up to the appropriate place in the painting to determine the different effects achieved by the different colors. This procedure is certainly preferable to trial and error in the painting itself.

DETAIL

The key to the sense of shining light here lies in Arnett's handling of the value relationships. For the whites in the shadowed areas of the quilt, she chose values in the 4, 5, and 6 range — leaving room for several jumps in value between them and the whites in the areas where light was shining (on the flower and one edge of the quilt). Then, in order to make these shadowed whites appear to be white, she placed darker values next to them — using values of 1, 2, 3, and 4 for the patchwork of flowers. The amaryllis itself was given a very large value range, from 10 to 2, in order to draw attention to it as the center of interest.

To paint the quilt, Arnett first outlined the outside edge of each hexagon quickly and loosely in a dark, neutral color (alizarin crimson and sap green). In this way, she was able to paint each hexagon quickly, without having to worry about getting right up to its edge. The paint was applied fairly thickly, sometimes in chunks, to give the quilt a rough, uneven texture, just like the actual one.

SUGGESTED PROJECT

To make your own value cards, first cut out ten cards, each measuring 3 × 3½ inches, from canvasette paper. Using a paper puncher, punch two holes in each card about 1 inch from one of the card's edges.

Now, using either acrylic or oil paint, mix ten different values going from pure black to pure white. It is easiest to mix the values of gray by starting with black and adding white to it. Mix a very dark gray first, then a lighter one, and so forth until you get to white. Make sure that the transition from black to white is gradual, without any big jumps from one value to the next. Also, mix the paint well so that there aren't any streaks.

Once you're satisfied with your ten values, paint each card with a different value. Then, after the cards are dry, number them from 1 to 10, with black as 1 and white as 10.

To check a color's value, lay the card over it and look through the two holes. Be sure to squint your eyes. If the holes fade away, you have matched the value card to the color. You can also check the value by looking at the edge of the card where it lays on top of the color. Again, squint your eyes: if the sharp line of the card's edge and the underlying color disappear, they are the same value.

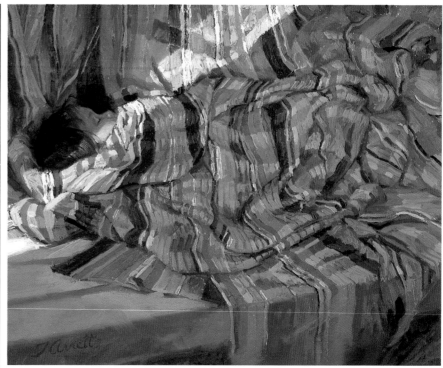

KALEIDOSCOPE
14" × 18" (36 × 46 cm)
Oil on canvas

On a visit to Guatemala, Arnett's husband photographed this child sleeping in a weaver's hut. Arnett was immediately attracted to the vibrant colors of the blanket and the patterns they created as they folded in and out. She wanted her painting to come across first as a strong, abstract design, with the viewer only gradually realizing that there is a sleeping child inside the blanket. It is the emphasis on the blanket and the streak of light across it that makes this painting a still life rather than a figure study.

The blanket provided a challenge. How could she capture the curving in and out of its folds and also incorporate the dramatic lighting she wanted? As a first step, Arnett underpainted the blanket area in a medium to dark, semitransparent red so that she would not have trouble covering the white canvas when laying in the stripes. If she failed to cover it completely, the red would show through and provide a nice glow. To paint the folds and stripes, Arnett decided to mix three different values for the color of each stripe — three values of purple, three of dark green, three of light green, and so on. The lightest value was for the front of the fold; the in-between value, for the place where the fold starts to turn back; and the darkest value, for the point where the fold becomes a crack. These three value mixtures, however, were used only for the parts of the blanket that are in shadow. For the area of the light streak, Arnett mixed an entirely different group of values. The colors in the shadowed areas ranged from 2 to 6 on the value scale, so to create the light streak, she chose values of 8, 9, and almost 10. This gave her two jumps in value from the lightest part of the shadowed area to the darkest part of the light streak. To increase the illusion of light, she dulled the colors in the shadows with black, but kept the colors in the light-streaked area as intense as possible. They are thus not only lighter than those in the shadow area but also brighter.

To give the painting more zip, Arnett painted the child's hair very dark, with a mixture of alizarin crimson (the largest portion), Thalo green, and burnt umber. Placed next to the light streak, this very dark area makes the light seem even lighter. As Arnett points out, adding dark darks can be just as important as adding light highlights in making a painting sing.

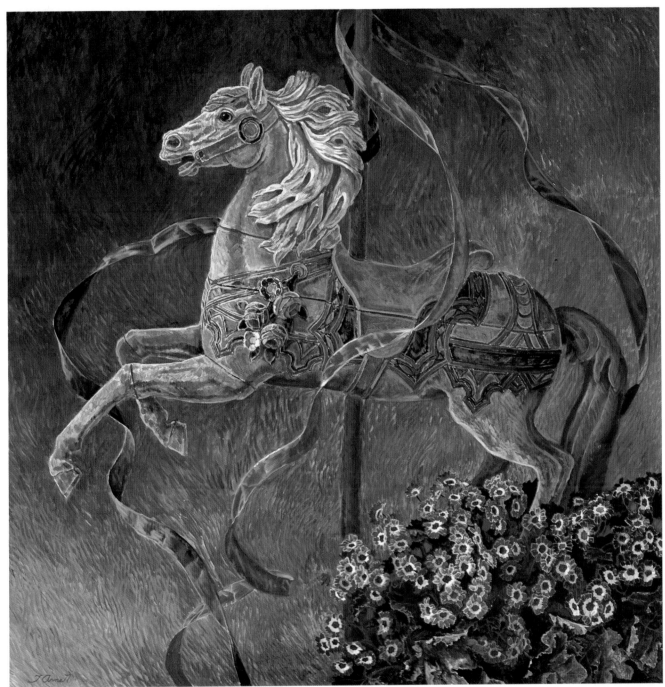

SUMMER'S DREAM
44" × 44" (112 × 112 cm)
Oil on Masonite

Gaiety and whimsy pervade this piece, which Arnett refers to as her "happy" painting. She remembers living out some of her most wonderful fantasies on a carousel as a child. The idea for this painting started in an antique store in Austin, Texas, where she admired a beautiful, hand-carved carousel horse. Without a camera to photograph him or $1400 to buy him, she left the shop without her subject. Several years later, an advertisement for a shop in Dallas

selling carousel animals prompted her to catch a flight there. She left the shop with some six rolls of film for reference material.

When she was ready to begin her composition, she could not decide on one particular horse to feature in her painting, so she made a composite of four different animals: the head from one, the mane from another, the body from a third, and the body decorations from yet another. Sometimes Arnett draws her subject on the board several times before she gets it right. In this case, she had completely drawn the horse when she decided that he needed to be two

inches to the left. To strengthen the feeling of fantasy, she included swirling, floating ribbons. The flowers provided a mystical quality because they, like the ribbons, were somewhat out of place or, rather, not where one would expect them.

To give the painting a transparent, luminous quality, Arnett mixed her paint with medium so that it would flow on thinly. For the areas that she wished to emphasize — the flowers on the horse's body and the sparkle of light on the ribbons — she used bold, thick colors in very light values.

Eileen Goodman
Moving into the Shadows

Eileen Goodman is most drawn to the quality of light as it passes across forms and into darkness, and to all that this implies and reveals. A flood of warm light may envelop the entire composition, bathing even the shadows, which then take on a character and expressiveness all their own. Indeed, the shadows are as much a focus of Goodman's interest as the objects.

Usually Goodman chooses a perspective that places us above, looking directly down at the composition. It is almost as if we were the source of the light, and, by looking down, all is revealed to us with clarity. In her arrangements we find clusters of objects with tensions between them. The placement of objects may look rather random — as if the oranges and peppers or kumquats had spilled out of the basket — but each situation is very carefully set up. Once Goodman's ideas are clarified, there are no great compositional changes. Backgrounds are often white, especially in her watercolors, or quite patterned. They are part of the structural architecture of the painting and serve to offset the objects.

WORKING METHODS

For her oil paintings, Goodman uses primed linen canvases with a medium-textured surface. Her palette is large, including some fifty pigments. She prefers flat sables, from no. 2 to no. 12 and occasionally one larger size.

Usually Goodman begins her oil paintings by making a light charcoal tonal drawing, which is precise in terms of proportions and scale. Before she does this on the canvas, however, she "thinks out" the composition on a scale of approximately 3×5 inches in a small spiral sketchbook that she keeps for this purpose. After the charcoal lines are in, she washes over them with Payne's gray. Then she begins touching in some color, using thin washes. In this way she eases her way into the painting. Her color is not really finalized or specific until she is almost finished with the painting.

For her watercolor paintings, Goodman uses a tin of Pelikan watercolors enhanced with single tubes of Winsor & Newton. Her paper is usually d'Arches 140-pound cold-pressed. She has an old favorite brush that she has been using since her art school days.

When she begins a watercolor, she starts with a light pencil drawing, which is very specific in terms of location, proportions, and scale. If a complicated pattern is involved, it will be indicated in this pencil drawing. As she paints, she builds her forms from light to dark. Her drawing then serves as a guide, letting her know where to leave the paper white.

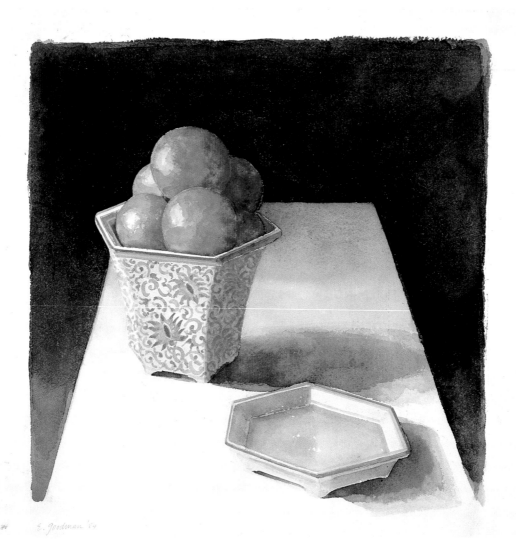

TANGERINES
15" × 22" (38 × 56 cm)
Watercolor on d'Arches 140-pound paper
Courtesy of Gross McCleaf Gallery, Philadelphia

The angle of view in this watercolor, which rushes us back into space, differs from Goodman's other work shown here. Yet the angle is important in conveying the feeling of light streaming in from the window, next to which this still life was set up.

Using a black-and-white Polaroid of her arrangement, Goodman first sketched her composition on the paper. As she painted, she referred to the tangerines and their con-tainer for color, but it was the Polaroid that offered guidance in developing the shadows that define the forms. For the background, Goodman chose a mixture of Payne's gray, indigo, and Prussian blue; she used a lot of pigment in her washes to get the very dark tone she wanted. She painted the cast shadows in a similar, but watered-down mixture, adding a touch of alizarin crimson. Toward the end, she clarified everything, bringing up the intense contrast between the sunlit orange of the tangerines and the dark blue behind.

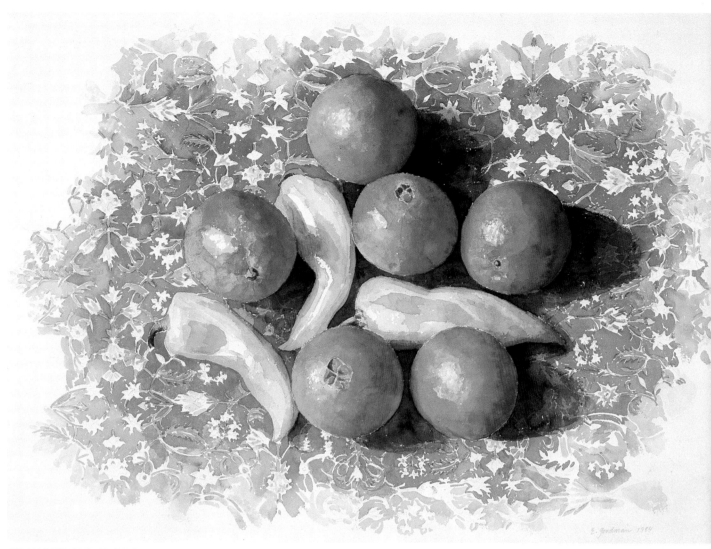

ORANGES AND YELLOW PEPPERS
16" × 20" (41 × 51 cm)
Watercolor on d'Arches paper
Courtesy of Gross McCleaf Gallery, Philadelphia

This painting has an amusing history. The peppers that inspired it started out as white peppers. In fact, Goodman was drawn to them at the vegetable store because of their almost pure white color. But once she brought them home, within a matter of days they began to acquire a yellow cast. By the time she had photographed the arrangement from several angles and decided on the composition, the peppers were yellow. Al-though the black-and-white Polaroid was a guide to the composition, Goodman's color comes from looking at the actual objects — so the peppers in the painting are yellow.

Here, as in many of her waterolors, Goodman focused attention on the center. As she moved away from the center, her handling of the patterned ground became looser and her washes lighter until finally they fade into the white of the paper at the edges. Our eyes keep coming back to the center. There, through Goodman's seemingly random arrangement of the or-anges and peppers, we are led in and out of the shadows and around the forms.

In laying in the form of the orange, Goodman worked from light to dark. But the deep shadow next to it was an equally important consideration in defining its con-tour and positioning it in space. Goodman rarely paints the object and then the shadow; the two go hand-in-hand. She might start with some light washes in the orange, turn to the shadow to bring out its shape, and then continue with the orange, moving back and forth.

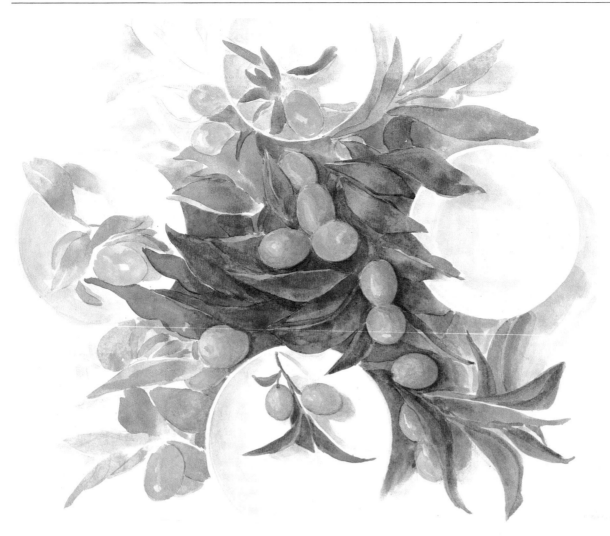

KUMQUATS
15″ × 22″ (38 × 56 cm)
Watercolor on d'Arches paper
Courtesy of Gross McCleaf Gallery, Philadelphia

Before Goodman did this watercolor, she had painted a large oil using similar subject matter. She wanted to explore the kumquats further, but, instead of executing another oil, she decided to work with watercolor to see how differently she might portray them. It was one of her initial attempts at watercolor, and she used the transparency of the medium to enhance the delicate feeling of the kumquats.

DETAIL

The loss of focus at the edges of this painting helps to concentrate our attention on the dark areas in the center. Here Goodman used looser brushwork and thinner washes than in the center so the area has less visual weight. Notice how even here she gave definition to her forms through the shadows. It is the delicate play of the purple shadows that creates the spatial feeling of the kumquat resting on the plate.

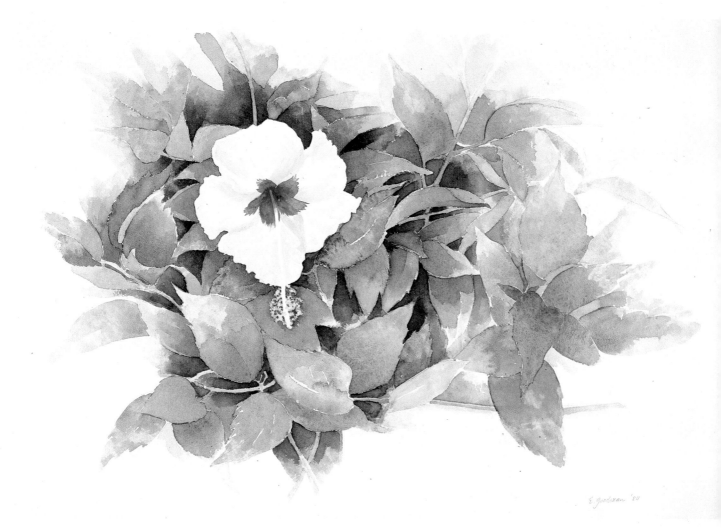

WHITE HIBISCUS
15" × 22¼" (38 × 57 cm)
Watercolor on d'Arches paper
Courtesy of Gross McCleaf Gallery, Philadelphia

This white hibiscus was painted directly from color photographs taken by Goodman in the Caribbean, on the island of Jamaica. Although the viewpoint here is a frontal one, rather than the overhead view Goodman generally prefers, the effect is quite similar in terms of inviting us directly into the painting. Once again, the subject is centrally placed and as the eye moves out of the painting the edges become fuzzy.

The crucial role that shadows play in Goodman's painting is well illustrated here.

The white of the flower is actually the white of the paper, but it seems much more brilliant than the paper at the edges. To get this effect, Goodman built up the darks that surround the flower and define its contours, throwing it into relief. As she moved toward the edges, she added more water to her washes so there is less of a contrast with the white paper. Within the flower, she used very pale washes of yellow to articulate the form. Combined with the vivid red in the flower's center, these touches of yellow make the white of the flower warmer than the white at the painting's edges and thus project it forward.

David Fertig
Creating a Quiet, Intimate View

For David Fertig, the still life is the epitome of all genres of realistic painting — encompassing figure, landscape, and portrait painting. When he paints landscapes, for example, he finds himself reacting against a strong stimulus. In contrast, with a still life, he starts from "zilch"; it is the ultimate opportunity to create an environment that he wants to paint.

Fertig uses reality only as the starting point for his work. He is much more interested in expressing his feelings about reality and establishing a contemplative mood in his work. Pastel is an ideal medium for the expression of tranquillity, but even in his oil paintings Fertig renders objects peaceful and dreamlike, enveloped in a quiet order.

Fertig credits Robert M. Kulicke (see page 92) as an important influence on his still life painting, even though he has never studied with Kulicke directly and paints on a much larger scale. Both artists strive for "an intimate, serene order" in their work (to use Kulicke's words). Fertig has also been inspired by Vuillard, Bonnard, Fantin-Latour, Redon, Morandi, and other great still life painters. Often their work helps him choose the objects he uses for his paintings.

WORKING METHODS

In developing his painter's eye, Fertig found he benefited enormously from using a camera obscura, lent to him by artist Robert M. Kulicke. Essentially, through lenses and mirrors, this optical device translates a three-dimensional space into a two-dimensional space. When you look through the viewer, you see how objects and the sense of depth are flattened when they are depicted on a two-dimensional surface. In fact the use of the camera obscura was quite popular among such sixteenth-century landscape artists as Canaletto, and it was a direct precursor of the modern camera. Although Fertig never used the camera obscura to actually paint from, he underlines that it helped him train his eye to *see.*

For his oil paintings, Fertig first sizes his cotton duck canvases with rabbit skin glue, which closes up the pores of the fabric. He then uses a lead white primer that establishes a barrier between the pigment and the fabric. It also provides a nice white painting surface. His palette is built from some twenty-five Schmincke and Winsor & Newton oil colors. In addition to more traditional pigments like cadmium yellow and cadmium red, he includes less "expected" colors like bayrete yellow and rose doré. To get the variety he wants in his whites, he chooses from flake, titanium, and cremnitz (a very heavy, opaque white). For brushes, he prefers filberts because they are ideal for painting soft edges. He is not at all interested in giving his objects hard edges — that isn't how he sees.

In his pastel work, Fertig uses Rembrandt pastels much like a brush: he removes the jacket and paints with the flat side of the stick. He never draws or crosshatches with the tip. He prefers white Strathmore charcoal paper beause it is very soft and smooth. While working with pastel, he often sprays a workable fixative between layers of color in order to stabilize the pastel, and occasionally even uses a permanent fixative at this point. At the very end, of course, the permanent fixative is sprayed on several times.

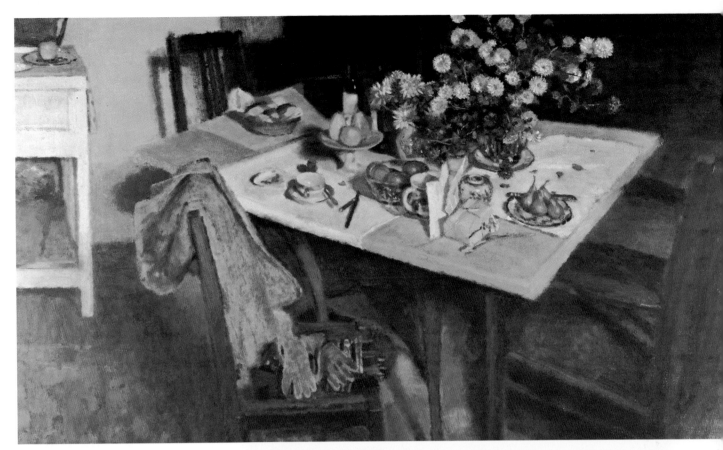

HIS GIFT TO HER
48" × 72" (122 × 183 cm)
Oil on canvas
Collection of Chatta Robinson
Photograph courtesy of Marian Locks Gallery,
Philadelphia

His Gift to Her *is part of a series of large
paintings that explore the table and objects
in Fertig's studio. The day before he started
this painting, Fertig organized the picture
physically by setting up all the objects, ar-
ranging them, and rearranging them — on
the table and off — until he was satisfied
with the composition. To isolate his view of
the arrangement from its surroundings, he
made himself a small viewer. Taking a
9 × 12-inch piece of cardboard, he cut out
a rectangle in the correct proportions of the
canvas; by looking through this, he could
concentrate solely on the images that would
appear in his painting. The more he worked
on the painting and the more the shapes
became defined, the less it was necessary to
use the viewer.*

*After indicating the main shapes very
lightly with pencil, Fertig gently painted all
over the canvas, starting from the outer
edges and working in. Each time he passed
over the canvas again, forms became more
defined. Yet he didn't want a sharp focus.
In fact, to augment the hazy quality of the
painting, he mixed his oil pigments with
Dorland's wax medium. The wax softened
the color, making it reminiscent of pastel.*

DETAIL
*Even an isolated detail conveys the intimate order Fertig is after. Here the soft color and
careful modeling of the fruit, as well as their gently rounded forms, establish a peaceful
harmony. The triangular arrangement, augmented by the bottle behind, helps to convey a
sense of stability, of "rightness" — as if the objects had to be in this place. Most important
is Fertig's use of soft edges. Although the individual shapes of the objects are clear, nothing
is harshly defined.*

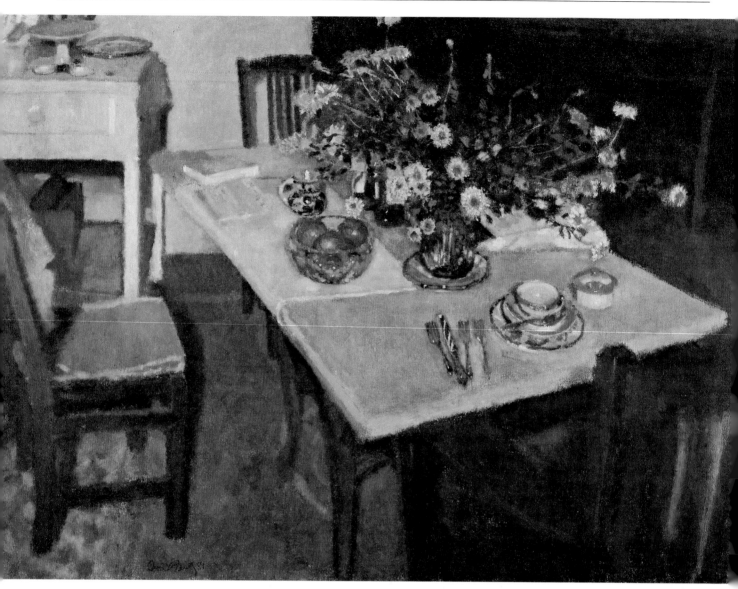

YELLOW TABLE
42" × 60" (107 × 152 cm)
Oil on canvas
Photograph courtesy of Marian Locks Gallery,
Philadelphia

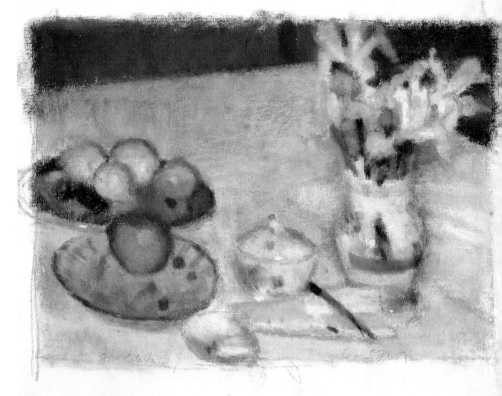

This painting is a companion piece to His
Gift to Her, *as you can see by the similar
arrangement of the table, chairs, and other
objects. The second floor of Fertig's studio,
where this painting was made, is quite
small; the table and other objects took up
almost the entire space. Fertig found that
he couldn't get back far enough from the
setup to see it clearly as a whole. Moreover,
because he was almost on top of his setup,
he constantly had to deal with the problem
of distortion. Specifically, he didn't want the
viewer to experience a disjunctive shift in
perspective from the objects in front to those
in back. Instead of depicting the crowded-in
aspect of his own view, where it was impos-
sible to focus on foreground and back-
ground at the same time, he tried to convey
a sense of space. To give himself a "single"
view of his subject, Fertig looked through a
reducing glass, which provided an extra 10
feet or so of distance. Then, as he painted,
he outlined everything so he wouldn't lose
the perspective he wanted. The drawing was
a reminder, helping him to translate what
he saw into the view of the painting.*

*Fertig delayed finishing this painting be-
cause initially he felt that it was much too
simple — there were only a few objects to
occupy one's vision. But as he continued,
he found that even a simple arrangement
has all sorts of problems to be worked out.
In general, when he feels that a particular
setup is no longer challenging and that he
has learned all he can from it, he stops
working with it. After seven paintings, Fer-
tig felt that this theme had run its course
— but that doesn't mean that a year or so
from now he might not return to this very
same table and similar objects to explore the
theme yet further.*

DETAIL

*By the care he gives to every element in his
painting, Fertig draws us into the view. In
addition to taking in the larger view of the
painting as a whole, we move into the
painting to look at still lifes within the still
life. Here the round glass bowl of apples,
with its soft highlights, is subtly echoed in
the creamer, which picks up the gleam of
light. Fertig's use of color — the delicate
variations of white, as well as the pairing
of the deep blue of the creamer with the
warmer but muted reds of the apples —
adds to the sense of balance.*

YELLOW FLOWERS
19" × 24" (48 × 61 cm)
Pastel on paper
Photograph courtesy of Marian Locks Gallery,
Philadelphia

*Fertig's pastel work relates to his oil paint-
ing in the sense that he handles the pastel
stick more like a brush than a pencil, using
its flat side to sweep in areas of color
throughout the composition. Here he started
with the briefest of drawings in light gray
pastel to establish the placement of the vari-
ous objects. He then added a light layer of
color — almost a mist — all over the
surface. Gradually he built more and more
layers, working all over so that at each
stage everything in the picture was in
synch. At first the objects were indistinct —
blurs of color — but as he continued, the
images slowly began to crystallize and ac-
quired more definition. When too much
pastel accumulated on the paper, he used a
workable fixative to create a new surface on
which he could continue to work. Whenever
the colors again began to move around, he
resprayed the drawing to stabilize the pastel.*

*Fertig believes that working in north
light helped him to get the range of whites,
from the tablecloth to the vase, that contrib-
ute to the quiet mood and pristine quality.
This kind of light allows him to see very
subtle gradations in the white areas. With-
out his careful observation of these changes
in the white, the pastel would be far less
interesting to look at.*

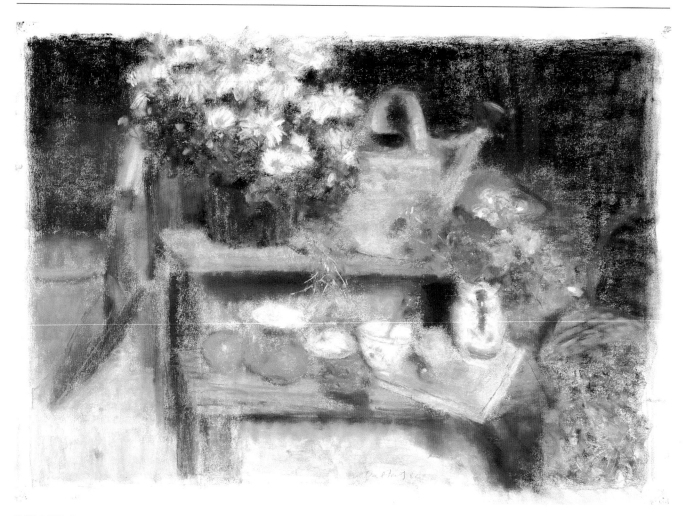

GARDEN STILL LIFE
25" × 35" (63 × 89 cm)
Pastel on paper
Photograph courtesy of Marian Locks Gallery,
Philadelphia

Here Fertig was intrigued by some paintings by Courbet and Delacroix that depicted benches with flowers surrounded by garden tools. In arranging the objects in his studio, he decided to include a few domestic objects, like the teacup, to reinforce the feeling of an interior view.

Although Fertig used a wide range of colors, he took care to anchor them with neutral grays. These grays, ranging from very pale to very deep, almost charcoal, support the other colors and make them come to life. The grays also create a base of tonal gradations for the more intense colors. In fact, Fertig often uses his grays in a way that is similar to underpainting, laying a brighter color on top. At other times he will place a neutral gray next to a strong color so that it becomes all the more vibrant.

DETAIL

In this closeup view, you can get an idea of how Fertig's use of grays both heightens and unifies areas of more intense color. If, for example, you simply placed a bold red next to a bright yellow, the two would tend to cancel each other out. By letting small areas of gray show through from underneath the color, you can actually increase the intensity of the red and yellow. At the same time the gray provides a common bond between the two colors, bringing them into harmony.

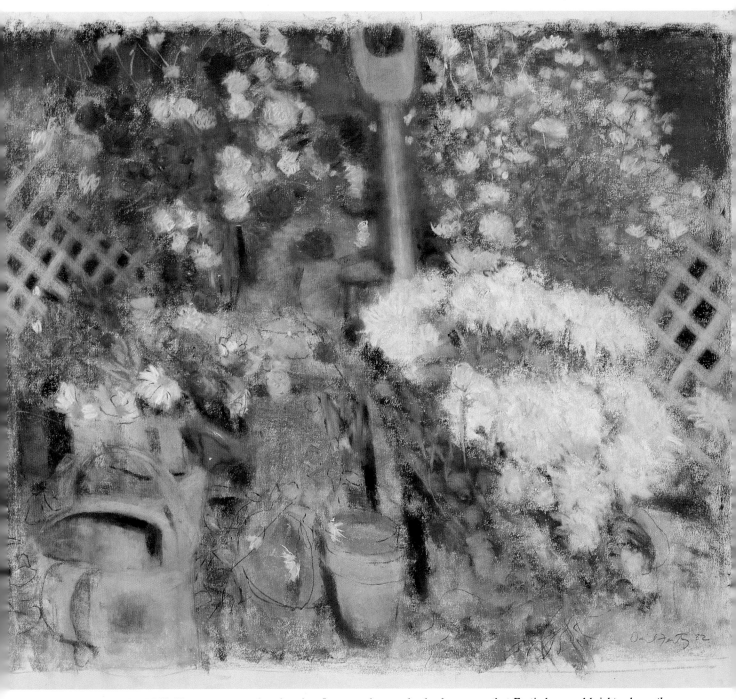

FLOWERS AND TRELLIS II
25" × 30" (63 × 76 cm)
Pastel on paper
Photograph courtesy of Marian Locks Gallery,
Philadelphia

*Fertig set the trellis and props up on a table
about waist-high in his studio, along with
freshly cut flowers from his garden and his
garden tools. The arrangement re-creates a
sense of the outdoors indoors; we seem to be
viewing this scene from a sitting position on
the ground in a greenhouse. At the same
time the dark background — from the wood
of the interior walls of Fertig's studio —
closes in the space, suggesting the intimacy*
*of an interior. Its warm brown also lends a
softness to the colors and shapes of the
objects.*

*What is striking about this still life is
how everything seems casual and at the
same time ordered. Fertig's composition
and use of color are important in creating
this effect. The positioning of the gray wa-
tering can, as well as the burst of bright
red in its spout, lead us to the colorful
flowers. The strong gray vertical in the cen-
ter, as well as the structured trellises at the
edges, then help to contain the "riot" of the
flowers. Actually, if you look closely, you'll*
*see that Fertig has used bright color rather
sparingly. It stands out because of what's
around it.*

*This pastel work is a large one for Fer-
tig. It took him several months and some
fifty other pastel drawings to work up to this
size. Yet, surprisingly, Fertig finds that in
his larger pieces, he uses about the same
amount, or even less, pastel than in his
smaller ones. Also, because the large works
come at the end of a series, when he is
more familiar with his setup, they take
about the same time to complete as his
earlier, smaller works.*

Peter Eichner-Dixon
Bridging Symbol and Reality

The paintings of Peter Eichner-Dixon (called PED, for short) stem from concrete visual experiences, from objects that he has seen and been deeply affected by. Painting, for him, is a visual language, allowing him to communicate complex inner emotions and relationships between nature and humankind. Certain forms seem to inherently suggest emotional states. Nautilus shells, for instance, not only have a physical beauty but also generate meanings through their womblike structure. Both aesthetically and philosophically, they appeal to PED's creative needs as a painter.

Although he uses the external world for symbolic purposes, Eichner-Dixon allows his objects a presence all their own. Ultimately his paintings oscillate between symbolic presentation and realistic portrayal; they are at once pictures of actual settings and maps of emotional response. For PED, it is important that the realistic and the symbolic levels support and merge into each other. "Although we are separated from nature in our essential 'otherness,'" he says, "we are still part of this astoundingly beautiful universe." What he strives for in his work is a harmony that will bridge the gap between nature and culture, people and their environment, the inner self and the outer world.

WORKING METHODS

Eichner-Dixon started out as a watercolorist, then went on to working in acrylic with oil glazes on top. His favored watercolors are Winsor & Newton and Schmincke, a German brand. For acrylic, he mainly employs Liquitex. He uses round sable brushes for direct painting, glazing, and scumbling. Splattering is done with a toothbrush and with bristle brushes, which are rigid enough for him to simply flick the paint off the brush. In addition, PED often uses rags for dabbing on and removing pigment, a soft-edged fan brush for blending, and an airbrush for correcting and toning areas of color.

His watercolor paper is generally d'Arches 190-pound hot-pressed or 300-pound cold-pressed. For acrylic work, he uses 100% rag museum board or the same d'Arches paper that he uses for watercolor. When he adds oil glazes, he generally works on Masonite, which he primes with about three coats of Liquitex gesso, sanding it in between the applications of gesso. This creates a surface somewhat similar to cold-pressed paper.

In order to imbue his acrylic paintings with the sort of transparency inherent to the watercolor medium, Eichner-Dixon uses glazes, moving from acrylic to oil. Liquitex gloss medium and water are mixed with acrylics and brushed or splattered onto the canvas. Because the glaze dries fast, he must work very quickly. For his oil glazes, he uses Winsor & Newton's Liquin, which he thins with turpentine, or Liquitex's Permtine for a flowing consistency. The oil glaze is also fast-drying and is usually a darker tone of the color it will cover.

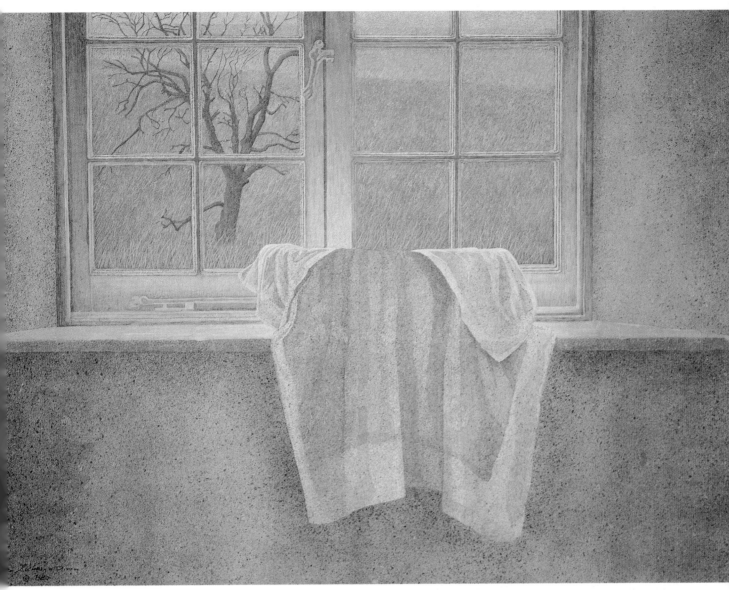

DEVON DAY

19⁷/₈" × 27³/₄" (50 × 71 cm)
Acrylic on gessoed paper
Courtesy of PS Galleries, Dallas, Texas, and
Ogunquit, Maine
Photograph by Ken Sanville

When Eichner-Dixon saw this still life inside a room where he stayed overnight, it reminded him of his rural childhood. The view outside the window, however, was actually of a brick wall; he recomposed it entirely to fit in with his childhood memories. At first he placed a figure outside the window, but he changed this to a tree because it seemed to disturb the dreamlike effect that he was after. The viewpoint was chosen to give the impression of someone lying on a bed, looking out the window.

After taking several photographs of the inside of the room, PED made a quick sketch. From these sources he developed the interior. For the tree, he used a slide of a tree his grandfather had planted for him when he was a child.

Working on gessoed paper, PED began with a line drawing of the inside and started to build up the forms in acrylic, with transparent layers and splatters of color. He chose his colors carefully to develop the dreamy mood he wanted. To create the wall structure, he used a toothbrush and bristle brushes to splatter clear, transparent colors (cadmium yellow, cadmium red, and cobalt blue). He then unified these dots of color by applying sev-

eral glazes of thin color — using either a mixture of yellow and cadmium red, or, in the shadows, French ultramarine blue and burnt umber. In addition, at points, he loosely scumbled semi-opaque color (mixing the colors just mentioned with white). For the window frame, he turned to sable brushes; here he started with opaque paint and then applied transparent layers of color over it. With the towel, he again splattered the paint and also used a stippling technique. The outside scene was painted last, partly by splattering and partly with a fine sable brush. He added several glazes to tone down the colors and thus reinforce the painting's dreamlike quality.

31

WINTER MORNING
(Study for "Ode to the Useless Beauty of the Egg")

9½" × 12⅝" (24 × 32 cm)
Watercolor on paper
Collection of Professor Mohing

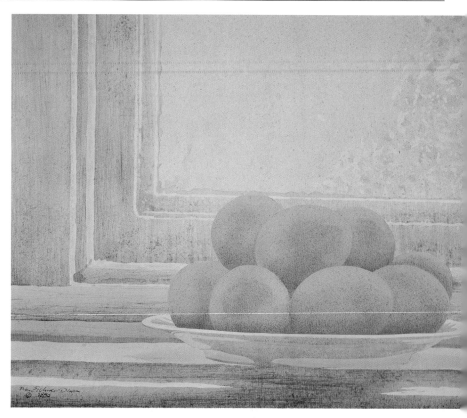

Eichner-Dixon began collecting egg shells because he found them so beautiful. Eventually he had accumulated so many in his studio that they began to get in his way, so he put them in a box. One day he took the box, set it in front of a window, and tipped it over. This was the prelude to Ode to the Useless Beauty of the Egg *(facing page). As a contrast to the spilled-over, broken and "useless" egg shells, PED decided to include a plate of actual eggs, whose shells were still functional. To capture their perfection, he first made this study. The major difference from the plate of eggs in the final painting is the quality of light. Here there is only one light source, from the window, and everything takes on a slightly greenish cast. In the final painting, however, PED had to add artificial lighting in front; otherwise, the inside of the tipped-over box would have been too dark.*

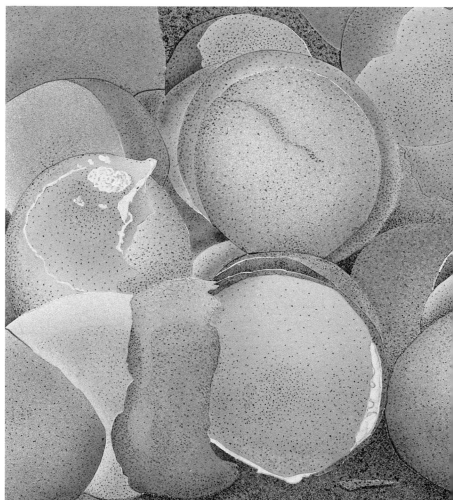

DETAIL

To get the shadows of the egg shells, PED used an airbrush, which creates a very fine spray without disturbing the washes underneath and allows subtle gradations from light to dark. For the airbrush work, he first blocked out the highlights in the eggs with Maskoid (a liquid frisket) to save the pure white of the paper in these areas. He also cut stencils to limit his working area; but, to avoid harsh transition, he lifted the stencil slightly as he worked so that a little bit of color would go underneath.

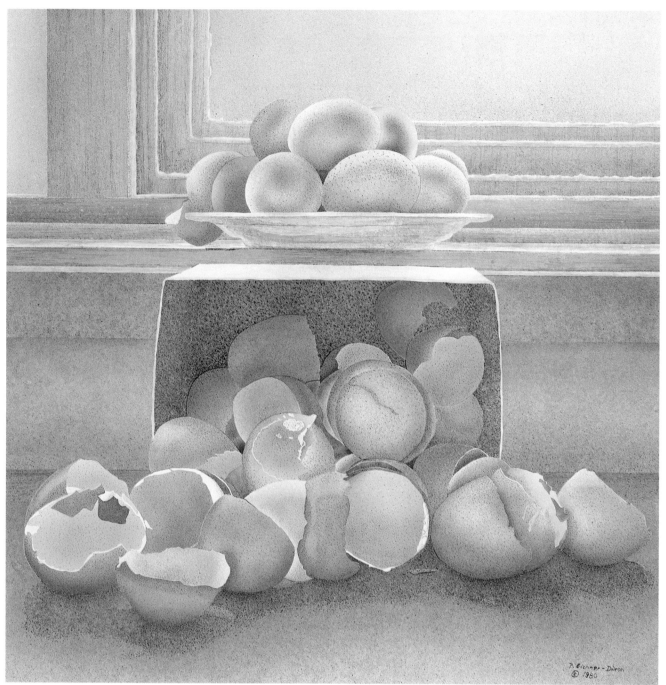

ODE TO THE USELESS BEAUTY OF THE EGG

14^1/$_2$" × 14^1/$_2$" (37 × 37 cm)
Watercolor on paper
Courtesy of MacLaren-Markowitz Gallery, Boulder,
Colorado
Photograph by Ken Sanville

In setting up his composition, Eichner-Dixon chose the rectangular, "man-made" forms of the window to play against the ovals of the "natural" eggs. He also decided on a viewpoint somewhat below eye level so that we are directly confronted with the tumble of egg shells (which seem larger than life) and have to look up to the plate of pristine eggs on the window sill (almost an altar). This point of view also accentuates the tension between the rigid geometry of the window and the graceful curves of the eggs. It is primarily the drawing and modeling of the eggs and egg shells that give a sense of full-bodied space; the window frame recedes only as a series of stiff parallel planes.

In line with the mood he wanted, PED kept his colors subdued and simple, not at all like the actual setup, which was more brightly colored. He worked with mixtures of yellow, ocher, brown, blue, and traces of red, as well as the white of the paper. After mixing his paint in little containers, he applied it with brushes, or splattered with a toothbrush, building the color very gradu-ally, in very thin layers. Given the fragility of watercolor and the difficulty in making extensive corrections, he did most of his experimenting (especially for the texture in the background and the eggs) on a separate piece of paper. In this way he could solve any problems beforehand.

When he was nearly finished, PED deepened the inside of the box by applying several washes and stippling the paint. But as he worked, he didn't have a preconceived idea of what the final painting would look like. He finds that his best paintings usu-ally develop naturally, without a predeter-mined framework.

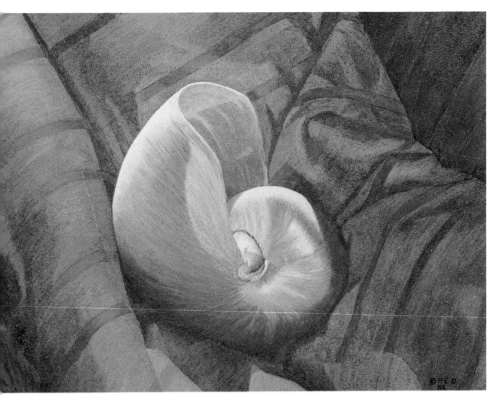

WELL-CUSHIONED SHELL
7³/₄" × 9" (20 × 23 cm)
Acrylic and oil on Masonite
Courtesy of Clifford Gallery, Dallas, Texas

Eichner-Dixon is fascinated with the symbolic possibilities of nautilus shells, with their womblike structure. He is also drawn to their intricate coloring and the way they reflect light. Here he was working on a still life of a grouping of nautilus shells when he momentarily set one aside in the cushion of a nearby chair. Enchanted with the arrangement, he made only a slight adjustment — to let the early morning sun hit the shell in just the right spot. After taking several photographs from different angles for later reference, he decided on a viewpoint from slightly above to open up the shell form.

In order to achieve the strong highlights in the shell and a full range of tones, PED felt he had to work in acrylic and oil glazes rather than watercolor. To experiment with the tonal contrasts, he first did a two-hour study in acrylic. He realized that he would have to build the contrasts very gradually, working from the middle values toward light and dark, and eventually shifting from acrylic glazes to oil ones when he wanted subtle gradations (and a slower drying time).

PED began by underpainting the shell in cadmium yellow, cadmium red, a mixture of the two, and cerulean blue. He then scumbled layers of semi-opaque color (mainly different shades of white tinted with cadmium yellow, cadmium red, and cerulean blue). Using a fine sable brush, he applied very thin, transparent glazes to define form and texture. The shadow areas were established with glazes of cobalt and French ultramarine blue, sometimes with a trace of cadmium red or burnt umber. Later, he pulled out the highlights with titanium white and then glazed them down and modeled them with thin, transparent glazes of cadmium yellow, cadmium red, and cerulean blue.

For the cushion, he first underpainted in mixtures of cadmium yellow, cadmium red, and burnt umber, as well as cerulean and cobalt blue. To establish the highlights, he used semi-opaque scumbles of these colors; he then glazed down the shadow areas with cobalt blue. Next, using a no. 10 sable brush, he glazed the entire background with French ultramarine blue and then modulated this by removing some of the glaze with a clean rag. After reestablishing the highlights, he finally glazed parts of the shadows with a mixture of ultramarine blue and burnt umber. Then, at the very end, he applied a coat of varnish over the whole.

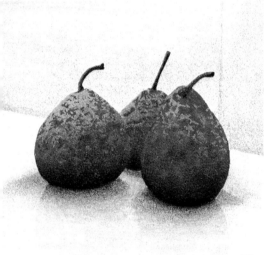

Left
THREE PEARS
8" × 8¹/₂" (20 × 22 cm)
Acrylic on paper
Collection of Professor Dr. Kurt Staph

Intrigued by the rich color and texture of the pears, Eichner-Dixon decided to paint them in a simple setting, with backlighting for an interesting shadow pattern. He first did a pencil study on a separate sheet of paper to determine his composition. Then, by placing a mat on top of the drawing, he decided where to crop it.

In this painting PED worked only with brushes, using no. 1, 3, and 10 round sables. Combinations of cadmium yellow, cadmium red, cobalt blue, cerulean blue, red oxide, and burnt umber gave him the color of the pears. To render them full and round, he painted from light to dark and then scumbled in the soft highlights.

Quite a bit of experimentation was involved in creating the simple suggestiveness of the background and the light-filled shadows. Using touches of burnt umber, cobalt blue, and ultramarine blue with titanium white, he worked the background from light to dark and then back to light — a procedure that was repeated several times. The same colors were used in the shadows, but here he splattered titanium white to break up the darks with light.

At the end PED tightened everything, deepening the dark parts of the pears with glazes, breaking up the shadows, and clarifying the background.

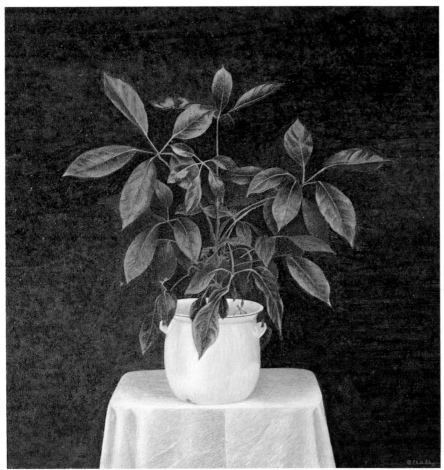

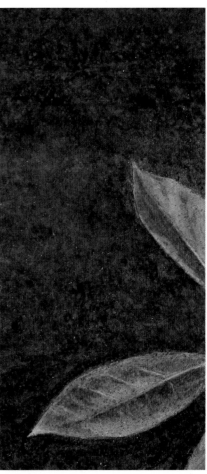

STILL LIFE WITH PLANT
12⁵/₈" × 12¹/₈" (32 × 31 cm)
Acrylic, alkyd, and oil glazes on Masonite
Private collection

Eichner-Dixon spent considerable time arranging this still life to get the feeling he wanted. After putting a favorite rubber plant in an old bucket, he tried out various locations and different lighting situations. Finally, he positioned it on a small table in front of two sliding barn doors, which provided a contrast in their strict geometric patterns, as well as a surface for interesting shadows. Ultimately, however, he decided that this arrangement worked against his aim of painting a simple portrait of the plant. He ended up placing the plant against the dark background of the inside of the barn.

Choosing a small scale for intimacy, PED began with an outline drawing of the plant. He then blocked in the basic shapes in acrylic, using a mixture of yellow, blue, and red for the leaves and underpainting

the pot and tablecloth in blue. After refining the basic shapes with some modeling, he laid in the background. At this point PED shifted to oil and alkyd (a resin-based paint which is much stiffer than regular oil paint, dries faster than oil, but stays wet longer than acrylic paint). Using semi-opaque scumbles and glazes, he modeled the forms. For the plant, he applied yellow, blue, and red glazes and scumbled the highlights, using a mixture of titanium white and yellow for warm areas and titanium white and blue for cool ones. The tablecloth was done in scumbles of titanium white mixed with red, blue, and yellow. After adding a glaze of French ultramarine blue to the background, PED refined his modeling of the still life forms with thin oil glazes. He then splattered and worked wet into wet in the background. At the end he applied a glaze over the entire background and, once everything was dry, added a protective varnish to the whole painting.

DETAIL

The background is of great importance to this painting. PED wanted it to be very dark with a free-flowing, abstract patterning. Yet he also wanted it to suggest rich color and depth rather than looking like a flat, painted surface. To get this effect, he used a variety of techniques — working with rags and brushes, splattering, and glazes. As a first step he dabbed several bright acrylic colors (mostly primaries) onto the white ground and then applied an oil glaze of ultramarine blue and alizarin crimson. With a toothbrush, he splattered several oil colors and then modified this with a fine sable brush, working right into the wet glaze and splatter. Once the surface had dried thoroughly, he added a final glaze to modulate the overall flow of the shadow.

SUGGESTED PROJECT

When you come to paint a still life, you may wonder how best to translate a three-dimensional setup onto a two-dimensional plane. Both sketches and photographs can be helpful in opening up different ways of seeing and testing possible approaches. To explore how they can work for you, first set up a still life in a stable lighting situation with objects that excite you. Now decide on the angle of view and take several photographs at different exposures from this angle. Also draw or paint a quick sketch of the still life from the same angle.

Observe how your sketch differs from your photographs, and how both differ from the actual still life. What kind of information is more readily available from the photograph or from the sketch? A photograph, for instance, may lack information in certain areas, such as the shadows or highlights. Or it may be unclear whether one edge is harder or softer than another. Look at your sketch to see how you have treated these areas and compare this with the actual still life. Try squinting your eyes while looking at the still life and see how this affects the overall light and shadow pattern.

After you've examined the difference in the lights and darks, look at the form of the objects. How has the camera changed or "distorted" the forms, and how have you changed them in your sketch? Can these changes be used to clarify your pictorial concept, or do they lessen the impact of what you want to express?

Now study the different textures and surfaces in your still life, and compare your observations with the way the photograph depicts textures and surfaces and how you hinted at them in your sketch. Again, consider what will enhance your aim in your painting. If you took color photographs and did a color study, you will also want to examine the different color relationships, especially in areas of reflected color.

All these comparisons will help to sharpen your perceptions so that you are more aware of what you see. Try making a new sketch, incorporating your new insights. By this time you should have a thorough understanding of your still life and the problems involved in translating it, which will help as you move on to paint it.

SETUP 1

Setting up a still life is a very intuitive visual process for Eichner-Dixon. Here he started by arranging a few objects that had personal significance for him. He wanted to include a book of poems by his favorite poet, Paul Celan, and eventually one of the poems lent its title to his drawing.

SETUP 2

Looking at his initial setup, PED decided it didn't have enough visual excitement — so he brought in more objects and shifted his original arrangement slightly. He also decided to try a dark feather against the book for contrast.

SETUP 3

Even slight adjustments can make a difference in a still life. Here a few objects have been deleted and others shifted again. PED is guided mostly by his own inner responses. Each artist, he explains, will make different choices.

SETUP 4

After arriving at this arrangement, PED realized that he wanted something simpler — more in line with the preceding setup. For his drawing, he chose only the lower part of the still life. He also decided to eliminate the two shells at the top left and lower right corners as they destroyed the oval shape created by the other objects.

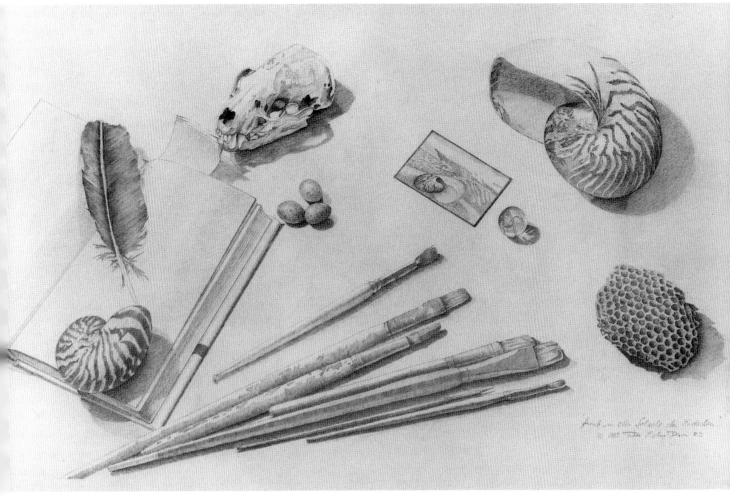

DOWN INTO THE TUNNEL OF THOUGHT

12³/₄" × 21" (32 × 53 cm)
Pencil on paper
Courtesy of MacLaren-Markowitz Gallery, Boulder,
Colorado
Photograph by Ken Sanville

While working on this drawing, Eichner-Dixon realized that it had significance beyond its visual impact, but he did not dwell on this at the time. Instead, he concentrated on the richness of his drawing, using pencils from H2 to B2 to control the tonal contrasts, as well as an eraser. After positioning the objects in faint pencil lines, he worked carefully on the shading, moving from a middle tone to light and dark. Although the shadows and perspective give a sense of space, he didn't define the ground because he wanted the objects to almost

"float" in a dreamlike state. At the very end he deepened some shadows, softened some hard edges, and brought up more highlights with an eraser.

Only after the drawing was completed did its meaning become clear to PED. In it he sees two themes woven into one. The first concerns life and death, hope and despair, expressed not as a linear progression, with life at the beginning and death the end, but as a cyclic movement in which one depends on the other and both are equally important. This concept is also expressed in the poem by Celan from which the title of this drawing is taken — although in a completely different way. PED's drawing is not a visual interpretation of the poem; the poem was simply a starting point. And here PED sees his second theme: how one form

of art may inspire the creation of another. Within the drawing itself, the main connection between literary inspiration and visual expression is provided by the book and the brushes, which point in a fanlike motion toward the other objects. It is as if inspiration flowed from the book into the brushes and came out at the other end in the depiction of the objects in the drawing.

The different objects in the drawing express variations on the two major themes. Images of life (shells, eggs) are followed by images of death (the skull, the wasp's nest). The dark, almost despairing mood of the poem flows from the black feather (writing quill) into the shell, whose womblike form and spiral pattern suggest life and continuation.

Penelope Harris
Conveying the Object's Spirit

Asked to explain how she approaches a painting, Penelope Harris immediately responded, "By intensely observing, looking and looking." The reason she examines each object so carefully, over a long period of time, is that she wishes to capture not only its shape, texture, and color but also its inner vitality and spirit. In her work the objects become much more than their reality.

Often Harris chooses objects that are lying around her studio — things that she has collected because their shape, texture, or character stirred something inside her. Pebbles and peaches, for instance, appeal to her because of their simple, sensuous shape. But no object is taboo. Anything may intrigue her next year, or even the next time she paints.

In arranging her still lifes, Harris may include a number of seemingly unrelated objects. Yet, through her composition, she makes contrasting elements work together and bring out the best in each other. Often she will chose a tilted-up angle for her painting so that we are directly confronted with the objects and forced to look into them. And when we do, we become conscious of their energy. These are not mere decorative forms; they are living things, due to the intensity of Harris's vision. They entice us to look further and further into the painting and, perhaps, into our own environment. With her provocative combinations, Harris asks us to reconsider our everyday point of view so that we may see the objects around us with a very different eye from now on.

WORKING METHODS

Harris is a slow, meticulous painter, who is most concerned with form. She spends a great deal of time preparing her surfaces to get something that is soft and satiny and gives her the impression that she is painting into a buttery surface. To size her canvases, she uses rabbit skin glue (the grainy powder version), then stains her canvas with lead white. When she works on a harder surface like museum board, she uses Rhoplex so the oil won't sink in.

After priming the canvas, Harris underpaints it entirely in a warm neutral tone (usually a mixture of burnt sienna, raw sienna, and a touch of blue), which "cuts" the white. At this point she is ready to transfer the very careful drawing that she has executed on heavy-duty tracing paper. She then models all her forms in gray tones. This value painting in gray (or grisaille) helps her later, when she comes to mix her colors.

Harris mixes her Winsor & Newton paints on a large, disposable paper palette. She mixes her colors spontaneously and has no idea beforehand what she might unexpectedly need. So, in order to play it safe, she has a myriad of colors on her huge palette at all times — regardless of whether they will all find a place in her painting. A medium of damar varnish, turpentine, and sun-thickened linseed oil ensures her that the paint will go on smoothly.

In addition to bristle and sable brushes, Harris uses a badger-hair brush for rougher textures, as well as a palette knife. For additional texture, she works subtly with sponges, cheesecloth, rags, and toothbrushes — or anything else that might be at hand and appropriate to use. She doesn't waste time searching for the exact tool. Instead, she improvises and always manages to get the results she wants.

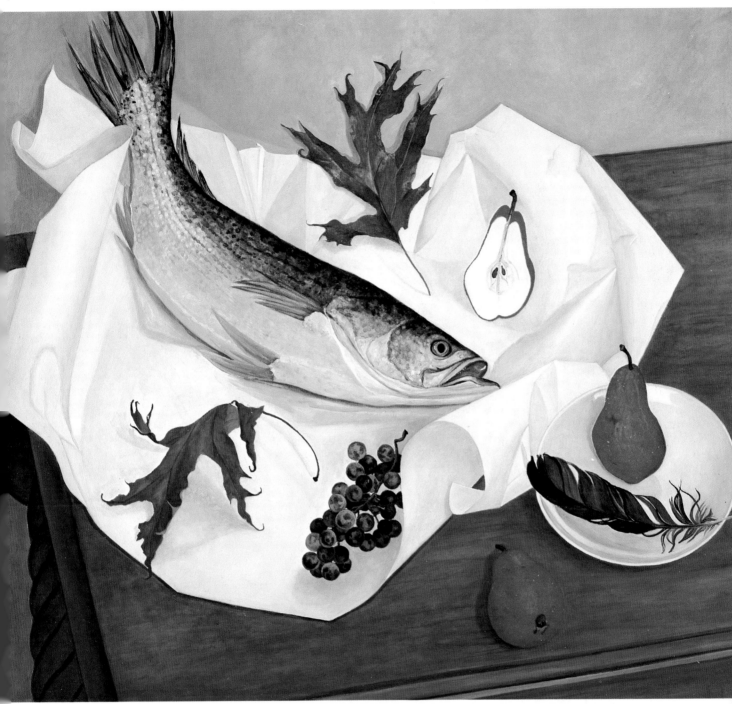

AUTUMN STILL LIFE
34" × 38" (86 × 97 cm)
Oil on museum board
Collection of Mr. and Mrs. Morris Cheston, Jr.
Photograph courtesy of Gross McCleaf Gallery,
Philadelphia

*For Harris, fish have a wild vitality and,
at the same time, a bewildered expression.
She was also drawn to the iridescent scales
and sinuous shape of this fish. The season
was autumn, and it seemed to her that the
fallen oak leaves danced with the movement
of the fish. The paper in which the fish was
wrapped also curved, suggesting the motion
of waves. To heighten the sense of energy*

*she wanted to capture, everything was ar-
ranged with an eye to strong diagonal
movements. In addition, by tilting up the
perspective, she forced a direct confrontation
with the subject.*

*Time was of the essence because Harris
was working with fresh fish. A museum
board coated with Rhoplex was already on
hand, and, after doing a bare outline of a
drawing in charcoal on tracing paper, she
transferred it to the museum board. To do
this, she blackened the reverse side of the
tracing paper and then used it like carbon
paper, going over the lines of her drawing*

*gently so they appeared on the board. If you
press too hard, she warns, the dark char-
coal of the blackened side may leave a
smudge.*

*Given the time factor, Harris didn't do
her usual underpainting. Instead, she
painted directly, judging her values right off
in color. She chose contrasting colors —
red and green, yellow and purplish blue,
black and white — to heighten the drama
of her subject. All in all, she is pleased
with the vitality and action expressed by this
work, and especially with the strong sense
of light.*

39

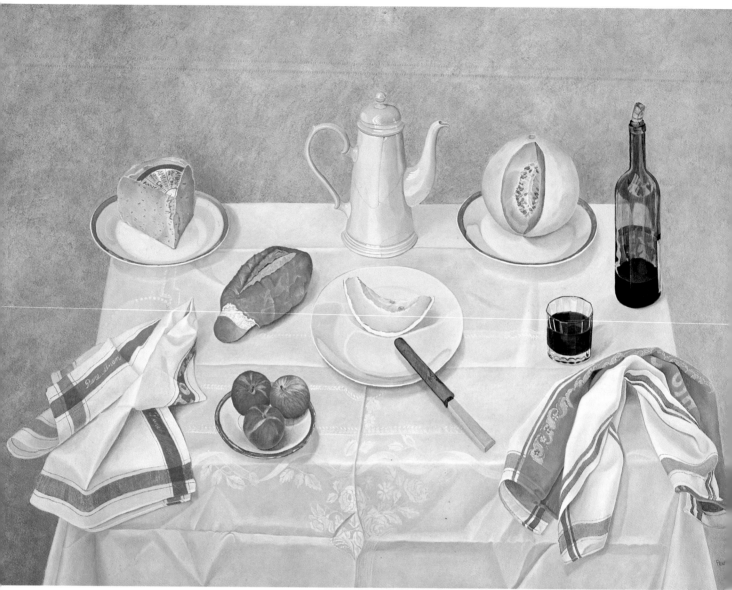

WHITE NAPERY
43" × 59" (109 × 150 cm)
Oil on canvas
Collection of Mrs. N. G. Harris
Photograph courtesy of Gross McCleaf Gallery,
Philadelphia

In studying the still lifes in pre-Renaissance paintings, Harris noticed that the objects seemed unconnected, resulting in simplicity in spite of the use of many objects. She wanted to create a complicated still life with many component parts that gave the illusion of simplicity and had a fresco-like feeling.

Harris started by drawing freely with charcoal on paper, until the composition emerged. She chose a fairly large sheet of paper (larger than the final painting) so that she would not be restricted in the form

or size of her composition. After transferring the drawing to the canvas, she did an underpainting in grisaille to develop form. As usual, she mixed her colors on her palette and then began to lay in first the middle tones, then the dark, and finally the light, moving gradually from transparent to opaque pigment.

In line with the pre-Renaissance mood she wanted, Harris decided to work mainly in whites and grays, reserving color for those areas where it would really count. To keep the painting from appearing spotty, she worked in blocks of color to form blocks of weight: the red apples and red tea towel, the yellow-brown bread and cheese, the wine bottle and the glass. As it turned out, the warms dominated on the left and the cools

on the right, creating a strange mood, as if some sort of ritual were in progress.

The background was executed last, with an eye to the fresco feeling Harris wanted. To give a warm glow to this area, she splashed a lot of different colors, especially cadmium red, within the overall yellow-orange hue. She also used blue, the complement of orange, to augment the vibrancy. Her very free use of sponges helped to create the textural effect.

Among her final touches, she remodeled some of the forms on the table that were slightly blemished when the background was laid in. She also double-checked the sharpness of her edges and added the last, but very important, highlights.

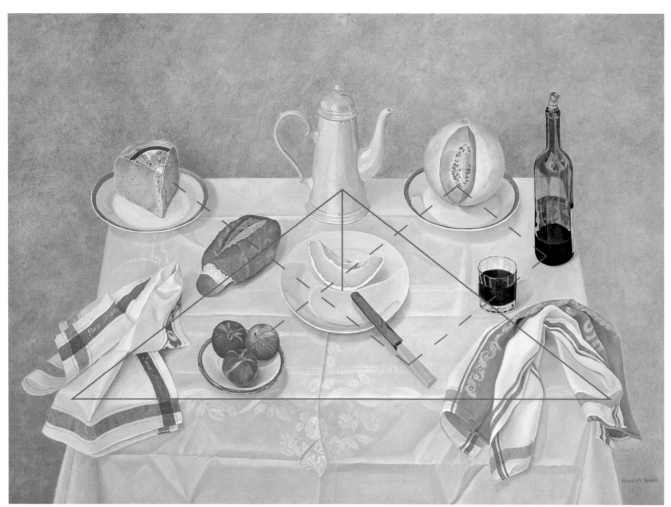

COMPOSITIONAL DESIGN

The design of this painting is crucial in relating the seemingly disparate objects and bringing unity to the whole. The objects all line up along diagonals, from right to left and left to right, so there is a kind of crosshatched network over the whole. At the same time slight variations, like the angle of the knife, keep this pattern from being too rigid. The knife, in fact, redirects our eye, leading us to the curve of the melon slice, which echoes the bottom of the coffee pot in the center. The coffee pot then stands at the apex of a triangle, moving through the bread and wine glass on either side to the tea towels at the table corners, with the edge of the table (parallel to the edge of the picture) as the base. This triangle is an important anchoring device. As we follow the diagonals or the repetition of circular shapes in the plates, our eyes "jump" around the composition. The triangle provides a stillness, a kind of resting point.

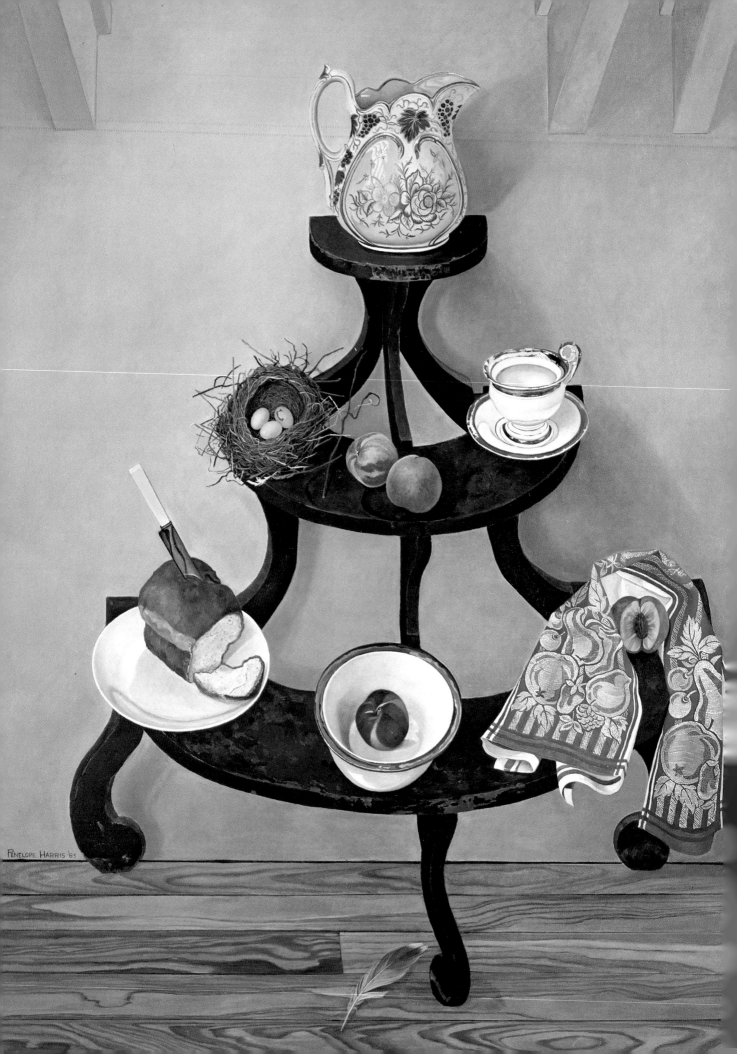

Left
GREEN PLANT STAND
63" × 48¹/₂" (160 × 123 cm)
Oil on canvas
Collection of Mr. and Mrs. David Sims
Photograph courtesy of Gross McCleaf Gallery,
Philadelphia

A wonderful old green plant stand inspired Harris to create a multilevel still life, one which would include a number of objects and yet give the illusion of simplicity. In order to connect the levels, she repeated forms and colors. Her desire was to create a painting that would lead the eye from the top pitcher all the way down to the feather on the floor. The perspective is such that everything is tipped forward, so that objects are observed head-on and the sweep of shelves creates a series of arcs. The white objects then pull our eyes toward one side,

but the peaches always invite us to travel to the other. Again, all this movement is contained by the implicit triangle of the stand.

In addition to piling up horizontal levels, Harris wanted to include levels of depth. She used the peach in the bowl and the blue eggs in the nest to create this sense of depth; there's a feeling of looking into not simply at the objects. Similarly, the ceiling beams keep our eyes from continuing up, out of the canvas, and bring us back inside. Yet when we look at the horizontal floorboards, the perspective shifts and everything is thrown forward, toward us, as if there were no space. All this makes for a tension that belies the simple format so that we keep going back to the painting and relooking.

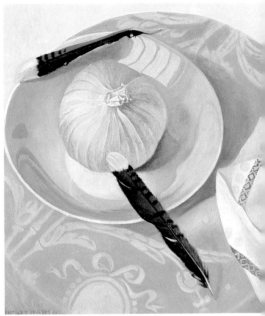

Above
BLUEJAY FEATHERS AND PINK ONION
11¹/₄" × 10¹/₄" (29 × 26 cm)
Oil on museum board
Collection of Mr. and Mrs. Lloyd Goodrich
Photograph courtesy of Gross McCleaf Gallery,
Philadelphia

After a friend presented her with this beautiful pale pink onion, Harris decided to combine it with two bluejay feathers that she had been saving and make an intimate still life. The wedge shape of the feathers created a tension with the robust onion in its round dish. Vitality and solidity were the qualities she was after in this simple composition.

For this painting, Harris chose museum board, which she protected with Rhoplex. It was the first time she had used museum board, and she found that she very much liked its hard, flat surface. Paint seemed to float on it, much more so than on her carefully primed canvases.

To achieve a layering of whites, with one white distinguished from the other, she underpainted the whites in cool and warm grays. As usual, she started by painting all the middle tones, then the dark, and ended with the highlights. The feathers were delineated with the very smallest of brushes. When she determined that the painting was nearly complete, she sharpened up the edges or softened them where needed.

The onion proved to be a complex and thoroughly fascinating subject. To Harris, it seemed to have hundreds of angles from which it could be painted. She held onto it for quite a long time with the intention of using it over and over again as a subject. It started to sprout, however, and eventually became a transparent shell.

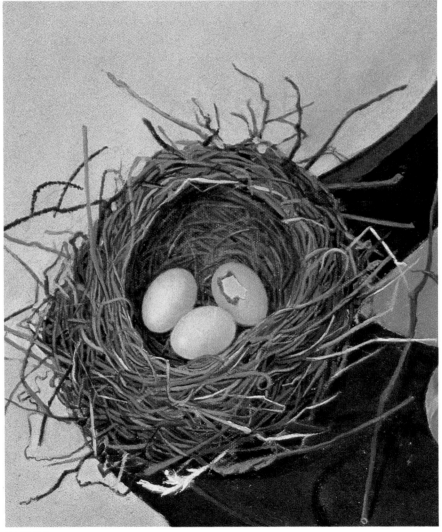

DETAIL
The care with which Harris paints each object has a lot to do with the vitality of her work. Here she first underpainted the nest to clarify its form. Then, using a very small brush and different browns, she painted all the twigs. It's agonizing work, she admits, but without this intensity, the nest would be nowhere near as "alive." Of course, the strong color of the eggs — mostly cerulean blue — adds to the feeling of energy.

LADY IN THE WIMPLE
26" × 28" (66 × 71 cm)
Oil on canvas
Collection of Mr. and Mrs. David Sims
Photograph courtesy of Gross McCleaf Gallery,
Philadelphia

*After glancing through a book on London's
National Gallery of Art, Harris decided to
return to the painting she was working on.
As she set the book aside among her
brushes on her window ledge, Robert
Campin's fifteenth-century* Lady in the
Wimple *gave her a jolt. She was amused to
see the Lady's eye caught between her
brushes and knew immediately that she had
a painting.*

*The painting seemed to compose itself,
although Harris deliberately added the diag-
onals of the large brush and pencil in the*

*foreground, which bring the painting for-
ward, into the viewer's space. She particu-
larly liked the tension created by the wedge
shapes of the groups of brushes and the
thrust of the beams. This vitality is contin-
ued throughout the work, in the many
relationships between objects and the vari-
ous diagonals. At the same time a sense of
quiet simplicity is expressed by the gentle
curve of the lady's head and the large, solid
jar of golden stand oil. There's also an
aura of clear, cool light, rather pre-Renais-
sance in feeling, which Harris pushed
throughout the painting by playing cool col-
ors against subtle notes of warmth.*

*After underpainting in various tones of
gray, Harris began her color work with the*

*Lady; from there, she went to painting as a
whole. Working in this way gave her better
control over the relationships and contrasts
in the colors and tones — she could change
something, if necessary, before it was en-
tirely modeled. Although she used a good
deal of cadmium yellow, Naples yellow, al-
izarin crimson, raw umber, lamp black,
raw sienna, as well as an assortment of
blues, especially cobalt, the overall effect is
rather monochromatic. The drama results
from the contrast between black and white,
as well as between cool and warm.*

*One of Harris's last concerns was to give
the Lady's wimple an old, cracked ap-
pearance. This she accomplished by
applying glazes of yellow ocher.*

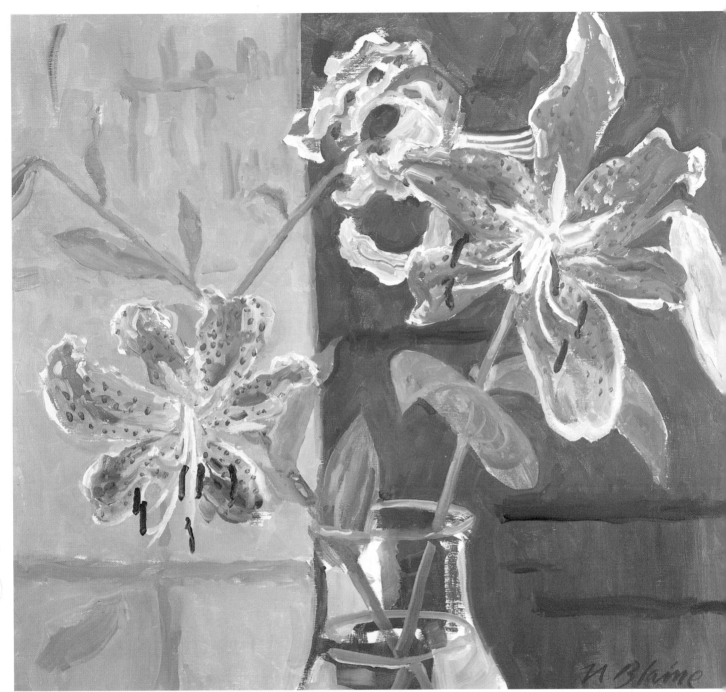

DOUBLE RUBRUM
22" × 24" (56 × 61 cm)
Oil on canvas
Private collection
Photograph by Otto E. Nelson

Blaine was attracted to the flamboyant quality of this ruffled lily. Because the flower itself was so exotic, she felt that a certain starkness was called for in the rest of the setting. Her choice of a simple, almost abstract background, composed of light gray and dark blue cloths, forces our attention forward, onto the lively rhythms of the flower and its bold, warm color. In

addition, by limiting the space, Blaine heightens our awareness of the lily's vitality. The swirling lines of the petals seem to move all over the canvas, almost growing. The narrow space and frontal background then create a sense of tension or confinement. Blaine's choices here are obviously important in conveying the "spirit" of her flower.

To capture this spirit, she began by looking at her subject — and looking and looking. It is through what she calls "abso-

lute attention" to her subject that she achieves a kind of physical empathy that "tells" her how to paint. In other words, by focusing keenly on the lily, Blaine was able to translate its rhythms into her own inner body rhythms and thus into her brush-strokes. As she painted, she worked all over the canvas, moving from color to color, from tints to saturated areas. Although this process is intuitive, it is grounded in her initial, concentrated observation of her subject.

47

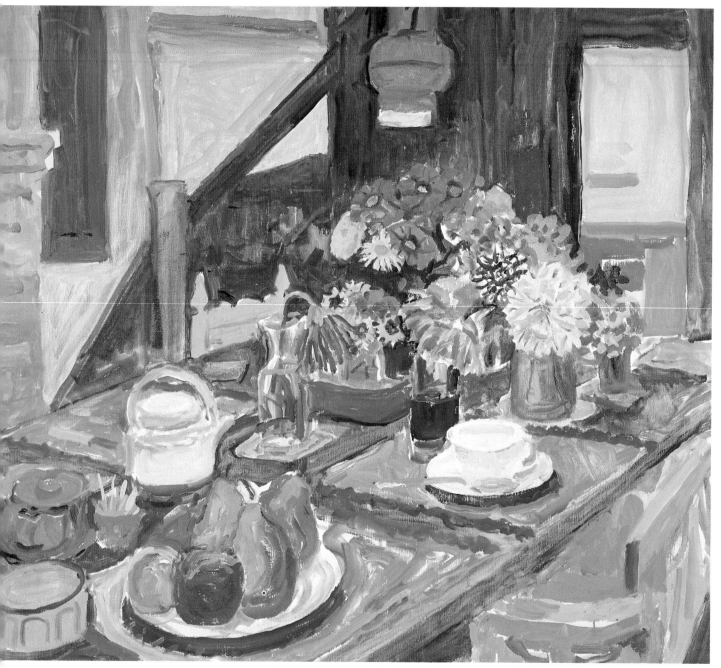

EUDORA ROOM, OCTOBER
28" × 32" (71 × 81 cm)
Oil on canvas
Private collection
Photograph by Otto E. Nelson

The living-dining room of Blaine's studio cottage in Gloucester, Massachusetts, is a warm, hospitable place. For this painting, she chose an angle of view that clearly invites us into the space. Spatial and compositional considerations also governed the objects that she selected for her painting. She did not wish to include everything — that would have been too much. Instead, she focused on contrasting elements: the

bright color accents against the wood tones of the walls, and the rounded, warmly colored fruit and flowers against the sharp angles of the staircase and the table with mats.

Before she actually began to paint, Blaine used her brush to lightly sketch the major rhythms and forms of her composition. This is quite unusual for her — she usually works quite directly, without a preliminary sketch. Here, however, she felt she needed to indicate the painting's underlying geometry.

DETAIL

Negative space — the space between and around objects — plays an important role in creating the rhythm in Blaine's work. When she paints, she is concerned with every inch of the canvas — there are no "dead" areas. Here the triangle of the wall seen in between the staircase is an active element, sharpening the statement of angularity. Similarly, the wall behind the flowers is not simply a filled-in area. It is painted in tandem with the flowers to bring out their irregular contours and casual arrangement.

DETAIL

With her brush, as well as color, Blaine gives a sense of movement to her forms. The curves of the pears here were accentuated by the rhythm of her curving brushstrokes. Indeed, in this painting, Blaine varied her touch in a number of different ways. She played hard edges, such as the line defining the edge of the mat from the table, against softer edges — for instance, in the mingling of the fruit. She also contrasted thick and thin, painting the apple solidly in an opaque red while letting areas of the canvas breathe through in the plate to give a sense of transparency. These variations contribute to the energy of the whole.

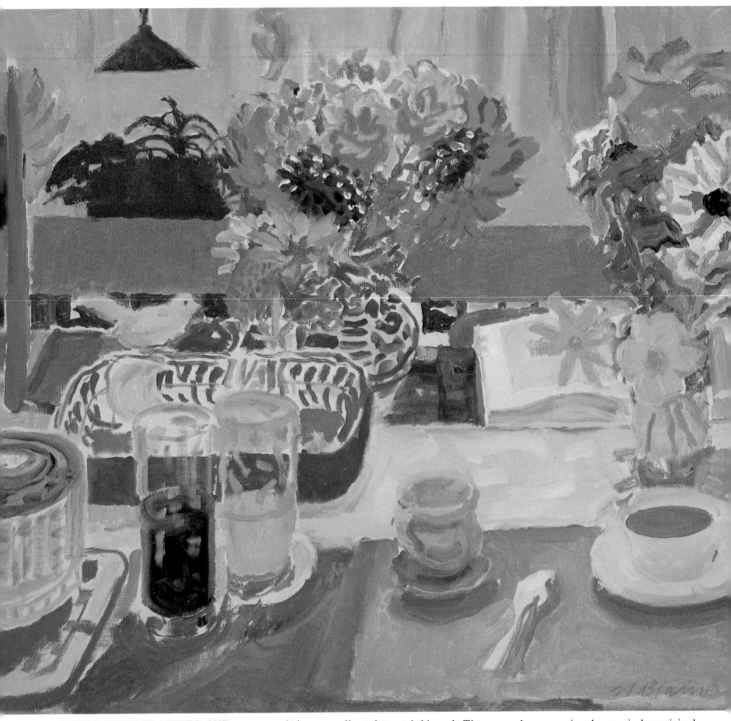

TABLE WITH FLOWERS AND YELLOW BIRD
28″ × 32″ (71 × 81 cm)
Oil on canvas
Private collection
Photograph courtesy of Fischbach Gallery, New York City

"*I didn't pick them, they picked me,*" *says Blaine of the objects that make up this lively work. The objects were all familiar ones, found on her refectory table, and she wanted to draw the viewer into their intimate relationship. At the same time she wanted to convey their lushness, their visual excitement. Many of her compositional* choices were directed toward this end. The angle of view brings us right to the tabletop, confronting us with the rich array of objects. Although Blaine decided to keep the background relatively simple with so much going on in the foreground, the sense of space heightens our awareness of the closeness of the objects. Her use of light also augments our involvement with the objects and creates a sense of wonder as it highlights certain areas.

Blaine worked all night and into the morning for two days to complete this work. Aside from a few color touches, she didn't make any major changes in her original still life setting, although even a seemingly minor change can have a major effect on the final work. In the beginning she lightly indicated the main spatial areas, the verticals and horizontals, and the major shapes. Soon, however, she was working all over the canvas. Indeed, because she paints so spontaneously, she finds it almost impossible to describe her step-by-step actions. What she tries to capture is the essence of what she sees. Her choice of colors comes from a feeling for that.

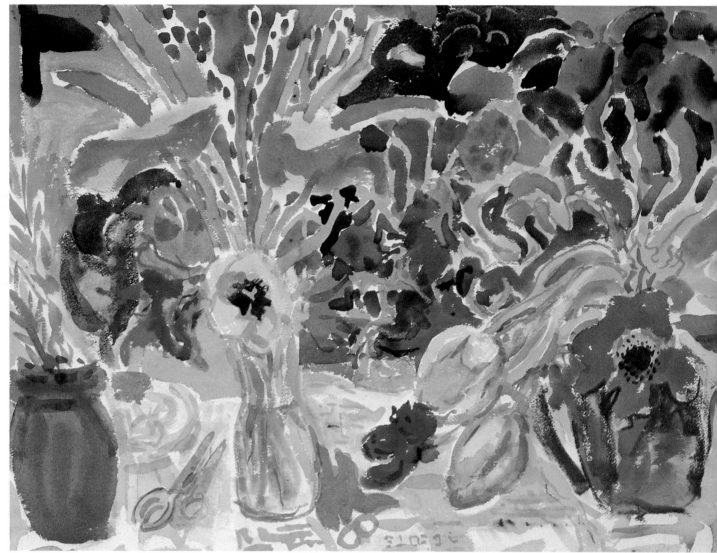

ANTHURIUM AND TULIPS, II
18" × 24" (46 × 61 cm)
Watercolor on d'Arches paper
Private collection
Photograph courtesy of Fischbach Gallery, New York City

When a friend brought over a bouquet of flowers, Blaine was excited by the "crazy" pinks and yellows. She decided on a casual, loose arrangement which would allow the lush, saturated color free play. Her aim was to re-create the flowers' visual energy. To heighten the impact of color, she simplified the shapes. Then, with her free-flowing brushwork, she brought out the lively rhythms that keep our eyes moving all over the painting.

Because Blaine felt that liquid, flowing color was essential to what she wanted to express, she set aside her oils here in favor of watercolors. Using two or three sable brushes, she applied bright pinks, orange, Payne's gray, red, blues, and violets into both wet and dry areas. Although she based her colors on nature, she modified them in places to intensify the visual excitement of the painting.

BLUE HYDRANGEA
26" × 22" (66 × 56 cm)
Oil on canvas
Photograph by Carolyn Harris

For Blaine, hydrangeas presented a special challenge, in part because they were such a common sight in the town where she grew up. Every suburban house had them planted stiffly around the yard, and she confesses to having had a certain snobbish disdain for them. From her experience as a struggling gardener and with her painter's inquiring eye, however, Blaine now looks at hydrangeas differently. In this painting she wanted to evoke the spirit of the flower, the "miracle" of its being.

To emphasize the large, globular, almost archaic simplicity of the hydrangeas, Blaine chose a straightforward, well-lit arrangement. She introduced the second vase of assorted flowers to provide a sense of scale and to place the hydrangeas "on a pedestal," so to speak. The vibrant reds of these other flowers serve as a foil to the softer blues and purples of the hydrangeas, in a sense increasing their dignity.

Blaine believes that the space around her subject helps create the subject. Her decision to keep the background simple, with a hint of horizontal and vertical structure, lends prominence to the flowers. The blue color, of course, is important in setting the mood.

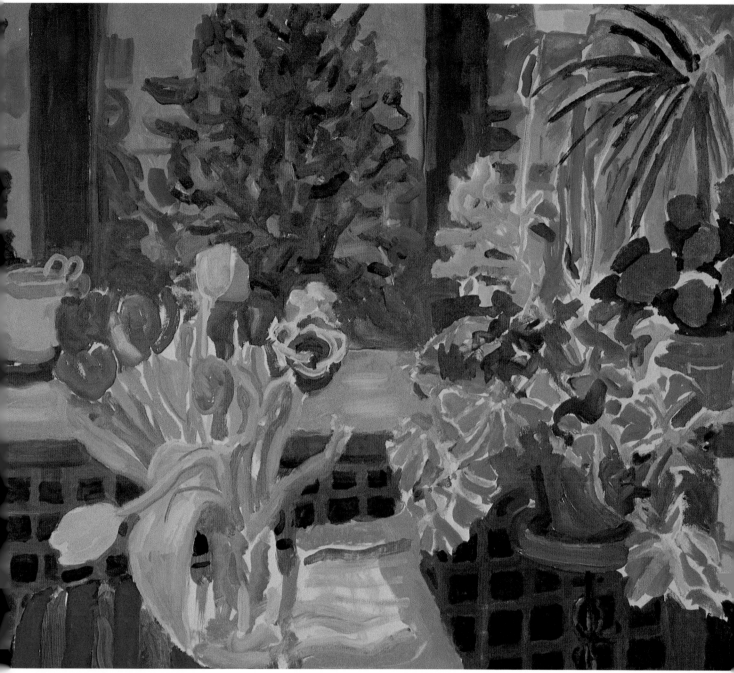

TULIPS AND PLANTS AT DAWN
22" × 26" (56 × 66 cm)
Oil on canvas
Photograph by Carolyn Harris

In general Blaine dislikes jarring jux-
tapositions of color. Yet she insists that a
painter should never be afraid of color.
Here, she wanted to see if she could effec-
tively combine red, green, and blue —
colors that she associates with Christmas
and that she usually finds end up scream-
ing when they are positioned against one
another. What attracted her were the colors
and shapes of tulips, plants, and a tiny
spruce tree positioned against a window in
her New York studio, just before dawn.

She wished to capture the feeling of ap-
proaching dawn, as well as a sense of
mystery.

To express "dawn," Blaine distilled the
strong colors — the reds, blues and greens.
There's a sense of full color just about to
emerge. Of course, nature dictated her color
scheme, but she took liberties. By stressing
the warm browns of the background, she
gave a muted, quiet feeling to the whole.
Then, with spots of bright color, as in the
striped cloth in front, she suggested the
flood of color waiting on the horizon —
when dawn breaks.

Harriet Martin
Underpainting for Rhythm

Still lifes can have rhythm and humor, and Harriet Martin aims for both these qualities in her work. Timidity finds no place here; often she chooses objects that are in and of themselves exaggerated and arranges them so that they communicate with each other on the canvas and with the viewer looking in. Among her favorites are droopy flowers, long past their prime, whose floppy petals take on expression and movement.

Martin approaches her composition as geometric patterns. The geometry, however, is something that evolves — she does not set it up that way. As she transfers what is before her onto the canvas, she emphasizes or exaggerates its two-dimensional shape. The play of one shape against another helps to make the flat surface come alive.

Martin's extremely colorful underpainting also makes her work vibrate with life. The blaze of color from the underpainting that shows through at the contours of her objects accentuates their shapes and heightens the feeling of movement. Each object is set up in its own space and at the same time everything jostles together.

WORKING METHODS

Martin first primes her canvas with several coats of gesso to get a smooth surface. She then establishes the general lines of her composition with a charcoal or pencil drawing, based on a realistic sketch done off the canvas. Her drawing on canvas is apt to change, becoming more complicated and then more simplified. She takes out lines, puts them back in, erases again without hesitation. Sometimes she takes a break and tries to work on something else. In any case she spends quite a bit of time with this on-canvas drawing before she starts her underpainting.

For both her underpainting and overpainting, Martin uses Liquitex acrylics, along with Liquitex gel medium, which makes the paint easier to apply. Her brushes are mostly synthetic ones, although she uses small camel-hair brushes for fine lines and a few sables (but very sparingly). Her palette includes every color in the Liquitex rainbow, and she doesn't hesitate to use any of them.

Martin's underpainting is extremely colorful. Any one painting may be underpainted with phthalocyanine green, phthalocyanine blue, cadmium red, brilliant blue-purple, dioxazine purple, cadmium yellow, and permanent green deep. Often she uses these colors straight from the tube, but she may also mix new colors from them. She applies the colors individually, side by side, although sometimes she lets them overlap. Which color goes where depends to a large extent on what she plans on top. Usually she chooses something in the opposite range — a green-blue or purple perhaps for a red flower. In general the color in the underpainting is far more intense than the one on top. In Martin's words, "it is the underpainting that makes the top colors dance."

When Martin does her overpainting, she always begins with the space around the objects, including the background and foreground. Vases, flowers, and other objects come last. Their colors are always related to and determined by the space around them.

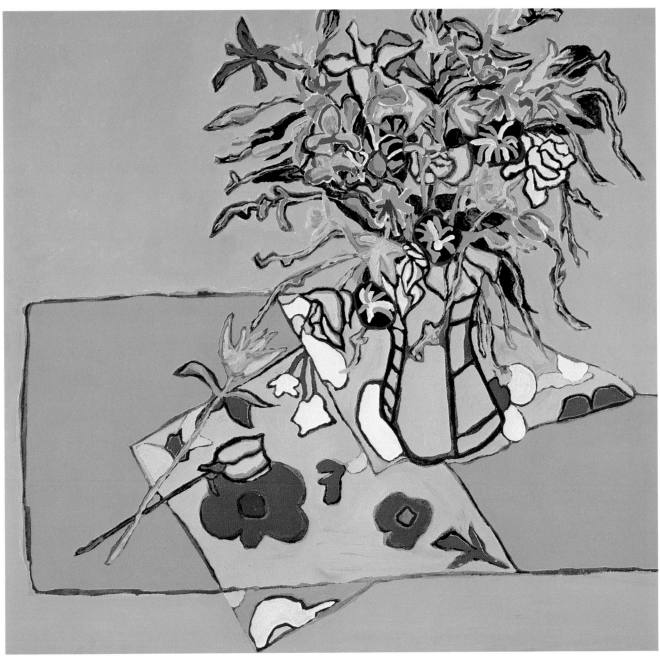

FRENCH BOUQUET
34" × 36" (86 × 91 cm)
Acrylic on canvas
Courtesy of Gross McCleaf Gallery, Philadelphia

In this painting Martin tried to capture the haphazard motion of flowers beyond their peak. She also wanted to see what would happen if she added more pattern to the ground, instead of leaving it a relatively solid color, as she usually does. The simple, scattered flowers of the cloth here lead the eye up to the riot of swaying flowers in the vase. The yellow flower lying on the patterned cloth also directs our gaze upward; it seems to be pulling itself up in an attempt to propel itself into the vase.

For her underpainting, Martin chose

vivid reds, greens, blues, yellows, oranges, and purples. The thin, uneven lines of these colors that peak through at the edges of the objects add vibrancy to the color on top. The top colors, however, also "move," especially in the flowers. In part this is a result of the way Martin painted the flowers — moving all over with her brush, dabbing pigment here and there in a rhythmic manner. It would be impossible to say exactly where she started because, in effect, there was no one starting point. Yet her color choices were not haphazard. Although she changed her mind any number of times as one color affected another, the final color is there because it contributes to the overall success of the painting.

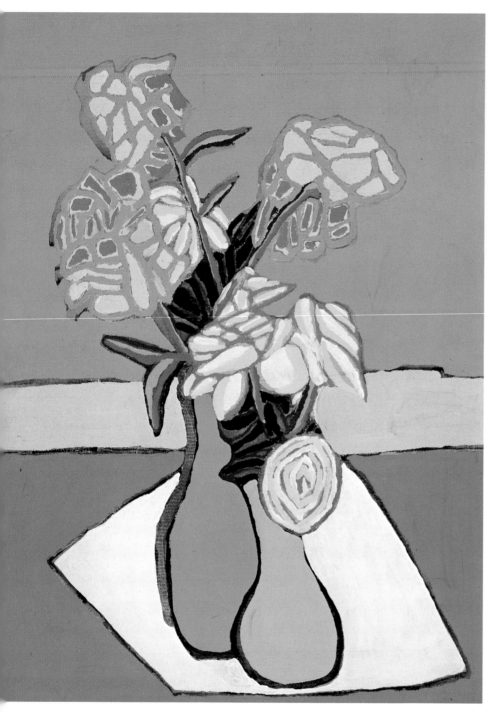

ROSES AND PEONIES
32" × 34" (81 × 86 cm)
Acrylic on canvas
Courtesy of Gross McCleaf Gallery, Philadelphia

When Martin saw these roses and peonies side by side in buckets at the florist shop, she was intrigued by the resemblance of the two flowers. She decided to re-create the big, floppy petals in full bloom.

After simplifying her composition into basic patterns, Martin did a colorful underpainting using all the primaries and secondaries. When she turned to the top colors, she chose more subdued tones, but the underpainting made them sing. As usual, she painted the background and foreground and all the space around the vases and flowers first. An important choice was the use of a strip of thick white paint to divide the canvas just off center. It both balances the composition and enlivens it, creating tension between the bottom and the top.

When Martin came to the flowers, she started with the light shades, worked up to the darker ones, and occasionally lightened dark shades and then darkened them again. She moved back from the canvas each time she finished a part of the flower, examined it carefully, then went back and changed something again. This process was repeated until she felt that she had gotten everything right.

Looking back now at her work, Martin finds that the canvas is perhaps too crowded. A larger canvas, with an additional 12 inches or so in each dimension, would have allowed her to render the flowers floppier, with more shadow areas. It also would have enabled her to exaggerate more. Moreover, she is not entirely pleased with the pink and yellow combination. She believes that the colors need more variation, perhaps five tones each, to give them more substance.

T-SHIRT
32" × 22" (81 × 56 cm)
Acrylic on canvas
Courtesy of Gross McCleaf Gallery, Philadelphia

In a whimsical mood, Martin created this playful arrangement, where the lively irises and lilies are caught in their vases and the lone tulip seems about to enter the jaws of the scissors. The cutout shape of the T-shirt might well be a product of the scissors' work; it also reminds us of the sort of attire appropriate for gardening work, and thus of the entire process of going into the garden, cutting flowers, and coming back inside to arrange them in vases.

All in all, Martin's arrangement expresses tension and motion. She calls it a "kind of talking and dancing communication between the objects." The movement starts in her drawing of the composition, as she decides how to simplify or exaggerate the shapes. Here, by placing the T-shirt slightly off center, she created an initial tension, which she heightened by making one sleeve narrower than the other. The fat and skinny vases echo this theme and at the same time suggest depth.

Another factor in the movement in the painting is of course the underpainting. But it isn't just the bright color that enlivens the objects; it's also the way that Martin lets it come through. What we see are wobbly edges of color, not hard lines, so that there is a sense of shifting motion and jostling between one color and the next.

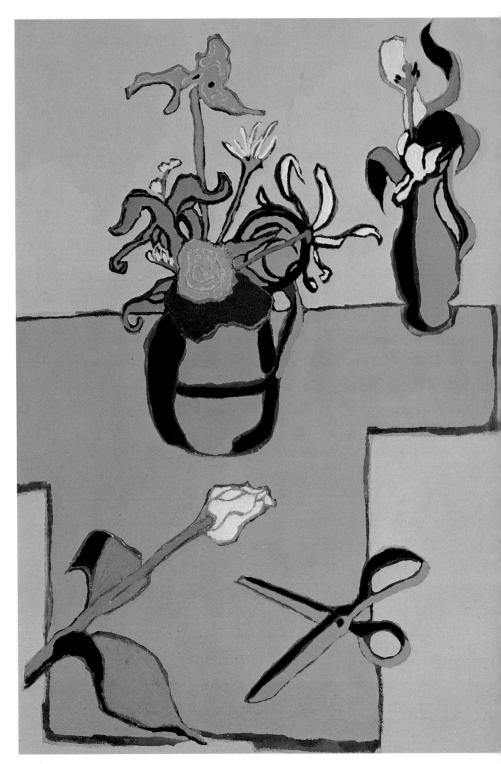

BIRDS OF PARADISE
52" × 24" (132 × 61 cm)
Acrylic on canvas
Courtesy of Gross McCleaf Gallery, Philadelphia

Martin admits that she has always been amused by birds of paradise. The gladiolas added a similar stiff presence while the daisies provided a floppy contrast. As she looked at the flowers, she realized that they all reminded her of animals or "funny faces." In the painting she decided to make them "converse" with each other in a playful way.

Martin chose a vertical canvas to accentuate the drama of her composition and to elongate the already stalky birds of paradise and gladiolas. Throughout the painting she wanted to set up a pushing-out/pulling-in movement. She did this both with the underpainting, which tends to push the shapes forward, and with her design. For instance, although she drew the table in perspective, leading the eye back into space, she painted the wall in a flat color, which pushes the eye forward again. In the window area she made the gladiolas almost pop out by using the black behind, but then she painted the vase black, so it pulls the eye in to the black shrubbery. All this visual push and pull augments the back-and-forth "conversation" between the flowers themselves.

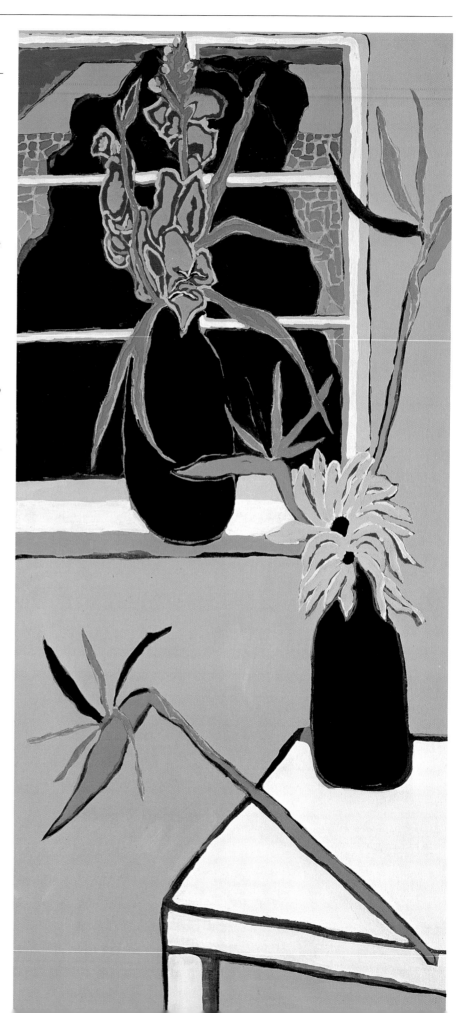

DETAIL

When you look closely at this painting, you're surprised at how much color there is. Vivid blues and oranges add zest to the subdued pinks and purple-grays in the gladiolas. At points the underpainting even glows through the black shrubbery behind, which is painted fairly thinly. At the top, around the window frame, different notes of green, purple, and red peek through, lending flickering movement to the shapes and contributing to the aliveness of the whole.

To experiment with underpainting, take a piece of canvas or paper and first sketch your composition. Try to simplify what you see into basic patterns; don't get caught up in detail.

Now take your acrylics and begin to lay down strips or dabs of color, the more brilliant the better. Choose colors that provide some contrast with the colors in your still life — a yellow for an area that is blue-green or an orange-red for a blue. But don't just stick to one color for each object. Especially around the contours, experiment with a variety of color, laying one beside another or even overlapping them. Use different size brushes and variations in the pigment's thickness to give the underpainting texture.

After you've covered the entire surface, study your underpainting and decide for yourself which colors work well together and which clash, which express movement when placed side by side and which, tranquillity. It isn't important whether you like the color combinations; what is essential is that you come to understand how various colors work with others.

As you start to lay in the top color, be careful not to cover your underpainting completely. Allow the underpainting to serve as a border separating one shape from another. Let as much of the underpainting show through as you can find a use for. When you have finished, study your work to determine what the underpainting has added. Does it increase the vitality and sense of movement? Do your top colors look richer than they usually do? As you continue to experiment with color and how one color affects another, you'll open up new possibilities for expression in your painting.

Catherine Behrent
Offering Bold Interpretations

Everything finds its proper place in the work of Catherine Behrent, whose canvases express her preference for strong design and unusual points of view. Her compositions are carefully thought out before she starts to paint, with an eye to balancing the color relationships and arrangement of objects in the picture space. At times Behrent's color is soft and soothing (the play of white on white, for instance); often, however, it is vivid and alive. She refrains from painting objects with a great deal of pattern because she finds it tedious. On the other hand, she will paint the same flowers over and over again because she finds they become entirely different when they are related to different colors and designs. Indeed, her preference for flowers has to do with her sense of design: Behrent likes to fill her entire canvas, and flowers do it very well. She rarely leaves a large solid space in her work; when she comes to paint the background, for instance, her instinct is to divide it in a way that reinforces her design.

Over the years Behrent has assembled a huge collection of magazine clippings of objects or flowers that she finds enormously appealing. Often when she comes across an object that spawns an idea for a still life, she refers to this collection for accompaniments. Sometimes a painting will be created solely from these clippings. She may incorporate a vase from one clipping, a bouquet of flowers from another, and a background suggested by yet another clipping. At other times Behrent will herself photograph the items that she intends to paint. Using her own photographs or her clippings as a guide, she then experiments with the composition in her mind and in pencil sketches.

WORKING METHODS

Behrent first primes her canvas with gesso, using one thick coat or two thinner ones, depending on the degree of smoothness that she is after. If, for example, she intends to include large, slick areas in her painting, she makes sure that the canvas is very well primed. Recently she has begun to use Belgian linen because it offers greater longevity.

Behrent always underpaints her canvases in primary colors to give her objects more depth and dimension. If she is sure about her composition, she will underpaint the entire canvas. But, because it is difficult to change the composition once the underpainting is down, she may first underpaint only one or two objects, complete them, and then judge the effect before going on to the rest. To choose the colors for her underpainting, Behrent looks for the color in the object's shadows or the lines that define its edges. A yellow object is almost always underpainted red; green is underpainted blue. If something is white, a yellow underpainting will render it a glowing white; a red underpainting will yield a more subdued pink-white; and a blue underpainting, a dull white. She always allows "cracks" of the underpainting to show through in the final work to clarify the object's contours and reinforce its color.

For her oil colors, Behrent generally chooses from cerulean blue, Prussian blue, ultramarine blue, cadmium red dark and light, alizarin crimson, cadmium yellow medium, Thalo green, and white. She mixes her paint on the palette, applies it with bristle brushes to the canvas, and then softly blends it on the canvas with either a Japanese fan brush or sable blender. Usually she uses pure linseed oil to make the paint application smoother.

Once Behrent beings to paint, she finishes one object in its entirety before going on to the next. She always starts with the predominant item, usually one in the foreground, proceeds to the one beside it, and so forth until she has depicted them all. The background is painted last, when she can see what the painting needs. Although her initial sketch includes the background as a division of space, more often than not the background will change once everything else is down. Its role is always to tie the composition together.

BLUE MARBLES

36" × 48" (91 × 122 cm)
Oil on canvas
Private collection
Photograph courtesy of Meredith Long Gallery,
Houston

Color was the starting point for this paint-
ing. Neighbors provided the inspiration
when they presented Behrent with a rich
blue vase full of vivid orange flowers. The
flowers, however, began to wilt, so Behrent
cut their stems and transferred them to a
smaller, clear vase. As it turned out, the
flowers had more impact once they were cut
— their petals spread out luxuriously and
in the clear vase you could see their stems.
But Behrent was also intrigued by the
"bubbly" effect of the florist's marbles in the
blue vase. The idea for a still life painting
began to take shape.

After photographing the vase with flowers
and the one with marbles, Behrent searched
for other items to fill out her composition.
For color balance and contrasting texture,
she introduced yet another vase — a pink
pitcher with a shiny gloss surface. In the

pitcher, she placed yellow ranuclous, whose
line pattern, not to mention color, differed
substantially from the orange flowers.
Again, she photographed this. Then she de-
cided she needed flowers in the blue vase to
tie the composition together. Neither the flo-
rist's shop nor her own garden suggested
anything exciting to her so she turned to her
magazine clippings and ultimately found
her solution there.

After sketching the images on her can-
vas, she underpainted everything. The clear
and blue vases and the flower stems were
underpainted blue; the oranges, yellows,
and pinks, as well as the cloth and back-
ground, were underpainted red.

The first items that she tackled in oil
were the orange flowers in their clear vase.
She next moved to the blue vase of flowers;
then to the pink pitcher with its ranuclous;
and, finally, to the tablecloth and the back-
ground. To capture the slick surface of the
pink pitcher, on which the tablecloth is re-
flected, Behrent carefully blended her paint
on the canvas, working from dark to light

and adding the bright highlights last. Once
all the objects had been painted, she turned
to the peaks, curves, and patterns of the
cloth, which she adjusted somewhat from
her original sketch. The underlying sketch
was only a guide; her final depiction of the
cloth had to await her painting of the main
elements, which dictated its rhythmic folds.

Similarly, the background was not deter-
mined until everything else had been
painted. Behrent kept it simple in order to
emphasize the vivid colors and textures of
the objects and to anchor what she saw as a
very busy scene. A solid plane, however,
would have been too heavy for the painting.
To structure the background and relate it to
the design of the tablecloth, Behrent added
thin, vertical white lines. These verticals
subtly reinforce the upward thrust of the
flowers and balance the horizontal format of
the arrangement. The white rim at the very
top is also important: it lends brightness to
the painting and gives a sense of complete-
ness, leading our eyes back to the tablecloth
and the flowers in front.

ARTISTS AND FLOWERS
30" × 36" (76 × 91 cm)
Oil on canvas
Courtesy of Meredith Long Gallery, Houston

Color and shape are major guidelines in Behrent's compositions. Here she was initially inspired by the book Flowers *by Irving Penn, whose bold photographic images she greatly admires. The recorder, painted egg, and vase with its assorted flowers were all familiar sights, found on a corner of her coffee table. What intrigued Behrent was the possibility of creating a lively design with an interesting variety of surfaces — smooth, lined, and patterned. Although the small pink vase does not have a permanent home on her coffee table, she included it for its color and for compositional balance.*

Behrent photographed the entire arrangement, as well as each individual item. Working from her photographs, she composed her setup in a sketch and then transferred the drawing onto the canvas. She underpainted the entire canvas — if you look closely at the vase or book in the finished painting, you can see where red or blue "cracks" show through from the underpainting and delineate the object's edges. Then, Behrent started with the largest object — the vase of flowers. Once she had finished these, she moved on to the next main object — the book — and so forth until she had painted all the objects in her still life.

Finally it was time to deal with her background. She decided to use a window to divide the space and offset the arrangement of objects. Although she had included the window in her initial sketch, she refined its form on canvas, once all the objects had been painted and she was better able to judge what was needed to complete the work. A window in her own studio was the source for the painted one. The deep blue color she chose suggests the world outside and also provides a solid area of color, which holds the composition together.

With each new painting, Behrent learns a little more about color and design. Often it's a matter of discovering how one color affects another. Here, for instance, she found she needed to add more blues and greens to the egg in order to balance the large vase.

DINNERTIME

15" × 15" (38 × 38 cm)
Oil on canvas
Private collection

For Behrent, Dinnertime *was a quick, fun painting. While browsing through a magazine, she came across a photograph of cooked halibut elegantly presented on a china plate (see below). She was struck by how the look of food can be just as important as its taste. With the plate as a lively background, she began conjuring up her own still life meal. Her choice of yellow lilies for the main course was sparked by a sense of playfulness and her interest in color. The sprig of parsley, orange slice, and ripe red strawberry all heighten the impact of color; they also subtly echo the design of the plate.*

Behrent didn't physically set up this still life; she created her composition with a sketch on paper. As a guide, she used the photograph of the plate with its parsley and lemon slice (the model for the orange). For the flowers, she clipped another image from a magazine (see below). She couldn't find the "right" photograph of a strawberry so she looked at a number of images and then made up her own. Working in this way, collaging images she likes, gives Behrent a lot of control over her design. She feels that it's important to have the actual objects or a photograph of them to look at as a reference point. But she will alter what she sees to heighten the impact of what she wants to express. Here the angle of view and oversize scale of the flowers emphasize the offering of "food," making it appear far grander than it actually is.

For Dinnertime, *Behrent deliberately chose a small canvas, although she admits it is sometimes difficult for her to work small since she is so used to painting on a larger scale. Every now and then, however, she likes to interrupt her usual routine of working thirty to fifty hours on a canvas and execute a work like* Dinnertime, *which is ready in about half the time.*

PACIFIC HALIBUT COOKED WITH TOMATO AND

GALLERY GARDEN
33 1/2" × 48" (85 × 122 cm)
Oil on canvas
Private collection
Photograph courtesy of Meredith Long Gallery,
Houston

Behrent was drawn to a magazine photograph she found of a New York City apartment. In particular, she liked the contrast of different art forms: earthenware pottery, a wall hanging of a flag in the background, and potted flowers (the art of nature). With the photograph as a guide, she rearranged the objects slightly, bringing them closer to the viewer and thus emphasizing their contrast. She also placed a rose bush — based on another magazine photograph — in the earthenware bowl to augment her color theme.

After sketching her composition on the canvas, Behrent experimented a little with her underpainting to get different glows of whites. The red underpainting she chose for the box in the middle, for instance, adds a warm note to this area, despite the brightness of the white. As she began to overpaint the various objects, Behrent focused on the interplay of soft earth colors and the lively reds and pinks of the flowers. Notice how the earth tones help to "ground" and thus balance the burst of color at the top.

As usual, Behrent painted the background last, using it to clarify the structure of her painting. The strong horizontal and vertical lines help to stabilize the activity in front. They subtly remind us of the painting's edges and thus give a sense of closure.

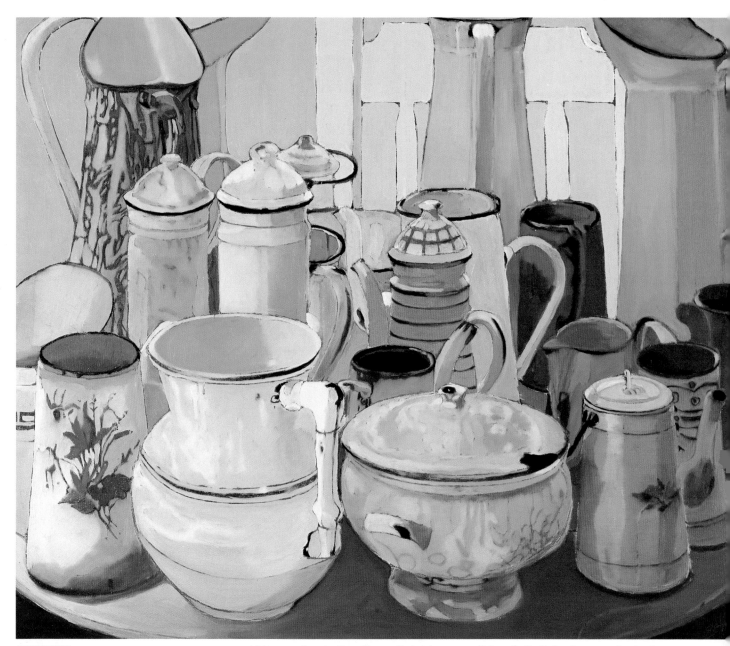

PITCHER
30" × 36" (76 × 91 cm)
Oil on canvas
Private collection
Photograph courtesy of Meredith Long Gallery,
Houston

*Pitcher comes as a surprise — the flowers,
so central to most of Behrent's canvases,
are missing. Indeed, Behrent made a delib-
erate choice not to include flowers. It forced
her to take a fresh look at the painting
space and find a different way of filling her
canvas. For source material, she used vari-
ous magazine photographs of pitchers, but
she wanted an arrangement that would
lead the viewer's eye all over the canvas.*

*Behrent's solution reveals the importance
of design in her work. The eye is drawn to
the two foremost items, the large pitcher*

*and tureen, then to the yellow coffeepot in
the center, and then 'round and 'round to
all the other items in the composition. In
effect the roundness of the pitchers and the
tabletop on which they rest is stressed by the
circular movement of the painting, which
comes to a stop once the eye focuses on the
background. The very simple outlines of the
chair divide the space easily without inter-
fering in any way with the pitchers. In fact,
the flatness of the background contrasts so
well with the pitchers that they are rendered
yet more curvacious. Very often Behrent
juxtaposes a flat handling of the back-
ground with a three-dimensional rendering
of her objects to force the viewer's eye for-
ward, keeping attention focused on the
domain of the objects.*

*Behrent's limited color range is also im-
portant to the effectiveness of this painting.
With too much color, the painting would
have been too busy. The overall whiteness
lends a stillness to the scene, which serves
as a counterpoint to the movement in the
design. By first underpainting the pitchers
in yellow, blue, and red, Behrent brought
out subtle variations in the whites. She also
used lines of color from the underpainting
to define the contours of each object. Then,
as she overpainted the pitchers, Behrent
added touches of color here and there, as in
the red floral design on the left. With these
color notes, she reinforced the movement
she wanted and also, through the contrast,
stressed the whites that tie everything to-
gether.*

SUGGESTED PROJECT

Combining objects from different sources can suggest new possibilities for your still lifes. Start by browsing through old magazines. Clip anything that strikes your eye. After you've accumulated a variety of images, choose one and analyze what attracts you to this picture. Is it the color? The shape of the object? Its texture? Now, think about possible accompaniments. Again, look through your collection of images for ideas. Once you've decided on several objects that seem to go together, take a piece of paper and sketch your composition. Try a variety of arrangements and viewpoints to see how best to emphasize what you want to express. You may find that you need another object to balance your design or a different angle to accentuate the focus.

SKETCHES FOR STRAW MAT

Working out her composition is a crucial step in Behrent's painting process. The idea for Straw Mat originated with a magazine photograph of a straw mat with a basket of borsht. Behrent was attracted to the lively interplay of colors, textures, and shapes. In another magazine she discovered a photograph of a potted pink flower, which related well to the pink soup. She then arranged these objects in a sketch (top), but decided that the composition needed more going on in it. Looking through her clippings, she found what she wanted — an orchid. Its yellow-white color related to the straw mat and its vertical stem served as a counter to the other, rounded shapes. In her final sketch (bottom), Behrent emptied the basket of its borsht, but she planned to use its pink color for the bottom of the basket. To clarify the space inside the basket and add balance, she introduced an orange.

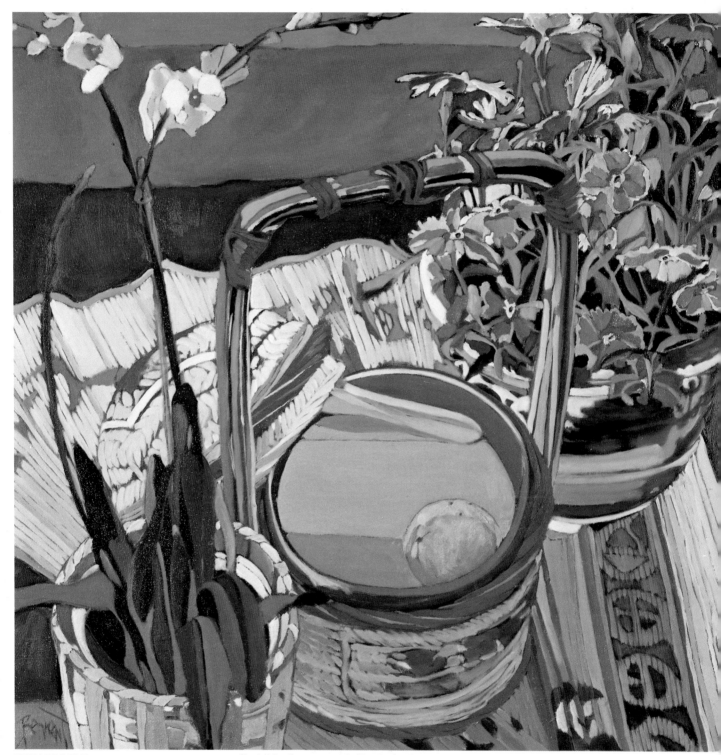

STRAW MAT
32" × 32" (81 × 81 cm)
Oil on canvas
Private collection
Photograph courtesy of Meredith Long Gallery,
Houston

Often in her work Behrent will present
more than one perspective. Here she accen-
tuates the liveliness of the painting by
creating subtle shifts in our point of view.
To draw attention to the pink color in the
basket and heighten the contrast between its
smooth surface and the other textures, she

tilted this plane upward. But notice how
she chose a somewhat different angle for the
basket handle in order to lead us back
down again to the pink bottom.

Behrent began her painting with the focal
point — the "soup" basket. As she painted,
she found that the casual, playful quality of
her composition encouraged her to work
with looser brushstrokes than usual. It's an
example of how her very choice of objects
can lead her in new directions.

Robin Eschner-Camp
Using Negative Space for Tension and Relief

The objects that Robin Eschner-Camp uses are simply things that have, at some time, caught her fancy. Often she paints the same things over and over again. Her glass-jar collection has grown over the years, but she finds that she reaches for the same bottles time and time again. The same is true with certain plants. Yet each new painting is a new departure point — it is as if she were seeing the objects for the first time, with new reflections and shadows, new form and color relationships.

While the objects Eschner-Camp chooses are important, she feels that if they are not set up to create an interesting arrangement, they become meaningless. She may spend hours moving her objects around until she discovers a combination that intrigues her. Once the still life is set and she starts to paint, however, she rarely changes anything.

After spending so much time arranging her objects, Eschner-Camp finds that they take on personalities of their own — and she attempts to capture this in her renditions of them. She may, for instance, accentuate the short, squat character of a certain bottle by exaggerating the fullness of its form and playing down the highlights.

For the last several years she has been working on a series of watercolors entitled "Paper Glasses," which include glass vessels positioned on scraps of paper. She likes the contrast between the pieces of paper and the hard, reflective glass. She also enjoys the visual-verbal pun of her "Paper Glasses" — after all, the "glass" seen in the painting is really only pigment on paper.

The large white areas in Eschner-Camp's paintings are very important in her work. They balance the more weighted, painted areas and provide a resting ground for the eye. There is both tension and relief. Tension because of the contrast between the brilliant white paper and the delicately painted objects. Relief because the empty areas serve as a breathing space, helping us "step back" from the objects to see their general form, before we are drawn back in again to their detail.

WORKING METHODS

Because the white of the paper plays such an important role in Eschner-Camp's work, she takes special care in selecting her paper. Recently she has experimented with paper made according to her specifications at Magnolia Editions in Oakland, California. For instance, she may chose cotton fibers mixed with flecks of blue for a quiet intimacy. She also likes d'Arches hot-pressed paper for its smooth surface, which doesn't absorb the color as much as a rough texture would and thus gives a crisper, cleaner look. At times she buys this paper in rolls 10 yards long, cuts the size she wants, and then stretches it on a large sheet of plywood, coated with enamel appliance paint and suspended on pulleys from the ceiling of her studio. She does not soak the paper; instead, she uses a spray bottle and wets only the back side.

Her pigments are Grumbacher and Winsor & Newton watercolors, which she mixes as she paints, three to four colors at a time. She uses sable brushes, along with stiffer bristle brushes for splattering. Often, when she splatters an area, she will first take some stiff paper and cut out the shape of the item she intends to splatter so that she can mask the areas around it.

The first thing Eschner-Camp does when she is ready to paint is to lightly pencil in the horizon line, which sets the "ground" for her still life. She then draws in the rough outlines of the objects at the perimeters of her setup, although she erases these marks later. In establishing the value range in her painting, she makes a mental note of the lightest areas and leaves these unpainted until she has completed a number of the middle tones. Toward the end, she goes back to darken shadows until the images pop out. She then softens the highlights, bringing them down into the range of the total work. She thus works both ways from the middle — bouncing from light to dark to light again.

As she paints, Eschner-Camp likes to let her colors pool on their own. Within a small wet area, she will apply a brush full of pigment and allow it to fan out. On the smooth surface that she prefers, the color flows unevenly so that when it dries there's a variable transition from light to dark. Of course, how much water and pigment she uses will affect the result, but there's always an element of unpredictability — which is part of the magic of watercolor.

EUCALYPTUS

43" × 68" (109 × 173 cm)
Watercolor on d'Arches 300-pound cold-pressed
paper roll
Private collection
Photograph courtesy of Allport Associates Gallery,
San Francisco

Eucalyptus *came out of Eschner-Camp's desire to produce a large, meditative study. She decided to let the eucalyptus leaves almost fall off the edge of the paper in order to create a sense of timelessness. Although she kept the colors of the leaves within a close range, in line with the quiet mood, she used quite a few different pigments, mixing three or four together as she went*

along. In fact, her palette included yellow ocher, cadmium yellow medium, golden yellow, scarlet lake, alizarin crimson, Thalo purple, cobalt violet, permanent magenta, cobalt blue, manganese blue, cobalt green, and sap green.

In painting the leaves, she started with those nearest the viewer and then proceeded to the rest. With each leaf, a clear wash was applied first, then small areas of pigment were placed within the borders of the leaf and allowed to fan out, with the color becoming subtler as the pigment dissolved into the water. To perk up the color, Eschner-Camp cut out leaf-shaped holes in

a piece of stiff paper, covered the area around the leaf, and with a stiff bristle brush, splattered intense color onto the already painted area. The splatters hit both dry and wet areas, creating differences in texture.

When she was nearly finished, Eschner-Camp added the shadows. She also ran a wash of water only over the jar, starting with clear water at the top and letting it lift up some of the color as she went. She finds that this helps to pull everything together inside the glass, making it look more self-contained.

FLOWERS FROM THE HILL
40″ × 26″ (102 × 66 cm)
Watercolor on d'Arches 300-pound hot-pressed
paper
Private collection
Photograph courtesy of Allport Associates Gallery,
San Francisco

The flowers in this still life were replaced several times before the painting was completed. Every four or five days some more would wilt and Eschner-Camp had to struggle in arranging their replacements to recover the feeling she wanted. She likes to work directly from her setup, although she always varies the colors somewhat.

After lightly positioning everything in pencil, Eschner-Camp began with the flowers. Her palette included cobalt blue, viridian, cobalt green, permanent green light, sap green, cadmium yellow medium, cadmium red deep, permanent magenta, and Thalo purple. She didn't paint the flowers in any particular order; rather, she bounced around from one flower to another, on to the jar and leaves, and then back again. When she was nearly done, she added the shadows and applied a wash of water to the glass jar, beginning at the top and working in a semicircular motion toward the bottom. Her brush picked up color from the stems as it went along so that by the time she reached the bottom, the color was somewhat muddy — not unlike the water in the actual jar.

SEND IN THE CLOWNS WITH PLANES

22" × 30" (56 × 76 cm)
Watercolor on d'Arches 300-pound hot-pressed paper
Courtesy of Allport Associates Gallery, San Francisco

This painting belongs to Eschner-Camp's series entitled "Paper Glasses." A playful mood is set up by the music box (which plays "Send in the Clowns") and the paper airplanes, which appear to fly and then rest within the space. The intense color of the music box presented a problem, and Eschner-Camp arranged the rest of her still life to balance its visual weight. It took quite a few of the delicately colored planes to keep the box from looking too heavy! In fun — and to help create tension with the box's clown — she decided to perch one plane on top of the bottle so that it seems to soar through the still life. There's never any question, however, that the planes are made of lightweight paper. That comes from Eschner-Camp's careful attention to the hard lines of the folds and the sharp shadows.

BLUE DANUBE WALTZ

14" × 11" (36 × 28 cm)
Colored pencil on d'Arches 300-pound cold-pressed paper
Courtesy of Allport Associates Gallery, San Francisco

Although this is a study for a watercolor, it works as a drawing on its own. You can almost hear the music playing as the boxes turn over in different directions, leading the eye around. Working in colored pencil Eschner-Camp used denser, more vivid color than in her watercolors. With such intense color, she left large areas of the paper's white for tension and relief. She also provided a point of transition in the small piece of lightly colored paper under one box. And there's a pun intended, for the drawn paper reminds us that everything we see is an illusion drawn on paper.

Polly Kraft
Playing Organization against Chaos

A sense of the accidental, almost disheveled quality of daily life is conveyed in Polly Kraft's still lifes. Everyday objects — a plate, a newspaper, a necktie, junk mail — seem randomly placed on a rumpled tablecloth or unmade bed. These are objects that engage her, and — most important — say something about her life.

Kraft's watercolors have been described as intimate. In part this stems from her use of familiar objects that refer to everyday events in her life. She also often chooses a viewpoint from somewhat above, which pulls the viewer into the painting. There is no distant space to lead us away from the still life; instead, everything is just there, before us. Kraft's handling of the watercolor medium adds to this feeling of immediacy. She works rapidly and gesturally, drawing with her brush as she goes and often mixing her colors directly on the paper. Throughout, there is a spontaneity to her way of working. She lets the unexpected happen and tries to avoid a rigid control. This intuitive approach then ties in with the casual look of her setup.

Nevertheless, although Kraft's arrangements may look random, they are carefully laid out with an eye to what will make the painting work. Rumples and folds connect the objects, leading us rhythmically through the composition. The key to her success in depicting her rumpled settings, with their scattered objects, lies in her rendering of the shadows. Before she details any of her objects, she makes sure the shadows are right. The shadows, which define the fabric's folds, set up a background network, or "grid." This grid is never rigid; it is more a flickering pattern of lights and darks. Yet because this pattern covers almost the entire surface, it provides a certain structure. In other words, there is a sense of order — however intangible — to the "chaos" that we see.

WORKING METHODS

For her watercolors, Kraft prefers d'Arches 300-pound cold-pressed paper because it can take quite a bit of beating before it loses its sizing or shape. At times she works on 100% rag Bristol board or a handmade paper by Cotman with a rather crinkly surface, which makes the color dry in a crinkly way. She uses a variety of brushes, most notably Winsor & Newton Series 7, Percy Baker sables from England (which hold their point well), and Raphael French no. 803 brushes, which are rather like Chinese calligraphic brushes. Her palette is a large, white porcelain meat platter, and she also uses some round, divided French porcelain watercolor dishes. Her pigments come from Sennelier, Winsor & Newton, and Rowney. Most frequently she chooses from a variety of blues, yellows, and reds — French ultramarine deep and light, permanent blue, indigo, yellow ocher, cadmium yellow, lemon yellow, cadmium red, cadmium scarlet, alizarin crimson, vermilion — as well as Payne's gray and burnt and raw sienna.

Kraft sets her still lifes up on a low table beside the high table on which she works. She prefers to stand while painting so that she can work gesturally all over her paper; sitting down restricts her spontaneity and ease of movement. Once she is satisfied with her setup, she lightly sketches her composition on the paper, using a no. 3H pencil or the point of an eraser. The eraser leaves a misty image; if it's not right, she simply wipes it off and starts again. When the marks are finally right, and it may take several attempts to make them so, she starts painting.

Kraft doesn't wet her paper, although she adds a lot of water to her pigment at first. With gestural strokes, she lightly outlines the shapes and indicates the shadows. In the early stages it's important for her to work as freely as possible, loosely sweeping in washes of color, letting bleeds "happen," even taking her paper off her drawing table and painting, standing over it, on the floor. She isn't afraid to make a bold statement, emphasizing one area or another, because she knows that later she can go back and make connections that will hold everything together.

At some point during the initial phase Kraft pins her painting on the wall and steps back to see how it's progressing. Only when the skeleton — what she calls the "grid" — begins to come alive, reverberating with energy, does she start to define things: clarifying shapes, darkening shadows, and stressing certain details. Each watercolor is an experiment for Kraft. If she plans too carefully or ends up rubbing out or scraping too much, the painting "dies" on her: it looks stiff and sterile. To get the spontaneity she wants in the final painting, she often has to throw out several bad starts.

PILLOWS WITH STRIPED CLOTH
30" × 40" (76 × 102 cm)
Watercolor and colored pencil on Bristol board
Collection of Michael Mills

*Since childhood, Kraft has loved the way
pillows crumple and fold. Here she used the
lumpy pillow shapes to set up a series of
tumbling-over diagonal movements. The
first pillow, at the edge, leads us to the
second, which flops over into a spill of pa-
per edges. The front-page banner of the*
Village Voice *newspaper then directs us to
the top of the scarf, which flows back to the
first pillow — and we go 'round again.*

*After lightly sketching in the placement of
the pillows, Kraft began laying in the shad-*
*ows to set up the underlying rhythm of her
composition. She worked all over, begin-
ning with light washes and gradually
adding more pigment, building her color in
layers. Occasionally she sponged or blotted
areas, and she made use of accidental
bleeds — on the background pillow, for
instance. Kraft describes her process as a
lot of trial — and error, too. She doesn't
have a preconceived approach; instead,
she's open to whatever may happen along
the way. She'll lay in a wash here, blot a
color there, add a darker definition, and
then — well — just "see." This spontaneity
is key to the aliveness of the finished work.*

In this painting Kraft experimented with
*Prismacolor pencils. Because she used
heavy Bristol board, the colors tended to
remain on the surface. To get the defini-
tions she wanted, she tried working into
areas with the colored pencils. In the upper
pillow, for instance, she used warm and
cool gray pencils, adding the thin blue lines
with an ultramarine pencil, to capture the
flickering quality of light. In fact, the al-
most milky tonality and soft light of the
whole have a lot to do with her use of light
gray pencils over the delicate yellowish and
purple shadows created with mixtures of
French ultramarine blue, alizarin crimson,
and yellow ocher watercolor.*

STRIPED TIE, STRIPED SCARF
22″ × 29″ (56 × 74 cm)
Watercolor on Cotman handmade paper
Collection of Rogers and Cowan, Inc., Washington, D.C.

Kraft wanted to create an almost abstract composition with a shallow space but strong shapes. Her husband's tie and a favorite scarf offered an interesting juxtaposition, with the folds and the wide bands of the scarf providing a kind of frame for the snakelike movement of the tie. To accentuate the tossed-together feeling of her setup, Kraft brought out a variety of rhythms. Notice, for instance, how the zigzag along the edge of the bottom of the scarf complements and thus reinforces the irregular horizontal line of the tie. The bands of the scarf then set up a countermovement, directing our eyes up and down at different angles. Kraft was careful, however, to keep the strong colors of the bands from becoming too solid. In many areas she worked quite wet, letting one wash bleed into another. What this does is to give a flowing quality to the color so that even though one hue predominates in each band, it's never static.

PAPERBACK, TWO TANGERINES
22" × 29" (56 × 74 cm)
Watercolor on Cotman handmade paper
Courtesy of Osuna Gallery, Washington, D.C.

Having brought some fruit to the studio to eat, Kraft set it down beside the paperback and liked the combination of red, yellow, and orange. The blue and white mug added a note of contrasting color. For a backdrop, she chose the damask cloth, which allowed her to create a variety of movements with its folds; at the same time it provided a frame for the still life with its broad red bands at either end. After arranging and rearranging her objects, she finally decided on a spillover effect, with something of a dwarf's view. The flow of the fabric takes over so that the tiny objects seem to be pushed forward along a diagonal until they almost fall over the edge.

Kraft's loose handling helps to bring out this spillover effect. In the fabric especially, one wash quite literally spills over into another so that we are always aware of the liquid flow of the paint. Kraft found that the crinkly handmade paper she used enhanced the movement she wanted. Her color dried unevenly — almost as if it, too, were rumpled.

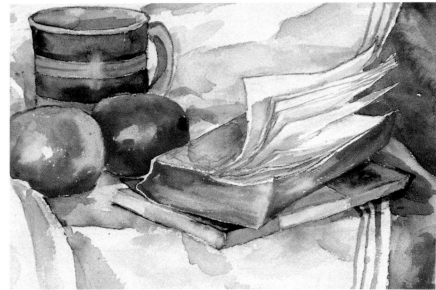

DETAIL

The well-thumbed paperback enhances the casual feeling of the painting; at the same time its curled-up pages play an important compositional role, directing our eyes back to the mug and oranges in a continuous rolling motion. To create the pages, Kraft had to think in terms of negative spaces. With her brush, she drew in the shadows that separate one page from the next. At the upper edges she paid close attention to how the red fabric cut into the pages and thus defined them. When she came to the cover, she let the yellow color "bloom," as if it were an actual water stain, adding to the worn look.

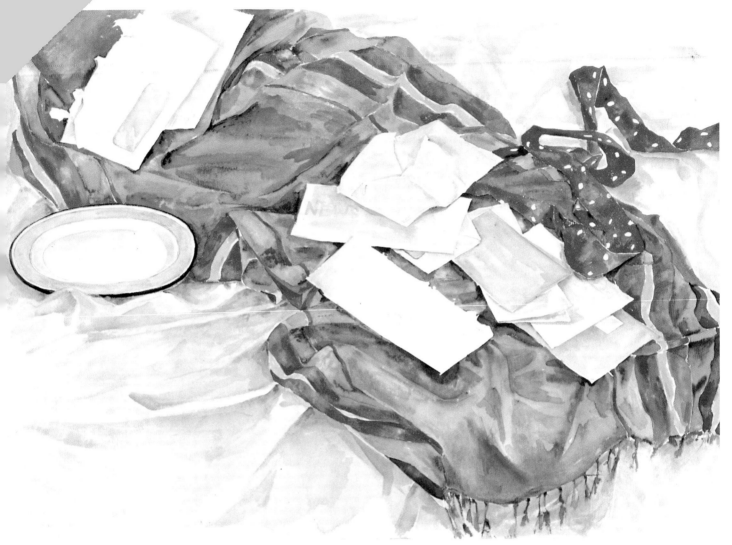

SAUCER WITH MAIL
30" × 40" (76 × 102 cm)
Watercolor on d'Arches 300-pound cold-pressed paper
Collection of Henry A. Grunwald

Almost everything in this painting flows toward the viewer. The undulating scarf seems to set the pace, carrying an endless stream of junk mail. Although Kraft had previously used the scarf in her paintings, she believes that this is the first time it truly "explodes." She doesn't have a set formula to describe how she created this cascading effect — a lot was trial and error.

Of course, her decision to make a strongly diagonal composition, with the scarf moving from one corner to the opposite corner, was important. By cutting the scarf off at the top and letting it hang at the bottom, she augmented the feeling of forward motion. But even more important was her painting of the scarf. To get the shadows that ripple through the central blue area, she didn't just use different tones of blue. Instead, we see a lot of reflected color — yellows, pinkish purples, even some green. These colors mingle, intermixing on the paper, so they don't seem separated from the blue. Overall, they contribute a flickering quality, a sense of light, which increases the feeling of movement.

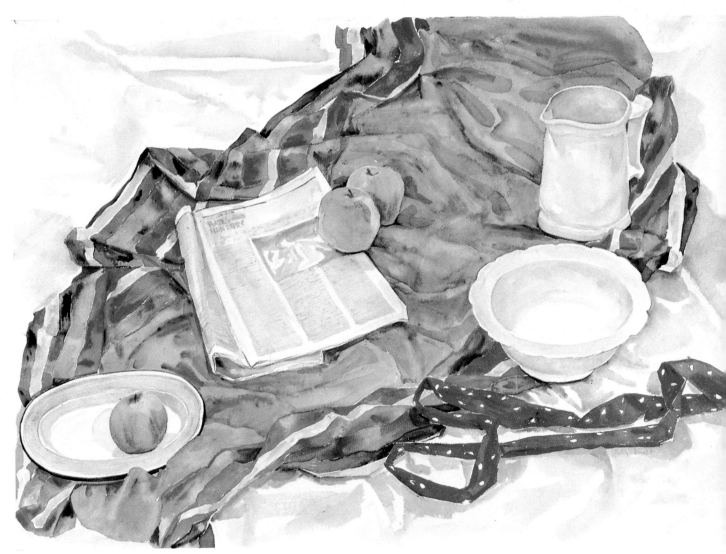

GRANNY SMITHS, RED TIE

30″ × 40″ (76 × 102 cm)
Watercolor on d'Arches 300-pound cold-pressed
paper
Collection of Mrs. Louise Melhado

*This painting was a direct outgrowth of
Saucer with Mail. Often, Kraft feels, one
painting simply evolves out of another.
Here, of course, she reversed the diagonal
and changed several objects — adding a
copy of* New York *magazine, which was
lying around in her studio, and the Granny
Smiths, which always find a place by her
side while she is working.*

*Although the composition is similar, the
mood of this painting is quite different from
Saucer with Mail. The scarf is more spread
out; its movement, slower. Most important,
the still life is imbued with a soft yellow
light. We see this in the highlights on the
apples, as well as in the yellow-gray washes
that articulate the columns of type in the
magazine. It is a moment of relative quiet.*

*Kraft began by noting the off-white ac-
cents at the top left. To define the various
white objects, like the bowl and the pitcher,
she painted around their edges and used
pale washes of color to indicate the shadows
within them. At the very end, she darkened
the rim of the oval plate and carried the
scarf off the edge at the top. Instinct told
her the painting was finished.*

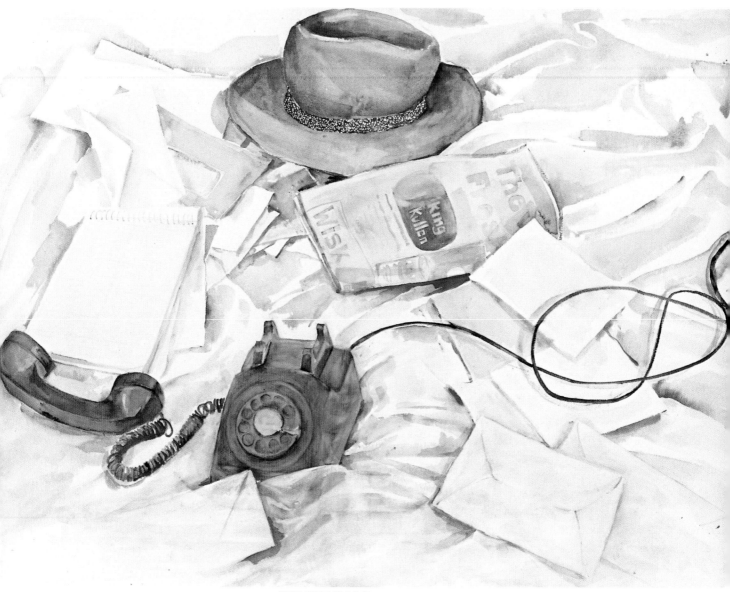

OFF THE HOOK
30″ × 40″ (76 × 102 cm)
Watercolor on d'Arches 300-pound cold-pressed paper
Collection of Mark Leland

The telephone is the great disturber and the essential communicator in Kraft's life. For this still life, she decided that she wanted an off-the-hook attitude. She knew that the heavy, black telephone would be a problem, so she angled it first and then positioned the other objects in relation to it, to offset its stiffness. Nevertheless, she had a very difficult time balancing such a dark mass with the weightlessness of the cloth and the mail.

Originally she painted the telephone with a mixture of indigo, ultramarine blue, and Payne's gray, but the indigo made the phone too flat. She rubbed, washed, and blotted far more than she usually does in order to make it appear lighter. What she wanted to do was to convey its hard-edged, solid form without destroying the transparent, flowing feeling of the watercolor medium. Thus, she tried to bring out the reflection of light on the phone. But she didn't just concern herself with the phone. She chose a darker color for the playful line of the cord, which helps to divert attention from the heaviness of the phone. In addition, she intimated touches of the blue-black color in the newspaper and the hatband. Finally, with the hat itself, she brought in a strong contrasting note — in both color and shape — so that our eyes move up and down, drawing comparisons.

GREEN HAT, SCARF AND GLASSES CASE
30" × 40" (76 × 102 cm)
Watercolor on d'Arches 300-pound cold-pressed paper
Collection of Artery Corporation, Washington, D.C.

A friend's Adirondack fishing hat evoked memories of a weekend in the mountains, climbing and camping out. Its color provided a challenge. How could she convey the vitality of the dark, almost opaque green and still retain the transparency of watercolor? Initially Kraft painted the hat in Hooker's green dark — far too heavy for the painting, she believed. By adding a variety of blues, cobalt green, Winsor emerald, and permanent green light to this, she lightened the color and gave it an alive look. But this didn't come easily. She had to throw away three or four different tries before she was satisfied with the mixture of green. Even then, she felt the color might still be too flat. Nevertheless, it resounded with the greens in the scarf and thus worked in the painting.

DETAIL
When you look at the hat up close, you can see that there's a definite feeling of how the paint was put down and how water lets the color flow — which makes everything more alive. Also, in places, the washes are quite thin so the paper's white lends its brilliance to the green.

Jane Piper
Creating Space with Color

Jane Piper's free and expressive manner of painting derives in part from her excitement about what she is going to paint. She never knows at the start what the results will be. In fact, she finds herself working over the canvas many times, moving back and forth between complexity and simplification as she feels her way into the work. Her first impression may change three or four times before she determines what it is that she really wants to express.

The longer Piper works, the more abstract her painting becomes in its representation of subject matter and use of color. The interrelationship of the forms and color is always more important to her than the subject matter per se. She chooses her colors to structure and organize the painting. She also favors certain objects for their structural possibilities. Compotes give an upward thrust, windows add vertical and horizontal lines, striped materials can divide and activate the space.

Piper's concern with space differs from the traditional illusion of three-dimensional space. She is always aware of the two-dimensional reality of the painting's flat surface. On that surface she creates a kind of spatial web, leading the eye up and down, back and forth, through the movement of line and color.

WORKING METHODS

Before she begins to paint, Piper makes several rather loose, free-flowing color sketches, usually in oil pastel. She does this to familiarize herself with the objects and their placement within the composition. Once she turns her attention to the canvas, she does not refer to these sketches; instead, she draws directly on the surface with charcoal. Occasionally these charcoal drawings become quite complex and could even stand on their own as compositions. The more finished the drawing, however, the more difficult the painting becomes for Piper. She feels trapped by the drawing if it is too complete to allow for experimentation.

Piper's palette consists mostly of bold colors — yellows, oranges, greens, reds, and blues. She likes to have all her colors out on her palette — as "a form of inspiration." She tends to avoid earth colors because they are weighty and "pull down" the painting. On the other hand, she uses white lavishly. Colors bounce off the white and appear richer than they actually are. Generally, she simply mixes her pigment with turpentine, but every once in a while she will also use a paint extender.

Piper's canvases are cotton duck, primed with three coats of gesso. When she works on paper, she either uses museum board or 100% rag illustration board — both gessoed on their two sides. She likes her painting surfaces to be slick so that the paint will not be absorbed. For brushes, she uses medium-size round and flat bristles and some sabeline, but never sable. At times she applies paint with a rag or paper towel because of the translucency that she can achieve by rubbing in the color, or rubbing it off.

RED AND WHITE CHECKERED TABLECLOTH
(For caption, see page 82)

Preceding page
RED AND WHITE CHECKERED TABLECLOTH
40″ × 30″ (102 × 76 cm)
Oil on paper
Private collection
Photograph by Joseph Painter; courtesy of Gross McCleaf Gallery, Philadelphia

Impressed with a red and white checkered tablecloth she had seen in a Bonnard painting, Piper searched for a similar one. She decided to add broad diagonal stripes in the background. Together, the pattern of the cloth and the stripes enliven and structure the painting.

The frontal view of this painting is unusual in Piper's work; more often she chooses a diagonal presentation. Here, however, as soon as she introduced the china platter at the bottom, she decided on a frontal arrangement, looking head-on at the red and white checks. Then, as she moved toward the top of the painting, she shifted a bit to create a sense of lively movement with the sway of the flowers and the diagonals of the stripes. This shift is important. Without it, the flat, horizontal and vertical tablecloth might seem static. Instead, our eyes gravitate toward the swirl of activity at the top and then, through color echoes (such as the oranges in the flowers and the fruit), we're led around and back into the rest of the painting.

For this painting, Piper chose to work with oil on paper rather than canvas. She confesses that paper doesn't feel "as big a deal or as risky" as canvas, in a sense encouraging experimentation. She also likes the fact that oil on paper can look somewhat like watercolor in terms of transparency. To achieve even more luminosity here, Piper at times wiped colors onto the paper with a rag or paper towel rather than painting with a brush.

Above
BLUE HYDRANGEA
44¹/₂″ × 40″ (113 × 102 cm)
Oil on canvas
Collection of Allentown Art Museum, gift in memory of Nathalie Gourlie Appleton
Photograph by Joseph Painter; courtesy of Gross McCleaf Gallery, Philadelphia

For this painting, Piper asked a friend to choose the subject matter and arrange it. She wanted another point of view to work from. Her friend placed the hydrangea in a large bucket and took it out into the garden. At this point Piper took over, moving the potted plant into a position where she was looking down at it from inside her studio.

Behind the plant, tall pine trees imposed themselves and Piper decided to include them in her still life. She started her painting with the hydrangea and then began moving all over the canvas. The work grew more and more complicated until finally she felt it had become much too dense and she set aside her canvas for nearly a year and a half. When she brought it out again, she added the areas of orange in the middle and the orange-red triangles on the right side. These small areas of color helped to bring the painting together, stabilizing it. Without them, your eye would wander rather aimlessly, searching for a resting point.

Obviously, Piper's painting is greatly abstracted from her setup with the plant and pine trees. Yet there is a definite feeling of landscape space that derives from her subject matter. Indeed, the dabs of warm orange she added at the end foster a sense of spatial recession in the cooler colors on the left. What Piper conveys, through her handling of color and movement, is the abstract structure of what she sees.

COMPOTE WITH FRUIT
39″ × 28¹/₂″ (99 × 72 cm)
Oil on paper
Collection of Mr. and Mrs. Donaldson Cresswell
Photograph courtesy of Gross McCleaf Gallery,
Philadelphia

By placing her still life in front of a window, Piper introduces an important structural element into her painting. Traditionally, painters have used the window frame, with its echo of the painting rectangle, as a balancing device. Here the window helps to contain the predominant diagonal movement. At the same time the window lends a feeling of openness. One has the impression of light streaming in from the outside and targeting the fruit in front.

The window is but one example of the many choices Piper has made that involve us in looking and relooking at the painting. There's a sense of both underlying order and constant change. Piper decided, for instance, to concentrate the rich color in the fruit and thus give weight to the bottom of the painting. Yet, with her diagonal lines and planes of color, she forces our eyes to move elsewhere in the painting before coming back to the fruit as a kind of visual holding area. In a way, the red and blue X's denote this crisscrossing of our view and thus help to stabilize the painting.

Piper's mixture of realistic and abstract elements contributes to the back-and-forth movement of the painting. Her inclusion of a Moorish arch in the upper left brings in a personal note, in addition to providing an important compositional balance for the curve of the compote. Piper was quite impressed with this form when she visited Tunis several years ago. She was also quite intrigued by the use of color in North Africa, which she describes as having almost a taste and touch. In her own work Piper is very much concerned with making color "more visual." Here, through her use of white, she creates an overall brilliance that makes us all the more aware of the color.

FRUIT COMPOTE AND RED STRIPES
42" × 50" (107 × 127 cm)
Oil on canvas
Private collection
Photograph by Joseph Painter; courtesy of Gross McCleaf Gallery, Philadelphia

Although the other paintings shown here are vertical, Piper actually prefers to work on horizontal canvases because they have more "repose." Since her work often becomes terribly complicated before it is simplified, the built-in tranquillity of the horizontal format allows her to feel her way around in a more assured manner.

This painting was done at about the same time as Red and White Checkered Tablecloth, *and several of the same objects were used in both. Piper admits that in setting up her still lifes she is making a*

plan for her painting — in the sense of selecting certain colors and shapes. But that is the only real planning she does. Her other decisions come out of the painting process, as she explores what she wants to express on the canvas.

Here the striped material in the background was the point of inspiration. Its strong lines provided Piper with a structure she liked. She kept the flowers, as well as the shape of the compote, quite evident, but she also worked abstractly, using color to define the painting space. All the white areas create the sense of both a flat surface and an openness. The color areas then lead our eyes in and out of this space and around the painting. This is perhaps most effective in the varied echoes of red and orange.

DETAIL

Touches of brilliant color add a lot to the vitality of Piper's still lifes. Here the intensity of the orange pulls our eyes to the compote. But it isn't simply a question of laying down a stroke of strong color; the rich, warm note of the orange has a lot to do with the other, cooler colors that surround it. Moreover, by adding the dark color behind, Piper pushes the orange forward. She also uses near-complements — the blue-purples — to increase the vibrancy of the orange. Then, with all the white areas, she gives her colors "breathing space" so that they seem purer than they are. Try to imagine what this detail would look like without the white — the colors would begin to cancel each other out and lose their identity and sparkle.

SUGGESTED PROJECT

Choose a setting that includes a window, the space outside the window, and several objects within the room, positioned in front of the window — for instance, a table, a few items on the table, a chair, and a portion of the wall. Include some pattern, such as a cloth with a checkered design. Begin by doing at least three sketches of the arrangement using oil pastels. Do not think about realistic portrayal. Focus on the color rather than texture or shape. See if you can describe the space by concentrating on the interrelationships of solid color, without shading.

For the first sketch, concentrate on the view outside the window; make it the focal point. Then, in your second sketch, make the window frame the center of interest. Finally, in the third sketch, focus on the objects within the room, with the window area and the outside scene as secondary considerations.

When you have finished your sketches, study them in terms of how the various colors you have used relate to one another. You should gain a better understanding of what color can express in and by itself and in combination with other colors, and how it can be used to delineate space. Moreover, by creating three versions of the same setup, you will see how the very same subject matter can appear quite different when the primary focus shifts. It's possible to look at the same still life or even a single object in a myriad of ways.

Susan Headley Van Campen
Balancing Color and Shape

Before she begins to paint, Susan Headley Van Campen relaxes. She prepares for the experience emotionally and arranges her surroundings so that calm prevails. Depending on where she is, she sits on the floor or ground and concentrates very deeply on what she is about to do.

The peaceful environment that she creates for herself is reflected in her paintings. The white of the paper and delicate cast shadows express space, as does the uncluttered arrangement of objects. Her objects are chosen for their color and shape; they are, for the most part, uncomplicated and depicted in a straightforward manner. Often, in choosing fruit or flowers, she tries to bring products of the same season together: peaches and petunias, or gourds and dahlias. One favorite indulgence is the inclusion of a small, detailed pattern on a bowl or plate. But, even here, the design is simple in terms of color and repetition.

Inspiration comes to Van Campen when she is at the grocery store, in an antique shop, or while visiting a friend. A big juicy pear, a dainty sugar bowl, a richly colored flower captures her imagination and she brings it home. Once home, she scans her house for the perfect accompaniments — often items bought for the express purpose of finding an appropriate place in one of her still lifes. She almost always includes flowers — big flowers, like orchids, irises, tulips, or daffodils. She doesn't care much for small flowers because she finds herself getting too caught up in their intricacy, which she can't seem to simplify to her liking. And simplicity is precisely what Van Campen strives for in her work.

WORKING METHODS

In her quest for simplicity, Van Campen aims for clear color. Her palette includes Naples yellow, lemon yellow, sap green, viridian, Hooker's green light, cadmium orange, burnt sienna, alizarin crimson, rose, cadmium red light and medium, French ultramarine blue, cerulean blue, cobalt violet, and ivory black. Pigment and water are applied with nylon brushes, specifically Simmons nos. 8, 10, and 12. A hard pencil and a ruler or similar straight edge are her only other tools. She almost always paints on d'Arches 300-pound cold-pressed paper. She is most comfortable with the 22 × 30-inch size, although lately she has gone on to the next paper size: 30 × 40 inches.

After choosing her objects, Van Campen concentrates on achieving a good spatial relationship, with a balance in form and color. In particular, she spends a good deal of time trying to get the space between objects to work. In tune with her desire for simplicity, she sets everything on a white ground, with a white background, and then sits on the floor in front, viewing her still life straight-on.

Once the arrangement is to her liking, she begins to lightly draw the outlines of the man-made objects — jugs, bowls, vases. She is very precise in her depiction of these forms; she wants to be sure that the curve of a bowl, for instance, is exact. Sometimes she even turns the paper upside down to view the lines from another angle.

Van Campen rarely draws flowers or fruit, however. Nature is alive and should have no restraints, no outlines or precise borders, she believes. The symmetry of vegetables and plants is simply not that important — the life they express *is*. And so, nature's products are allowed to evolve more gracefully, with the gentle strokes of her brush. Very occasionally, with a flower arrangement, she may paint one or two flowers — the "initial focus" — and while they are drying, lightly draw in the others so that she won't forget where she wants to place them. This is particularly true when she is painting an assortment of flowers in different colors. She doesn't want the colors to run so she must wait until the first group is dry before proceeding with the rest. The pencil marks are erased when she is ready to paint.

As she paints, Van Campen concentrates on the flow of water with the pigment. She works very wet, but only in one small area at a time, so that she can direct and control the flow. Painting from light to dark, she applies two layers of color at most. Details are added at the very end, if at all. She finds that focusing on detail takes away from the fresh, direct approach that she is after, and so she does without it as much as possible.

STILL LIFE WITH JUG
22" × 30" (56 × 76 cm)
Watercolor on d'Arches 300-pound cold-pressed paper
Courtesy of Allport Associates Gallery, San Francisco
Photograph by Joseph Painter

The brown jug here intrigued Van Campen; quite simply, she had never painted one before and felt compelled to give it a try. She chose the pears for their shape, which was somewhat akin to that of the jug, and the dark grapes for their contrasting color. In arranging her objects, she decided that the heaviness of the jug could be balanced by placing the deep, blue-black grapes at the opposite end. The pears then

draw attention back across the painting to the jug.

After lightly penciling in the contours of the jug, Van Campen painted it with a mixture of alizarin crimson, burnt sienna, and ultramarine blue. The mauve tone of the jug echoes the color of the grapes, which are a combination of ultramarine blue, black, and a touch of alizarin crimson. The grapes were initially painted as one huge lump. While this "bunch" was still wet, darker pigment was dabbed in some of the areas and water in others, to separate one grape from another. The center of the bunch, however, was left hazy. A drop of

water provided the shine; because everything was so wet, the pigment spread away from the drop, revealing some of the paper's white.

The painted designs on the bowl and the cup were executed last. The design on the bowl picks up the color of the pears, while the dark blues of the cup relate to the grapes.

Although Van Campen was satisfied with this painting, she wondered if the spacing between the objects might be too even. Perhaps she should have set some of the things further back to create a slightly more irregular arrangement.

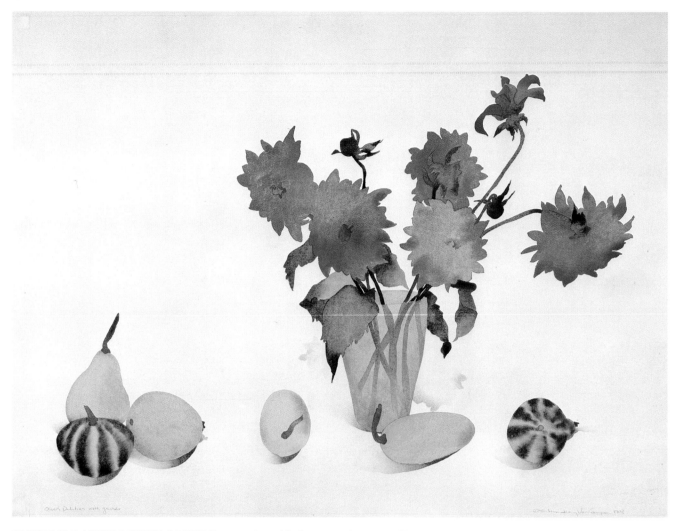

OLIVER'S DAHLIAS WITH GOURDS
22" × 30" (56 × 76 cm)
Watercolor on d'Arches 300-pound cold-pressed paper
Courtesy of Gross McCleaf Gallery, Philadelphia

Van Campen spotted these beautiful dahlias blooming in a neighbor's yard and asked if she might take some. She thought quickly of what might accompany them and decided on gourds. They, too, were late summer crops; moreover, their oval shape would work well with the flowers and their cool green stripes would offset the dahlias' rich salmon color. She spent some time shuffling the gourds around until she was satisfied with the balance between them and the flowers.

Van Campen painted everything directly, without any layering of color. To get a range of values, she simply varied the amount of water or pigment she used. Initially she concentrated on the dahlias, starting with the one at the center. To get the salmon color, she used a combination of rose and orange, imbuing some flowers with more orange, others with more pink. Only later, after completing the gourds, did she turn to the vase, which she painted a pale green. Once this was dry, she introduced the leaves and stems. She wanted the stems to look as if they were dissolving into the bottom of the vase, so she added more water to her brush when she reached their tips.

Toward the very end, Van Campen experimented somewhat with the shadows. Usually she simply adds shadows directly under her objects to suggest their location in space. Here, however, she was intrigued by the way the flowers cast light shadows from above onto the white ground and she tried to captaure this effect.

DETAIL

In painting this gourd, Van Campen first laid in the very pale yellow areas, using a lot of water. While this was still quite wet, she added the dark stripes with a mixture of sap green and black. The green thus ran into the lighter color at the edges of the stripes, creating the blurred, feathery look.

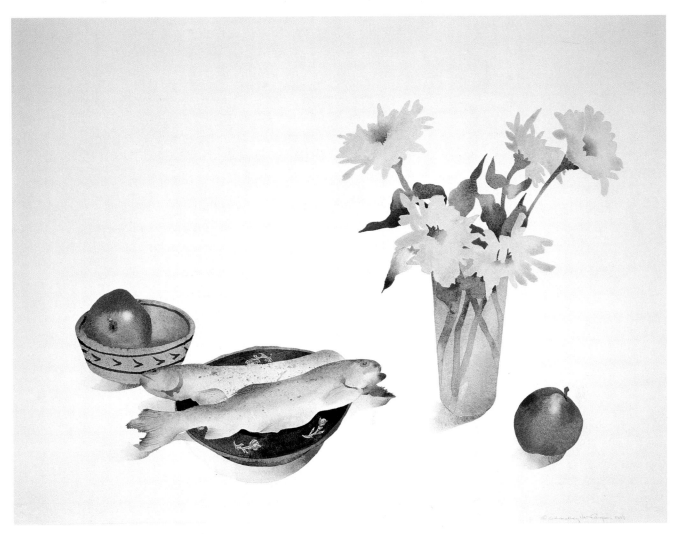

WHITE ZINNIAS AND RAINBOW TROUT

22″ × 20″ (56 × 76 cm)
Watercolor on d'Arches 300-pound cold-pressed paper
Courtesy of Gross McCleaf Gallery, Philadelphia
Photograph by Joseph Painter

The iridescent rainbow trout is the main focus of this painting; Van Campen chose all the other objects in relation to it. The white zinnias, for instance, echo the silvery quality of the fish, while the warm red apples provide an enlivening contrast. Van Campen's husband, a painter himself, actually arranged the objects and provided her with a different point of view. Focusing on someone else's design, she finds, enables her to learn something new.

As she painted, Van Campen made several changes to get the visual balance she wanted. Initially she chose a pale color for the dish under the fish. Once the trout was finished, however, she decided that the plate was not distinct enough and made it black for contrast, introducing a pattern to echo the flowers. She also added the bowl on the left, holding the apple, as a balancing device. Without it, the weight was too heavy on the right side, where the isolated red apple drew too much attention. This way, our focus is divided. Our eyes are drawn back and forth between the apples and then, finally, close in on the main attraction: the fish.

DETAIL

For this apple, Van Campen first mixed a light red shade and laid in the apple's shape. While this color was still wet, she added more pigment to define the darker areas. By carefully controlling the flow of her paint, she created the subtle transitions you see here. Then, for the highlight, she used a drop of water, letting it disperse the pigment in that area.

STILL LIFE WITH KELLER CUP
22" × 30" (56 × 76 cm)
Watercolor on d'Arches 300-pound cold-pressed paper
Collection of Provident National Bank, Philadelphia
Photograph by Joseph Painter

The inspiration for this painting was what Van Campen calls her Keller cup (in honor of Ted Keller, the Maine artist who created it). She likes its small, simple shape with the few bursts of color. In fact, color became a guiding point. The bachelor buttons pick up the blue of the bowl; the peaches relate to the petunias; the Keller cup includes a trace of all the other colors.

Once she was satisfied with her setup, Van Campen lightly outlined the vase, cup,

dish, and bowl in pencil. She then mixed together small amounts of burnt sienna, cerulean blue, and yellow. Using much more water than pigment, she applied this as a very pale beige wash to the cup, vase, and bowl. For the plate, she used a very pale wash of ultramarine blue, taking care to paint around the area where the peaches were to be placed. Although she introduced the dark blue of the bowl and the shadows on the vase while the initial color was still wet, she left the designs on the plate and cup for later, when the paint had dried.

Turning to the petunias, Van Campen began with the one at the extreme left and worked toward the right, adding more pig-

ment here, more water there. She then penciled in a few leaves and bachelor buttons — not to guide her brushstrokes, but as a reminder. Since she was not going to paint them until the petunias were dry, she did not want to forget where she envisioned them. The pencil marks were erased once she was ready to paint.

Only after all the objects were completed did Van Campen add the shadows, which anchor everything in place. These small touches of color are essential in giving a sense of depth to the open space of the white paper. Without the shadows, everything would seem suspended in air.

DAFFODILS AND ASPARAGUS
22" × 30" (56 × 76 cm)
Watercolor on d'Arches 300-pound cold-pressed paper
Private collection
Photographs by Tim Van Campen

THE SETUP

Van Campen started with the bouquet of daffodils; then brought in the two bowls, dish, and five asparagus spears. She later decided to add one more asparagus, angling it to set up a rhythmic movement.

SUGGESTED PROJECT

Set up a still life that you love looking at. Ask yourself what it is that intrigues you. Is it the shapes of the objects and the way one plays against or echoes another? Or is it the rhythm within the arrangement? In your mind, begin simplifying what you see in order to bring out what interests you. Don't get caught up in the details. In fact, forget about them initially. Go to the core of the object and determine which qualities are essential to make your point. For instance, what stands out for you in a plate with a floral pattern? Is it the roundness of the plate or the pattern that is key to your vision? Is it perhaps the colors of the pattern and not the flower design itself? If so, emphasize the color, not the design, in your painting. Determine what needs expression, and what does not, and focus on the important elements in your painting. Remember, details can be added at the end — if at all. If you get too bogged down in detail, you may destroy the vitality of your subject.

WORK-IN-PROGRESS

Van Campen first used a very light wash — mostly water — to create the shapes of the bowls and the dish (leaving space there for the asparagus). She then turned to the flowers but, as you can see here, she didn't work on the vase and stems until later — after she had completed the asparagus spears and the patterning on the plate.

COMPLETED PAINTING

Once she'd painted in the vase, Van Campen went back to refine the centers of the flowers. Next she added an orangish-yellow wash to define the inside of the blue bowl. As usual, the shadows were introduced only at the very end.

Robert M. Kulicke
Striving for Directness

In his work, as he himself points out, Robert M. Kulicke "aspires to a small piece of quiet pictorial order." As a classical realist, he takes as his own the traditional subjects of still life painting — a single, perfectly shaped apple or a half-peeled orange — as well as some untraditional subjects, like a two-dollar bill. What he sees and then translates onto his surface seems relatively straightforward; you are not aware of any special technique. And that is precisely what Kulicke intends: he wants it all to look deceptively simple.

Kulicke paints on an intimate scale. Most of his paintings measure no more than 10 inches in either direction. Small, yet powerful. Close up, from a distance of 15 inches or so, his paintings seem almost impressionistic, with dabs of pigment applied in loose brushstrokes. From a distance of 15 feet, however, his paintings become sharply focused, with amazing realistic exactness. This duality is what is known as the "classical illusion," and Kulicke is a master of this genre.

Kulicke is also a frame designer, whose innovations have become standard frames the world over. Among his best-known designs are the welded aluminum frame, the metal section frame, and the Plexiglas box frame. Kulicke defines a frame designer as someone who serves the painter by using the forms of an architect. In his own work he takes a lot of care with the framing — he considers his frame as a part of the overall work of art.

WORKING METHODS

When Kulicke became frustrated because fruit and flowers never managed to live long enough for him to complete his study of them, he decided to do something about it. One solution was to create his own stoneware "fruit" and "vegetables." He would buy a green tomato, for instance; wait until it began to turn red; and then paint his stoneware replica in the exact blush of color he wanted. Another solution has been to work directly from color transparencies. Using a Diastar viewer, placed next to his easel, he enlarges the slide to the object's approximate real size. He finds that by using slides, rather than color prints, he can see all the color in the shadows, as well as fine details.

Kulicke's painting technique derives from a method employed by the nineteenth-century Italian painters of the Macchiaioli school. These artists created small landscapes by applying the paint in color "patches." Like them — especially Giovanni Fattori (the leader of the group) and his student Giorgio Morandi (whom Kulicke considers to be his master) — Kulicke uses a very simple technique to reduce the image before him into its color shapes: he squints. Actually, his viewer does the squinting for him: he adjusts the focus so the image blurs and breaks down into its component color shapes.

Before he begins to paint, Kulicke works out the proportions of his composition in separate sketches and then makes a quick pencil drawing on his board to indicate masses. When he is ready to introduce color, he lays in the background and the foreground "support," and then starts applying patches of color quickly, working wet into wet. Although a single passage may be edited and restated several times until it is perfect, he is careful to scrub out the paint each time to keep the final look fresh, as if the paint had simply slipped off the brush. As he works, Kulicke gets up any number of times to check the "illusion" from a distance. Up close, what he sees are the dabs of color; he has to make sure that it all comes into focus from further away. Often he uses a reducing glass, which shows him what he would see if he moved away from the painting. At the very end — once he is satisfied with both the closeup and distant views — he applies a glossy varnish. He does this to enhance the "wet" look of his painting. Otherwise, once the paint dried, everything would look too matte.

Kulicke doesn't care to start out with a white surface because that would force him to relate all his colors to white. He prefers a more neutral background, so he tones his surface in acrylic paint, using a combination of white and brown or umber. His oil paints are top quality: Blockx, a hand-ground pure pigment which has no fillers, and Grumbacher's Finest. His brushes are bristle, sable, and camel-hair and quite small in size, the largest being ¼-inch wide. He constantly has to replace them because he scumbles a great deal and thus roughs them up.

MIRROR (CA. 1825) WITH FIVE PAINTINGS

overall: 32³/₄″ × 15¹⁵/₁₆″ (83 x 40 cm)
corner paintings: approximately 3¹/₈″ × 3¹/₈″
(8 × 8 cm) each
central still life: 8⁷/₁₆″ × 10³/₈″ (21 × 24 cm)
Oil on wood panels
Photograph courtesy of Davis & Langdale
Company, New York City

When Kulicke found this frame in a New
York City antique shop, it gave him the
idea of creating a trumeau — a kind of
decorative piece with a mirror and a paint-
ing on top that was quite popular in
eighteenth-century France. After uncovering
the original gilding of the frame (which had
been obscured by layers of radiator paint),
he built up the corners so that he could
include four small still lifes, in addition to
the painting above the mirror.

The mirror, which actually reflects the
viewer, sets up a contemplative mood. To
enhance this effect — the sense of stopping
and looking — Kulicke decided on a larger
view for the central painting and single
"closeups" for each of the corners. In select-
ing the corner images, he wanted to bring
out the delicate color transition in the cen-
ter tomato, as it turns from green to a
warm orange-red. Thus, in the top corners
he depicted a green apple and a pear, which
relate to the top of the tomato. For the
bottom corners, he selected an orange and a
peach to reflect the change of color at the
bottom of the tomato. In addition, he cre-
ated a right-left balance between the corners
and the center painting. The partly sliced
apple and half-peeled orange echo the partly
filled glass and the broken bread, while the
rounded pear and peach refer to the full-
bodied tomato (which is also in between
hard and soft). These corner paintings then
are an integral part of the whole: they both
mirror and frame, reflecting and providing
boundaries for what we see inside.

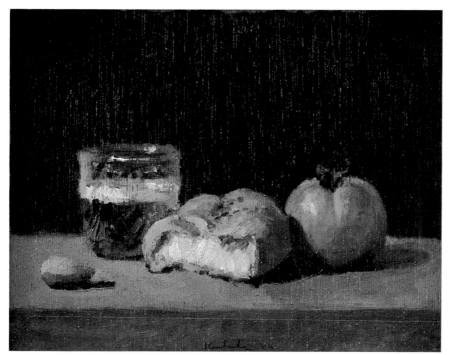

Preceding page
DETAIL

Despite their classical calm, Kulicke's still lifes are never static. Here both his choice of objects and his simple, direct mode of painting give a sense of immediacy. The foam in the glass, the broken bread, the tomato with its beginning blush of red — all suggest a particular moment of time, which has been preserved "forever." (In fact, for the tomato here Kulicke used one of his stoneware vegetables, with which he had already preserved the changing color of the tomato.) The grouping of the food in the center, with the almond just off to the side, reinforces the feeling of casualness within order. Most important, Kulicke lets his brushwork show so it is quite visible when you move close up. He doesn't smooth over his brushstrokes or subtly blend one area into the next. The closer you get, the more the painting comes alive with its small color patches.

TWO GREEN PEARS WITH AN ALMOND
8⁷/₈″ × 14″ (23 x 36 cm)
Oil on gessoed Masonite
Photograph courtesy of Davis & Langdale
Company, New York City

Kulicke claims that he is not searching for originality (whatever that may be). His aims are quite simple: "the right color and the right shape in its right order." With these pears, for instance, he looked for all the patches of color — in the shadows as well as the highlights — that defined the forms. He used his brushstrokes to bring out the shape of each color area. If you look closely at the pears, you can see how the brushstrokes move in different directions, varying in length and thickness. In other words, it isn't simply a question of getting the color, but also its physical shape and the way one color patch "fits" with another.

PEELED ORANGE WITH LEAF
7¹/₈″ × 6¹/₂″ (18 x 17 cm)
Oil on wood panel
Photograph courtesy of Davis & Langdale
Company, New York City

The kind of quiet pictorial order Kulicke strives for is well illustrated by this small painting of a single piece of fruit. The half-peeled orange suggests a transitory moment; yet everything in the painting is quite still, almost timeless. The small scale is important. If you were to come into a room and see the painting at a distance, the orange would look startlingly real — a jewel of perfection. Squint your eyes and you'll get a sense of the illusion. But, because the painting is so small, you'd want to come closer, to really look at the orange. Then, as you can see here, what is striking is the feeling of paint *— how the brushstrokes and touches of color create the form. This is the "classical illusion" — that what at first glance seems incredibly realistic is really a painting (not a photograph), with a strong sense of the paint's material texture.*

For this painting, Kulicke chose a wood panel, which he coated with a thin layer of orange shellac to get the tonality he wanted. In places he let the wood texture show through to enhance the feeling of a painted surface. It took him a long time to get the top of the orange right. The final result may look "easy" — just a few, quick touches of color. That's the effect Kulicke wants. But he had to scrub out and reapply his paint any number of times to get it.

RED APPLE WITH LEAF
7¹/₈″ × 6¹/₂″ (18 x 17 cm)
Oil on wood panel
Photograph courtesy of Davis & Langdale
Company, New York City

In this companion to Peeled Orange with Leaf, *Kulicke again focuses our attention on the wonder of a single piece of fruit. The simple background and foreground platform enhance the painting's directness. It all seems very matter-of-fact, unpretentious, and this makes us more aware of a kind of miracle — that small touches of color come together to create the apple that we see.*

For this painting, Kulicke chose what he calls his "medieval" strip frame. With the extra strip at the top and bottom, it becomes a tabernacle, enshrining what we see. This frame is not simply an afterthought; it is deliberately chosen to work with this painting, and it conveys the reverence Kulicke feels for his subject.

FOLDED TWO-DOLLAR BILL
(in "Federal" cast-paper frame)
6¹/₈" × 5³/₁₆" (16 x 13 cm)
Oil on Masonite
Photograph courtesy of Davis & Langdale
Company, New York City

*Here is a prime example of the classical
illusion. To see how it works, prop the book
up and keep moving back until everything
in the picture comes into focus. Or try
squinting your eyes so that the two-dollar
bill becomes more and more real. In con-
trast, from fairly close up, as in the
reproduction here, all the detail is fuzzy.
You can see that the bill is actually painted
in patches of color, laid in with loose, flow-
ing brushstrokes.*

*Before he began painting, Kulicke tossed
the bill about until he found just the right
folded effect. Then, he admits, he was faced
with quite a challenge. With fruit, for ex-
ample, you can be slightly off in your
depiction of the real object and the illusion
will still hold. With printed bills, however,
you have to capture the effect exactly or it
will look like a coupon. Although Kulicke's
brushwork may look casual, it's never ran-
dom. Nor is it easy. It took a lot of trial
and error before all the brushstrokes
worked together to create the illusion from a
distance.*

CAST-PAPER FRAME IN PROGRESS

*To frame his painting, Kulicke decided to
use cast paper to go along with the subject
of paper money. He chose a "Federal" de-
sign, in which the columns of the frame are
reminiscent of the classical architecture of a
bank. It all fits in with his vision of the
painting as an "American icon."*

*To make the frame, he first constructed a
wooden model and then covered it with
latex to make a rubber mold. He put the
paper pulp into the mold and then dried it
with a hair dryer for three hours. What you
see here is the paper frame as it emerged
from the mold. After trimming the edges,
Kulicke applied many coats of shellac to
harden it and give it a wood quality. He
then mounted the frame onto wood and
pattinaed it to enhance the aged look, which
stems from odd nuances of warping and
shrinking during the paper-making process.
The painting was slipped right in.*

RED AND WHITE TULIPS IN A GLASS VASE

11½" × 8⅞" (28 x 23 cm)
Oil on antique breadboard
Photograph courtesy of Davis & Langdale
Company, New York City

Kulicke collects breadboards in all shapes and sizes; he considers them to be excellent painting surfaces. After he had shellacked the surface of this board, he painted these tulips in a glass jar. The shape of the breadboard reminded him of a fifteenth-century Flemish window, and he emphasized that shape through his painting. Not only did he use the breadboard as a support, he made it the frame of the painting by letting the wood show at the edges. Within the painting, he used the shape of the tulips in the jar, and more particularly the individual petals, to subtly echo the shape of the board. The painting itself is like a window, through which we glimpse a peaceful little world.

Paul Wonner
Combining Imagination with Precise Realism

According to Paul Wonner, most of his work is "sort of autobiographical." Many of the objects in his paintings are everyday things, found in his house or studio. If you were to visit him, he says, what you would see very much resembles what you find in his work: a combination of pedestrian and somewhat exotic objects, a rather strict order, similar colors, and a quiet, fairly peaceful atmosphere. Some critics have said that his work reflects the times we live in by presenting a mixture of "art" objects and commercial products arranged so that each is isolated. For Wonner, the "meaning" stems from the fact that all the seemingly unrelated objects exist in the same painting, in the same world. What he wants to convey is the wonder and mystery of the everyday — that in the midst of the "throw-away" culture, one may find a transient rose or butterfly, a still moment which suggests timelessness and eternity.

For several years Wonner has been painting what he calls "Dutch" still lifes, which stem from his admiration for seventeenth-century Dutch still lifes. He wanted to do something in a similar vein, but entirely his own. At first he painted as straightforwardly as possible, but later he began to change shapes, colors, and sizes. He also started to compose as he went along, creating linear designs that direct the eye through the painting — one object points to another, which in turn leads to another.

Wonner doesn't start off with a set plan of interpretation. Many of his decisions are intuitive; only later does he understand why he did what he did. He insists that there must be an element of surprise and adventure for him, and for the viewer. If he knew everything that he was going to do beforehand, he probably would not be interested enough to do it. In the end, he looks for a kind of credibility — that no matter how changed from actual reality the painted things are and no matter how strange the combinations may seem, it is all possible. *The painting should present an enigma, but an enigma over which a general calm prevails.*

WORKING METHODS

Wonner's canvases are made up ahead of time, and he has no set rules concerning his decision to work on one size canvas or another, other than his mood of the moment. He uses Liquitex acrylics and applies the paint directly and fairly thinly, using water but no medium. Once in a while he alters a color by laying a thin wash of another color over it, but that's rare. Because of the difficulty of matching color in acrylic, he mixes a batch of whatever he is using for the background, floor plane, shadows — anything that appears more than once. He stores these colors in closed containers until the painting is finished — but that does not mean that the colors will not be changed, if necessary.

When he begins a painting, Wonner loosely brushes in the whole composition right away. Although he may push this initial design around, altering it, he feels the painting begins to take hold only when he has painted in some object precisely, almost as it will appear in the finished painting. He then moves on to the next, which is completed in the same way. Once an object is finished, however, it does not necessarily mean that it will remain in place. It may very well be changed, moved, or even completely painted out. It all depends on how the painting is unfolding and which element is crucial and which is no longer so.

The isolated appearance of the objects in Wonner's paintings ties in with the way he paints them. Each object is set up individually, as he paints it; he never arranges everything together in front of him. Admittedly, for some of the flowers, he may use a study that he has painted earlier. Also, when he is in need of an elaborate vase or other ceramic piece and does not have one handy, he will refer to catalogs from the Victoria and Albert Museum or the Tokyo National Museum.

When he sets up one of his objects, Wonner prefers a very strong, harsh light so that all edges are sharp and clear. In drawing the object, however, he may alter its perspective somewhat, making an ellipse of a jar or vase higher on one side than the other so that the object "moves" in the direction. This movement then directs the viewer's eye through the painting. It is an example of the kind of change he will make in what he sees to augment the design of his painting.

"DUTCH" STILL LIFE WITH STACKED OBJECTS AND A TELEPHONE
(For caption, see page 100)

Preceding page
**"DUTCH" STILL LIFE WITH
STACKED OBJECTS AND A
TELEPHONE**
72" × 64" (183 x 163 cm)
Acrylic on canvas
Photograph courtesy of Hirschl and Adler Modern
Gallery, New York City

*This painting was an experiment for Won-
ner. He wanted to see if he could present
each object so that it is viewed individually,
without scattering the objects as much as he
usually does. His solution was to depict the
objects in stacks. Each item can thus be
taken separately; at the same time the whole
stack becomes an object — in relation to
other objects, as well as to the other stacks.*

*Making the stacks work in the painting
was a challenge, and Wonner changed his
composition several times as he painted.
When he first began, he decided on the
color and value of the background and the
ground plane and then roughed in three
stacks, which went from the top of the
painting to the bottom. He painted a few of
the objects at the top of the stacks in full
detail before he decided that the stacks
weren't working. They just sat there —
one, two, three — without much point. To
make the painting more interesting, he cut
down the stacks so they varied in height
and created a "foreground" for the stacks,
with scattered objects and a fourth, small
stack.*

*Throughout the painting, Wonner strug-
gled with the dominance of the vertical
stacks and how to break it. At one point he
drew a long diagonal in charcoal across the
painting; later, this became the telephone
cord. Many of the seemingly random small
objects — like the pen in front, the scissors
in the middle, or the toy bird in the top left
— play an important role in leading the eye
in and out of the painting, in a movement
that runs counter to the stacks. The sharp
shadow patterns, as well as the sheets of
colored paper on the ground, also work in
this way.*

*Wonner also changed the color as he
painted. At first active colors prevailed, but
gradually he introduced more grays and
neutral colors. When a pale purplish tone
began to dominate, he decided to push it
throughout the painting to get the overall
sense of stillness that he wanted.*

DETAIL

*This cat and its companion, both staring out at us, seem to confront us with the painting's
enigma. They are simply there, like the other objects, "caught" in the same place. Although
one might imagine the cat playing with the balls, what Wonner brings out is a moment of
separate stillness. Each "object" exists in its own space, defined by its cast shadow. The
strong red, blue, and yellow colors accentuate the distinctness of the balls, which are also
turned in different directions.*

DETAIL

*Wonner's careful inclusion of the "identifying features" of each object — like the numbers
on the clock or the bands at the end of the pencil — asserts the object's distinctness. The
sharply delineated cast shadows further set each object apart. In addition, by tilting up the
ground plane and then looking down from fairly high above, Wonner keeps his objects
separate in space, so they don't overlap. Here, for instance, if the viewpoint were lower and
you saw everything gradually receding in space, the ball would appear larger and probably
lie over the pencil end.*

"DUTCH" STILL LIFE WITH CATS AND BUTTERFLIES

72" × 72" (183 x 183 cm)
Acrylic on canvas
Collection of M. B. Werner

The idea for this painting started with the large poinsettia plant. Because the weather outside was nasty, Wonner's cats had come into the studio to warm up, and he decided to include them in the painting. He then selected several items more or less because they related to the cats — the book about cats, the orange feeding bowl, the toy mouse. At first he also included a book on birds, but that seemed too obvious, so he replaced it with one on butterflies. Other objects were chosen for their color or size, or for contrast. The Chinese vase, for instance, was originally a blue and white vase, but it turned out to be too blue in relation to the blue wall behind it. When he couldn't find the vase he wanted among his

possessions, Wonner took one from a photograph in a museum catalog.

All the objects are placed to create a linear design, which directs the eye through the painting. For instance, the red ball at the very bottom leads you into the picture, across the books, to the pencil, which points to the black cat. A diagonal then moves from the cat to the mouse to the white dish, and so on up to the carnation and out of the picture. The eye is pulled back into the picture by the loops of the electric cord in the upper right. In addition, a vertical line moves up the surface from the red balls through the yellow ball, pink clock, and yellow flower, to the electric cord. Throughout the painting, similar horizontals, diagonals, and verticals are at work, moving the eye around. In fact, Wonner deliberately created the diagonal of light on the background wall to counter the one that

runs from the lower right through the tennis balls and out of the painting along a stem of the poinsettia.

Quite a few changes occurred as Wonner painted. He started by laying in the background and the floor plane, both of which he later changed. Then he painted the poinsettia, not off to the left side as we now see it, but in the middle. Each time he altered something, he had to repaint. When he changed the color and value of the background, for instance, he tried to "cut" around all the flowers and leaves, but inevitably some of the delicacy in their contours was lost so he had to rework them. Similarly, when he introduced the center stool midway through the painting, he had to move other items or take them out completely. Throughout the painting process, he adjusted the drawing, colors, and values to get the effect he wanted.

Left

"DUTCH" STILL LIFE WITH FLOWERS AND A BOX OF TACKS UNDER A LIGHT

72" × 50" (183 x 127 cm)
Acrylic on canvas
Collection of Exxon Corporation, New York City
Photograph courtesy of Hirschl and Adler Modern
Gallery, New York City

This painting represents one of Wonner's first successful efforts to include the source of light in the painting. Although he does not often paint at night, here he wanted to convey the closed-in feeling of being surrounded by darkness. He was also struck by how out-of-place the tall, elegant flowers looked at night, in the company of common studio objects. The whole painting projects an unusual mood, a little ghostly and slightly surreal. This effect is heightened by the sparse arrangement, with considerably fewer objects than in most of Wonner's "Dutch" still lifes.

Before doing this painting, Wonner had done a detailed study in acrylic on paper, in which he had worked out most of the composition. Here he began with the background and the electric light, painting more or less from top to bottom. Because he was guided by his study, there was a lot less trial and error than usual.

Right

DETAIL

Although Wonner's objects look very still, there's a lot of movement in his design. Here the elongated stems of the flowers shoot our eyes up, while the arc of cast light in the back sweeps our eyes around. At the same time there is a back-and-forth diagonal movement between the floppy iris and the rigid lily (which is balanced in the painting by the diagonal from the red flowers through the lily of the blue iris). In many ways the scattered tacks in back, pointing every which-way, epitomize how we look at the painting.

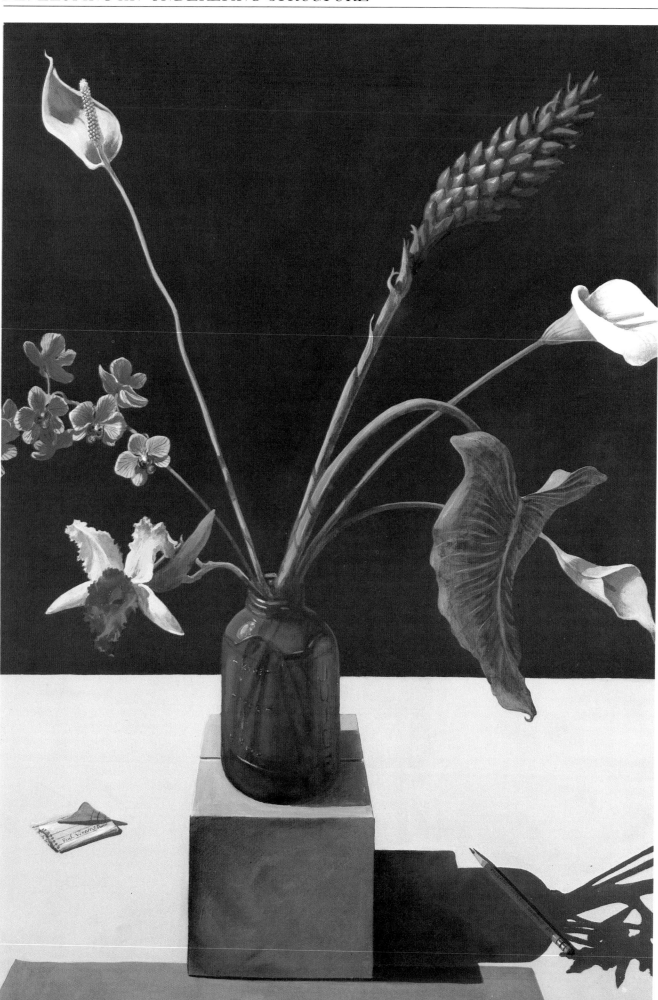

STUDY OF FLOWERS FROM HAWAII

40" × 27" (107 x 69 cm)
Acrylic on paper
collection of G. Akst

Although this work on paper is a finished painting in itself, Wonner considers it a "study" because he did it primarily to have a record of the flowers. He wanted to paint the flowers before they faded and died. In fact, often he uses studies like this one to guide him in painting the flowers in his larger compositions.

Even in this "simple" composition, Wonner's sense of design stands out. The fanlike arrangement of the flowers accentuates their individual shapes. The detailed pencil and torn notebook page then provide a counter-interest at the bottom. In fact, however simple it may look, it's quite complex.

Right

STUDY OF LEEKS AND A LILY

40" × 27" (107 x 69 cm)
Acrylic on paper
Collection of Robert Tobin

In this "study" — as in all his paintings — Wonner deliberately cuts off objects at the picture edges. He does this, he explains, to expand the painting space so things don't look cramped inside. It also, of course, suggests that what we are looking at is just a piece of the world. This feeling is especially strong here, where it seems almost as if we were viewing a detail from one of Wonner's larger paintings.

Iona Fromboluti
Analyzing Visual Relationships

What Iona Fromboluti likes about painting still lifes is the personal aspect: she has total control over her subject and thus a great amount of creative freedom. In general, she finds that she is attracted to subtlety and unlikely combinations. Often she will contradict conventions — for instance, choosing a lopsided composition. She is totally uninterested in the utilitarian aspects of the objects she paints. For her, the tabletop is a stage for visual activity, not storytelling. How light is reflected or absorbed, the way one color balances another, how line weaves through planar and modeled passages — these are the aspects that intrigue her.

The first thing Fromboluti decides on is the light and mood she wishes to establish. At the same time she selects what will be the major influence on light and mood in the still life. In the paintings shown here, it is the fabric that is the major element, not only as the primary focus of the composition but also as it directs the light and mood. Fromboluti prefers artificial light because it gives her more control. Also, she wants to avoid an obvious light source and time reference; the painting should have a timelessness, she believes.

Color is critical in Fromboluti's work. It is what creates light, mood, and space and gives everything weight and form. She likes to use color to "push and pull" her space instead of simply describing things through modeling. Although many of her color choices are made in setting up her still life, Fromboluti doesn't hesitate to depart from what she sees to amplify the particular mood she wants.

WORKING METHODS

Fromboluti feels that she is "led" in setting up a still life. She may begin with a piece of cloth, which she tosses about for a while. Something about the way it falls tells her whether it's right or not. She then piles objects on the cloth, feeling her way toward an idea. She knows that she has found the right combination when she is excited by it and challenged to paint it. Since she works on a painting for a month or two, she must feel strongly about her arrangement from the outset. If there is any hesitation, she will manipulate the fabric over and over again until she is completely satisfied.

Once she has determined her setup, Fromboluti paints — but not exactly what she sees in front of her. She never simply copies reality; rather, she translates it, bringing out the aspects of color, line, and form that make the setup visually exciting. As she starts to put her ideas onto the canvas, she loses her way. It takes some time and paint before everything begins to find its proper place. She doesn't work from one end of the canvas to the other, but constantly moves back and forth. Everything remains fragmentary until the painting is fully laid in and holds a space that is somewhat correct. Even then, some areas of the painting may be in complete chaos. She'll work these areas over many times to get the feeling that she wants.

In general, Fromboluti uses a palette of no more than five or six colors. Her range is expanded by creative mixing, both on the palette and the canvas. Sometimes the mixing becomes so involved that she has to write down the formula in case she wants to get the same color again. Blending directly on the canvas, she finds, helps to activate the surface. She also at times uses optical mixing, so that what seems like one color from a slight distance is really an assortment of colors.

Fromboluti always works in middle tones at first. Space, light, and form are defined by manipulating the color's chroma, or intensity, and warm-cool relationships. Definite darks and lights are developed much later in the painting. Fromboluti confesses that until she "discovers" the light in a painting, her colors are constantly changing. Once light and mood are established, the shifts become less drastic.

Fromboluti paints directly on the canvas; she rarely, if ever, uses glazes. She prefers sable brushes because they respond well to a light touch and allow greater variety in her strokes. Any brand will do as long as the hairs do not shed. She refrains from using bristle brushes because they seem to pound the paint into the canvas, deadening, she feels, the lush quality of oil paint. She finds that they work well only if paint is applied thickly or with a great deal of definition.

STRIPES AND DAFFODIL
(For caption, see page 108)

DEVELOPING AN UNDERLYING STRUCTURE

Preceding page
STRIPES AND DAFFODIL
36" × 30" (91 × 76 cm)
Oil on canvas
Collection of Schnaeder, Harrison, Segal and
Lewis, Philadelphia

Backgrounds are important in Fromboluti's work. No matter what the subject, she believes that a painting must deal with all four corners of the canvas. Here she "broke into" the background by drawing the fabric up over the back wall of the setup. Indeed, the fabric functions as both foreground and background; it is also an important shape in the painting as a whole.

To paint the fabric, Fromboluti first quickly set in the major lines, then worked on the shadowing. While the paint was still wet, she added the stripes and proceeded to blend into the wet paint until she got the balance and feeling of luminosity she wanted. The success of the center bow had a lot to do with very keen observation of the actual setup and how light fell on it.

Fromboluti's interest in aspects of drawing within painting is quite evident here, where the lines of the stripes moving delicately in and out, creating form and space. Yet her use of color and texture is equally important in setting the quiet mood. The glossy white surface of the vase, for instance, enhances the easy flow of the drapery and counters any sense of busyness. Moreover, despite the predominance of white and blue, there's a warm glow to the fabric. In fact, Fromboluti's palette consisted of cadmium yellow light, cadmium orange, cadmium red light, alizarin crimson, ultramarine blue, and titanium white. The warm notes help to keep the whole from seeming stark.

DETAIL

Although the lively forms and colors of the fabric add visual excitement to the painting, Fromboluti never lets the details get in the way of her design. Here the simple knot helps to tie the painting together. It is a kind of tension point. The diagonal folds seem to pull the corners of the painting toward it; even the bright red triangle leads back up to it. One has the feeling that if it were untied, everything would explode outward.

DETAIL

In keeping with her interest in the way that objects can contradict their space, Fromboluti placed the glass in a frontal position but painted it in such a way that it is totally enveloped by its environment. (The same is true of the vase.) To create the texture of glass, she shifted the perspective of the fabric behind slightly, so it looks distorted. She also blurred the color inside, letting it run in places. In contrast, she used clear highlight lines to define the contours of the glass.

KANDINSKY LANDSCAPE
30" × 30" (76 × 76 cm)
Oil on canvas
Collection of Mr. and Mrs. Alexander C.
Speyer, III
Photograph courtesy of Gross McCleaf Gallery,
Philadelphia

Kandinsky's use of color and expressive form inspired the title for this painting, which is composed of various mixtures of five colors: ultramarine blue, alizarin crimson, cadmium yellow, cadmium orange, and titanium white. Surprisingly, despite the involved pattern of the fabric, From-

boluti began with only a rough drawing, just to indicate approximate placement. Most of the drawing you see in the finished whole was done with her brush, as she painted. As usual, she worked all over the canvas, with one touch of paint suggesting the need for another, somewhere else. In trying to capture the light and mood she wanted, she experimented quite a bit, pushing around the paint and changing colors. Only when she'd caught the light did she begin to refine forms and sharpen the focus.

MIXED BOUQUET
48" × 36" (123 × 91 cm)
Oil on canvas
Courtesy of Gross McCleaf Gallery, Philadelphia

For Fromboluti, this painting was an attempt at some new ideas. She wanted to move off the table and explore the underneath. In choosing the maroon tablecloth, she posed an additional challenge — how to keep the bottom part of the painting from seeming too heavy.

One solution she found was to let the table legs show through the cloth, rendering it somewhat transparent. She also wove touches of lighter, yellower color into the maroon, especially in the gentle, overhanging drape. Then she pushed the maroon color throughout the painting, working a pinkish tone into almost everything and thus indirectly brightening the heavy maroon color.

The other objects also help to take some of the heaviness away from the cloth. Although the cup and saucer are white, Fromboluti rendered them thick and substantial. In addition, she placed the piece of glass on top of the cloth at an angle, jutting out into the viewer's space, so that it leads the eye to the center of the painting and the vase. For Fromboluti, this vase was the perfect choice in balancing the dark portion of the painting with the upper half. Because it was transparent, it wasn't overpowering; yet at the same time the stems gave it a strong shape, leading the eye up to the flowers. The flowers then become a focus point, "lifting" the painting up.

DETAIL

The delicate lines of the flowers lend liveliness to the painting. How Fromboluti uses contrast is apparent here. Even though the pale blue flowers are only tiny dabs of color, they stand out from all the pinkish tones around them.

DETAIL

To create the sheet of glass, Fromboluti outlined its shape in a few lines of color. She then used subtle variations of the tablecloth color to make it seem translucent. In particular, she moved the maroon color toward a gray purple to give the feeling of seeing the color through something. She also blurred the pattern of the cloth, lessening the intensity of the reds and making the flowers less distinct.

PATTERN COVERED TABLE, FLOWERS AND RUTH'S SUGAR BOWL

40" × 58" (102 × 147 cm)
Oil on canvas
Courtesy of Gross McCleaf Gallery, Philadelphia

Fromboluti has always been fascinated by the use of pattern against pattern in Japanese prints and the work of Matisse. Yet when she decided to use two different materials in this painting, she encountered difficulties in trying to bring the conflicting patterns, as well as the other objects, together in the light and space she wanted. She realized that she would have to sacrifice some of the details or solidity would be lost.

So, instead of describing the pattern of the orange and yellow tablecloth as a series of shapes, she painted it as a series of agitated strokes, moving vertically as well as horizontally. What this did was give the tabletop a solid, but active surface; at the same time, the quality of the patterned material remained.

Before she did this painting, Fromboluti had been working rather flatly, without texture. Here she used loose, broken strokes to describe the forms. The result was a much more luminous quality to the paint and the painting.

DETAIL

This silver and glass sugar bowl has qualities that satisfy all kinds of painting situations, according to Fromboluti. As an object for ordinary use, it may seem odd, but in a still life it can add a note of elegance. She particularly likes drawing its scroll-like pedestals, and she's intrigued by the mysterious way the embossed glass catches light. In fact, each time she paints it, it looks different.

SUGGESTED PROJECT

What activates you as a painter? Is it the personal significance of the objects or the visual relationships between them? To discover how much what you are painting can affect how you paint, try setting up two different still lifes. Include about the same number of elements in each. Also, keep it simple — perhaps just a piece of fabric for a backdrop and three or four objects on a tabletop, or wherever you may choose.

In choosing your objects for the first still life, pick things that have personal meaning for you. Then, as you set them up, let your emotional responses guide you. Don't try to draw obvious connections; just find something that "feels" right.

To prepare your second still life, select objects for their shape, color, or texture. As you arrange these objects, think in terms of their visual balance. Are two colors fighting against each other, or does one offset the other in a more complementary way?

Once you've decided on your setups, simply paint what you see, without imposing a particular style or viewpoint. Now compare the two paintings. There should be distinct differences. If you are an emotional painter, you will probably respond more to the narrative aspect of the first still life so that this painting will seem more alive. If formal relationships intrigue you, the second painting will probably have more vitality. Of course, it's not an either/or situation — both aspects come into every painting. But this exercise should tell you which kind of setup triggers your interest, which is a key to better painting.

Barnet Rubenstein
Building with Compatible Objects

Barnet Rubenstein will focus on dozens and dozens of cookies, all relating to one another in terms of shape, texture, and color. Or he may pile up paper bags and boxes, which also share common traits. He tends to prefer a certain color range, specifically earth tones, as well as objects that have a direct relationship to solid geometry. Indeed, his cookies seem like small pieces of wood carved into regular shapes.

Compatibility governs both Rubenstein's choice of objects and his arrangement of them. He builds his setups in a modular way, with one box or cookie next to or on top of another. These repeated shapes add up, giving a feeling of ordered geometry to what might seem a casual arrangement.

Often Rubenstein is inspired by looking at the work of masters of the past. Picasso's paintings from 1907 to 1909, when he was moving toward Cubism, as well as Cézanne's still lifes, have influenced his use of an underlying geometry to organize his shapes on the canvas. He also admires Chardin's and Morandi's choice of compatible objects and the way they explore these objects over and over, within a similar format, to create many variations on a theme.

WORKING METHODS

Oil paint, more than any other medium, helps to keep the subject vital, Rubenstein believes. The oil paints he uses are Blockx, LeFranc & Bourgeois, Winsor & Newton, and a few Rembrandt colors. His palette includes cadmium orange, cadmium red light, deep red, cadmium purple, peach black, transparent brown, cerulean blue, cobalt blue, ultramarine blue, pale yellow, and citron, as well as Naples yellow (a particular favorite). His white is flake white. He mixes his colors on the palette and uses a medium of Winsor & Newton linseed oil, damar varnish, and rectified turpentine to make the paint look "fresher." This solution is stored in plastic shampoo bottles. Mostly he uses sable brushes, as well as bristle ones for larger surfaces. He applies the paint directly, without glazing or any special techniques.

After Rubenstein arranges his still life, he studies it very carefully and tries to figure out the "rectangle" within which his composition will fall together. He works out any compositional problems in a full-size drawing, which he then transfers onto his canvas. Although he works on a white ground, he goes over the lines of his drawing in raw umber to set the key for the earth colors he prefers. When he is painting, he concentrates on one area of the canvas at a time, but he keeps an overview of what his values are going to be throughout the painting. Each new color, of course, affects everything else. If he has to change something, he will scrape the pigment off and even sand the surface so the canvas reappears rather than paint on top of a color. He wants to retain the immediacy of direct painting, without layering, as well as a certain translucency (where the canvas shows through).

TABLE NO. 2
45" × 52" (114 × 132 cm)
Oil on linen
Collection of Mr. and Mrs. Graham Gund
Photograph by Greg Heins; courtesy of Alpha
Gallery, Boston

After doing several small paintings of cookie jars, Rubenstein decided to try a more ambitious version. He massed together a number of jars and arranged them so that they would have maximum visibility and create interest on both the upper and lower levels of the table. For his canvas, he chose a squarish format, but one that was slightly more horizontal to offset the table, which verged more toward the vertical. After several drawings he opted for a central positioning of the table and a frontal view, parallel to the picture plane, so that our

attention goes right to the cookie jars without wandering back in space.

For the background, Rubenstein wanted colors and textures that would coordinate with his still life. He found some wallpaper that he liked, but when he taped it to the wall to get a better feeling for it, the color didn't seem right. So he painted the actual wallpaper until he arrived at a particular shade of green that he liked.

When he started to paint, Rubenstein went directly to the cookie jar in the upper left, just as he would if he were writing a letter. He almost always starts a painting from there. Careful observation instructed him on how to paint the cookies; it was a matter of looking at the color and value, mixing the appropriate shade on his palette,

and then putting it on the canvas. In general he established his lights and darks first, then worked on the values in between. He wasn't interested in detailing the glass textures; for him, the jars simply hold up the cookies. The impression of a glass container comes from the way the cookies are massed together and the distortions at the corners of the jar.

Rubenstein admits that the background presented a problem. He finds it hard to render big surfaces with "too much" texture; small, involved subjects are much easier for him. One lesson he learned was not to overwork the background. If he had a chance to do it again, he would relax his brushstrokes from the beginning and paint in the background in a sweeping motion.

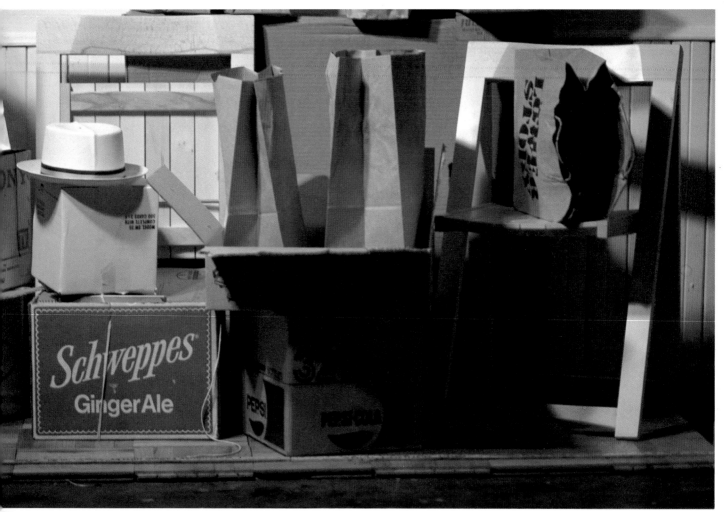

SETUP FOR CAMBRIDGE #1

Rubenstein can't work without an actual setup. The beginnings of the arrangement came about quite naturally. He had just moved from New York City to Cambridge, Massachusetts, and most of his belongings were still in boxes and bags. When he looked at them, they reminded him of a cityscape and the piling up of similar shapes and colors appealed to his sense of design.

Once he had decided to paint the boxes and bags, Rubenstein tried out several ar-

rangements. At first he put all the large objects on the bottom, with the smaller ones on top — but that didn't work visually. When you compare this photograph of the setup to the final version in the painting, you can see how important even minor adjustments are. By his repositioning of the bags on the right, for instance, Rubenstein balances the rhythm of the front stacks and also leads the eye easily up to the top row and around the painting.

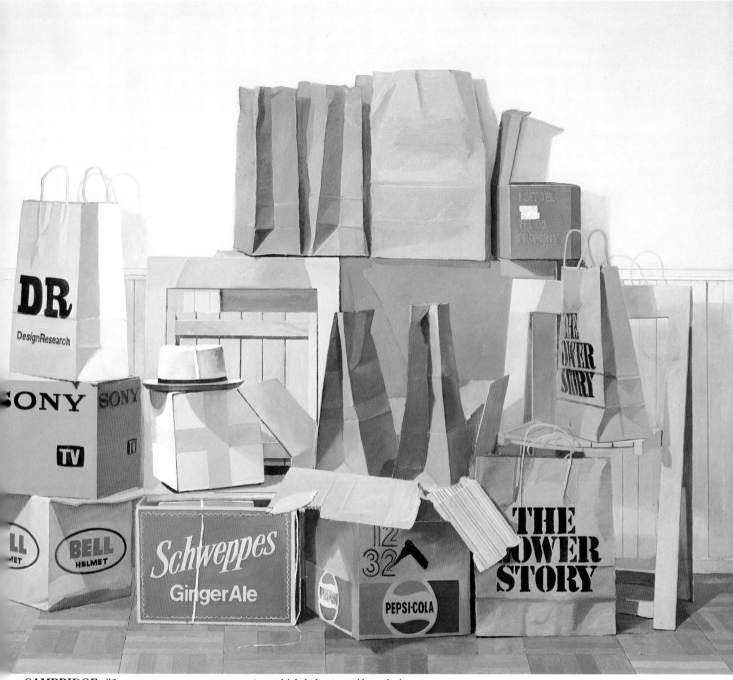

CAMBRIDGE #1
60" × 72" (152 × 183 cm)
Oil on linen
Private collection
Photograph by Greg Heins

For his painting to have the visual impact he wanted, Rubenstein decided that the objects had to be shown almost life-size. The large size also related to his vision of a cityscape, rather than an intimate still life.

The sense of architecture is quite important to this painting. Rubenstein likes to use his objects in a modular way so that they add together, one unit plus another, into the whole. Here the bags, boxes, and chairs all have a similar rectangular geometry, which helps to unify and give structure to the painting. Within this overall compatibility, slight variations — like the folds of the bags or the rounded edges of the hat — take on an extra vitality. Similarly, by using for the most part a neutral range of browns, whites, and grays, Rubenstein makes the bright color accents all the more arresting. Order and harmony are established by the compatible shapes and colors, and this lends the "ordinary" subject matter an almost monumental significance. At the same time, by introducing subtle variations, Rubenstein keeps everything alive so that the arrangement does not seem static.

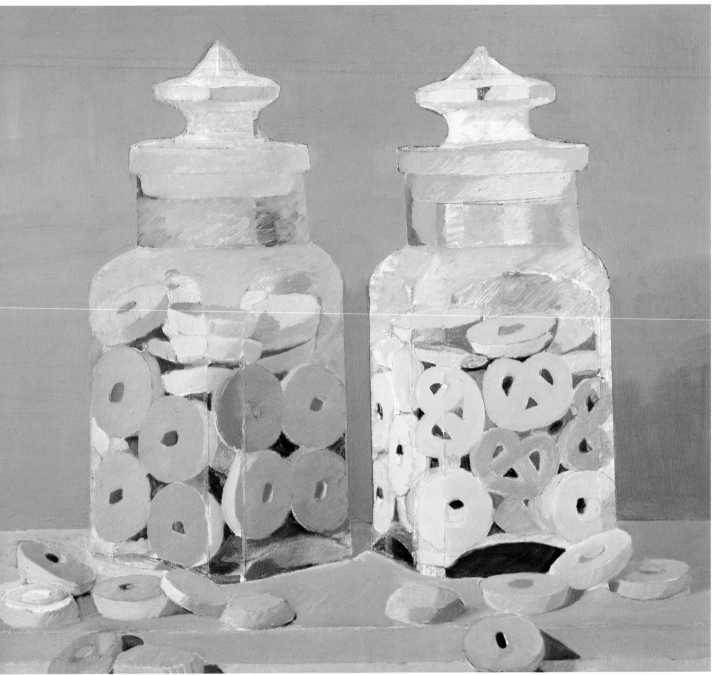

COOKIE JARS
14" × 15" (36 × 38 cm)
Oil on Baltic birch plywood
Collection of Hope and Mel Barkan
Photograph by Greg Heins; courtesy of Alpha
Gallery, Boston

Rubenstein began painting cookie jars in 1975, after he noticed some in a food store display. The repetition of the geometric shapes of the cookies intrigued him, as well as the various positions they assumed in the jars. There was a feeling of both order and playful chaos.

For this painting, Rubenstein chose a relatively small format — he likes to work life-size and cookies, after all, are small. He used a piece of Baltic birch plywood, which is similar to Masonite. After sanding the plywood, he sealed and gessoed it. Then he drew his composition on the board and laid in the lines with raw umber. Starting with the cookie in the upper left, he worked on one cookie at a time, determining his values as he went along. He used mostly earth colors, mixed on the palette to be as close as possible to what he saw in front of him. For brushes, he chose no. 4 and 5 sables so that he could work very small and lightly. He paid particular attention to the positioning of each cookie to give the impression that the cookies were restrained by the glass, that they were pressing against it. At times he simplified what he saw to keep the order of the painting as a whole clear. He also experimented with his brushwork to get the feeling of light coming through the tops of the jars.

DETAIL

To show the cookies pressing against the glass, Rubenstein kept their color and texture flat. He completely ignored the reflections that would normally be present (as if there were no glass holding them in); instead, he concentrated on how the glass distorted the shapes of the cookies. In particular, at the corners of the jar, he caught the slight shifts in perspective caused by the changes in the angle of the glass. He also paid attention to the variations in color and value as the direction of light also shifted with the angle of the glass.

DETAIL

Rubenstein kept his paint thin so that he would have better control over the subtle variations in shape and texture that distinguish one cookie from the next. If too much pigment built up, he took it off with a palette knife and then repainted the area in one fell swoop. This direct application of paint lends a freshness and sparkle to the work. There's an aliveness that comes from the awareness that Rubenstein's objects are actively painted, *not photographically depicted.*

Barbara E. Bohler
Revealing an Imaginary Landscape

Barbara E. Bohler is a multifaceted artist — in addition to painting in watercolor, oil, and acrylic, she is a poet, surface designer, photographer, and classical pianist. Currently she is creating a fashion line of wearable art under the name La Fleur Élégante. *In one way or another, these varied artistic pursuits affect her painting, influencing both her choice of objects and her manner of expression. Her paintings can be thought of as visual poems, reciting intricate stories through objects of great personal significance to Bohler. Often she includes a piece of her own design fabric, which becomes a symbolic representation of a lush landscape.*

Bohler develops her work in series form, with one thought inevitably leading to another, one painting to the next. It may take some ten to twelve paintings to explore a particular idea. Once finished, the series gives rise to another, interconnecting series, and so the process goes on.

When we look at Bohler's still lifes, our attention is engaged by the many meanings — hidden and obvious — in her work and her provocative and highly imaginative combination of objects. From a viewpoint high above, we gaze down on what is almost a fantasy world, a miniature landscape that is complete in itself. Often Bohler features a door or a window left ajar, suggesting a transition between the outdoors and the indoors. It is as if the still life existed "somewhere between heaven and earth" (the title of one of Bohler's series).

WORKING METHODS

Almost all of Bohler's paintings are the same size: 22×30 inches. She likes this standard watercolor paper size because it is similar in shape to the view through a camera. In addition, these proportions are well suited to the landscape references in her work.

Bohler's palette consists of some twenty-five colors, but the ones she uses most frequently are cadmium orange, cadmium red light, scarlet lake, alizarin crimson, viridian, and ultramarine blue. Rarely, if ever, does she use white. Her brushes are all sables.

In approaching the still life, Bohler thinks about *every* detail before she begins. Sometimes she sketches on a separate piece of paper, but mostly she works out everything in her mind. The light sketch that she actually puts down on her watercolor paper belies the intricate detailing that she has already decided on for her piece — it serves only to position the various forms that will have a part in the painting. Interestingly, in her other work (such as her outdoor landscapes), her style is freer, both in terms of composition and the application of paint.

Usually Bohler will begin a still life painting with the principal object, working on it until she is pleased with it, although fine details are left for later. She then proceeds to another object that directly relates to the first in terms of texture, shape, or color. This second object may be positioned right next to the first — or across the canvas. Having established the second item, she goes on to a third, whose position may be such that a triangle is established. There is no set formula for this progression, however; it is more a rhythmic development of the interrelationships between her objects, in which the visual "sound" of one leads to another.

Through experience, Bohler has gained considerable control over watercolor. In places she allows the color to flow and bleed on an already wet surface. She is not at all timid about using plenty of water in order to create a light and airy effect. The dreamlike, ethereal quality of her work is also enhanced by her layering of washes, so that even in the more solid areas of dense color you are aware of the transparency of the medium. By interweaving light and dark, thin and opaque, she reinforces the sense of a place "somewhere between heaven and earth."

CYCLAMEN REFLECTIONS
"Oriental Memories, Series II"
22" × 30" (56 × 76 cm)
Watercolor on d'Arches paper
Private collection
Photographed by Bruce Thornhill

"Cyclamen emperors nod in primrose and excitement, snow gods of eternity." This line from one of Bohler's poems inspired her painting. To create the contemplative mood she wanted, she arranged the cyclamen plant, sea-green fabric, and other objects around a piece of glass. There is a sense of looking at a beautiful Chinese garden reflected in a still lake. Further-

more, by positioning her objects in front of a window, she had the benefit of both natural and artificial light, which, in combination, generated a good many reflections in the glass.

After making a very sketchy drawing, Bohler began her painting with the center of interest — the cyclamen. The flowers' irregular edges, however, were only defined later, as she painted the material around them and allowed the wet color to flow in a slightly uneven fashion. To reinforce the wavy lines of the stems, she accentuated the

dark edge where the fabric meets the glass, as well as the shadow in back.

The rich red fabric in the background is the only thing Bohler painted from imagination. It supports the objects and at the same time dramatically contrasts with them. Notice how the red color effectively closes the space and bounces the eye back to the foreground. Moreover, through contrast, it makes the sea-green fabric, as well as the reflections, seem all the more delicate and peaceful. In fact the background is painted with thicker pigment than other areas.

SAUSHA'S VIOLIN
**"Somewhere Between Heaven and
Earth, Series I"**
22″ × 30″ (56 × 76 cm)
Watercolor on d'Arches paper
Private collection
Photograph by Bruce Thornhill

*When Bohler's son, Sausha, gave her a
violin, it first inspired a poem — "The tiger
lilies swayed in a soft cadence . . . sensing
the coming of song" — and then this paint-
ing. She used strong, sensuous color to
make the objects in the painting look alive,
in motion, and to reinforce the theme of
music by providing a "symphony" of color.
Often when Bohler works she listens to
music; what she listens to aids her greatly
in establishing the mood of a painting.
Even the strokes of her brush are deter-
mined by the rhythms she hears; the more*

*intense a piece of music, the more vigorous
will be her application of paint; romantic
themes inspire softer brushstrokes.*

*Bohler decided to cluster her objects to-
gether in the center of the painting almost
like a bouquet. At first she concentrated on
the colors and textures in this area, as well
as the interrelationships among the objects.
Notice, for instance, the echoes of red in the
flowers and the fabric. Bohler developed the
glossy surface of the violin with layers of
flowing washes. To emphasize the contrast-
ing sharp edges of the white teapot, she
drew them with very thin paint.*

*Throughout the painting, Bohler was
concerned with establishing motion, which
she did for the most part by playing diago-
nals against each other. The tipsy position
of the teapot, for instance, gives it a whim-*

*sical movement, as if it were swaying to the
sounds of music, while the violin strings
sweep up in the opposite direction. In addi-
tion, the wavy lines of the flowers' leaves
are repeated in the background clouds,
which then lead the eye around the painting
through their reflection in the wall on the
right, as well as in the teapot. Actually
Bohler did not work on the right side of the
painting until she was satisfied with the
center arrangement. She wanted this side to
present a contrast and so decided to accen-
tuate the hard edges, which she did by
using masking tape when she laid in her
washes. At the very end, once almost every-
thing was completed, she brought up the
intensity of the color in the fabric, which
helps to draw attention to the violin.*

THE CHINA BIRD
"Heritage Garden, Series I"
22" × 30" (56 × 76 cm)
Watercolor on d'Arches paper
Private collection
Photographed by Bruce Thornhill

Again, this painting was inspired by a line from one of Bohler's poems: "The china bird sits in the trumpet tree." She wanted to symbolize the birth of new ideas and chose the bird to herald the birth suggested by the eggs. To convey her idea, Bohler carefully arranged all the objects in relation to the bird. It is this relationship that draws our eye through the composition.

Bohler started her composition by selecting a round table. Then, in positioning the objects, she considered triangular, circular,

and diagonal movements. The major triangle is formed by the bird, the nest's white egg, and the lacquered blue egg on the left. The circular motion set up by the table's shape is reinforced by the nest, the porcelain pot and the piece of blue silk underneath it, and the curve of the bamboo chair's back. The twig in the foreground relates to the diagonal branch of the tree. In addition, everything in the composition, with the exception of the trumpet flower by the bird, moves clockwise, suggesting the passage of time involved in the creation of anything of beauty and significance.

Bohler first sketched the contours of the objects in pencil. Then she began to paint

the leaves of the "trumpet tree" (which is based on a bush that grows in Arizona). She worked on all the leaves before moving to the bird, then the nest, its egg, and across the canvas to the decorative egg. The flowers were among the last items to be painted.

The background, representing the sky, is a soft wash "wallpaper." Bohler isn't in agreement with it, but nothing else suggested itself to her at the time. She hopes to return to it one day and perhaps paint a darker area of royal blue with a slight pattern, to the left of the bird. She believes that this change would make the trumpet tree stand out more in the painting.

THE CHINA GARDEN
"Heritage Garden, Series I"
22" × 30" (56 × 76 cm)
Watercolor on d'Arches paper
Private collection
Photographed by Bruce Thornhill

When Bohler came across some antique miniatures in a shop window, the pieces reminded her of the china garden that she was devoted to as a child. For her painting, she chose a view from above, looking down, so that we have an aerial view of a richly textured landscape. A ray of sunlight highlights the major focus of the painting — the china garden — but all the objects reinforce the landscape feeling. Rivers are suggested by the front opening of the jacket and the Chinese necklace; parched land is represented by the floorboards; planted areas are created by the patterns in the fan, cloth, jacket front and sleeves, as well as by the red pomegranate. In all, there is the feeling of looking at a landscape within a landscape and entering a childhood fantasy world.

After lightly sketching in the objects, Bohler established the background "sky" with a soft blue wash. From there, she went on to the china garden, which she completed almost in its entirety with small brushstrokes full of pigment before going on to the other objects. By painting the items in the garden with thicker pigment, Bohler gave them a sense of dimension and solidity. In contrast, in other areas like the jacket, she used a lot of water to lighten the color and create an airy, less solid feeling. The yellow color that floods the left side of the painting then heightens the sense of a sunlit childhood memory somewhere between fantasy and reality.

THE CACTUS GARDEN
"Heritage Garden, Series I"
22" × 30" (56 × 76 cm)
Watercolor on d'Arches paper
Private collection
Photograph by Bruce Thornhill

Inspired by the Arizona desert, where she lives, Bohler designed an interior landscape to express the desert's subtlety. The aerial view conveys the desert's expansiveness. She used a streak of light from beyond to suggest a road traversing the cactuses, the prime elements in her tapestry-like garden. The background was executed in pale tones to enhance the depth of the desert landscape. Throughout the painting, Bohler withheld her usually bright color in order to reinforce her theme. Colors were kept within a limited tonal range to convey the stillness of the desert.

Bohler's fabric dominates this painting. It creates a horizon line, and its patterns suggest mountains and lakes — a symbol of the richness of the land. Even the bird, in the left foreground, is not very prominent; it is simply part of the landscape. Bohler's use of a living creature, like the bird, may seem unusual in a still life, but she believes it is natural for birds to inhabit her work in the same way that they inhabit nature. It is yet another way to emphasize the interior landscape that she wants to create.

SUGGESTED PROJECT

Choose some miniature objects and develop an entire landscape or cityscape on a table or floor. Be imaginative in terms of what you choose to paint. If you love cars, then why not assemble a group of toy ones in an arrangement that suggests an activity of some sort — say, a race car event?

Now determine the mood you want to express and set up your lighting accordingly. Try a harsh light — a bare lightbulb, for instance — and place it directly over the table or coming from the side. Take a good look at the hard-edged shadows that are produced as a consequence. For a different effect, experiment with a combination of artificial and natural lighting. Whatever lighting you choose, make sure it's in tune with what you want to express.

To get into the mood of your painting, try using music. Let the radio blare with hard rock if that is the sort of feeling you want your work to express. If you're after candlelight and a romantic table setting, with compotes full of ripe red strawberries, then let classical music guide your brushwork. Experiment with different music for different setups and pay careful attention to how the strains of music affect your selection of color and the rhythm of your brushstrokes.

Valerie Seligsohn
Evoking a Particular Place

The island of Tortola, in the British Virgin Islands, is the indirect subject of most of Valerie Seligsohn's still lifes. In fact, until 1982, much of her work was landscape. Her interest in tropical vegetation prompted her to acquire a number of tropical plants. Strongly influenced by her memories of Tortola, she began arranging vermilliad and zebra plants with Caribbean shells and Roseville ceramic pots to re-create a tropical landscape atmosphere. Backgrounds become symbols of land, ocean, and sky.

Seligsohn prefers a relatively small, intimate scale to foster the personal associations and feeling of place in her work. She tries to bring out the strong colors, contours, and patterns of her forms. Working in gouache allows her a density that fits in with the lush landscape feeling she wants. In fact, she makes the very surface of her painting rich with texture, varying the thickness and thinness of her paint and even leaving lines of the paper's white.

Seligsohn's theme is a constant, which nevertheless allows her to explore a variety of possibilities. The same objects appear repeatedly, depicted in different arrangements. Sometimes she even does a series of paintings of the same still life, experimenting with different horizontal or vertical "slices" of the whole. By using the same objects over and over, she believes that she acquires a deeper knowledge of them and thus achieves a greater conviction in her paintings.

WORKING METHODS

After arranging her still life, the first thing Seligsohn does is to establish an intricate, fine-line pencil drawing on her paper. In her drawing she plots out all the proportions and relationships, contours and value changes. In fact, it looks something like a map. Once the drawing seems satisfactory, Seligsohn begins painting. She does not deviate very much from the drawing and usually works with one item at a time after laying a light wash of lines over her pencil composition.

Seligsohn prefers gouache over watercolor because of its opacity, which can be watered down to become more transparent. No matter how many layers of watercolor are applied, an area can never be truly opaque. The problem with gouache, on the other hand, is that it must be applied very quickly to get a large, flat area. For Seligsohn, this difficulty comes up in her backgrounds, which she likes to paint as flat areas of color as a foil to the energetic brushwork and patterning in her objects. If she doesn't move rapidly enough here, the paper will absorb the paint and her brushstrokes will become evident. In other areas, however, Seligsohn deliberately lets her brushstrokes show. She plays thick against thin, small against large brushmarks to create the spontaneous feeling and richly varied surface she likes.

Of all the painting surfaces she had tried, Seligsohn prefers Fabriano hot-pressed watercolor paper beause it both absorbs the color and lets it sit on the surface. The effect is similar to painting in oil on canvas: the color has both depth (from sinking in) and texture (the physical feeling of paint).

The Winson & Newton gouache colors that Seligsohn frequently uses are cadmium red, alizarin crimson, cadmium yellow deep and pale, Winsor green, turquoise blue, and ultramarine blue, as well as two whites. Often she mixes her basic colors ahead of time in small, sealable baby-food jars. Sometimes she buys colorful fabric, or uses Color-aid paper, to help her mix interesting combinations. Then, as she paints, she creates variations of these mixtures in a ceramic pan. In addition, she usually mixes two to three — sometimes four — values for each color.

To apply the paint, Seligsohn uses square-tipped sable or sabeline brushes, from no. 2 to 12 and occasionally the largest size. She finds these brushes easy to maneuver, soft, and very precise — ideal for gouache work. Her brush is always damp before she dips it into the paint mixture, which has the consistency of light cream. She also takes care to shake her baby-food jars of paint often so that the colors will be well mixed (gouache tends to separate).

When she is nearly finished with a painting, Seligsohn studies it on her wood drawing table or a viewing wall. In approximately thirty to sixty minutes, she then pulls the image together with some final brushwork.

ZEBRA PLANT AND SHELLS

26" × 13" (67 × 33 cm)
Gouache on Fabriano hot-pressed paper
Collection of Fidelity Bank, Philadelphia
Photograph courtesy of Gross McCleaf Gallery,
Philadelphia

*Here Seligsohn wished to convey the clean,
cool sensation just after a tropical rain-
storm, once the warming sun has
reappeared. She chose a strongly vertical
format to give the impression that we are
looking through a narrow window at a
landscape outside. This format also helped
her to accentuate the interaction of the
leaves, which fill the surface and evoke the
lush growth after a storm.*

*In line with the cool feeling just after a
rainstorm, Seligsohn kept all her colors on
the cool side. For the background and
ground, she chose very pale hues so the
green of the leaves is all the more predomi-
nant. Even the bright yellow flower of the
zebra plant seems cool, although it does
suggest the beginning glow of the sun.*

*To get the rain-cleansed appearance of
the plants, Seligsohn experimented with
varying degrees of transparency. In some
areas she used a lot of water, while in
others, like the fronts of the zebra leaves,
she used much more opaque color. Notice,
however, how the contrast of the dark
greens with the white paper showing
through in the veins enlivens these areas.
Seligsohn's varied brushstrokes also con-
tribute a lot to the active patterning of all
the leaves and the vitality of the painting.*

VERMILLIAD AND SHELLS
26" × 15" (67 × 38 cm)
Gouache on Fabriano hot-pressed paper
Photograph courtesy of Gross McCleaf Gallery,
Philadelphia

In setting up this still life, Seligsohn was guided by her pleasant memories of Tortola's Cane Garden Bay. The vertical thrust of the vermilliad, similar to that of a tropical tree, dictated the arrangement of objects as well as her choice of a tall, narrow format. The angle of view augments the vertical feeling by encouraging us to look up.

After penciling in her composition, Seligsohn began to lay in the color, starting with the more translucent areas — the shells, vermilliad leaves, and pink and yellow flowers. To give her still life vitality and to convey a sense of lush growth, she brought out the patterning of the plant leaves, as well as the blue pot, with her brushstrokes. She also played dark, opaque greens against lighter, more transparent greens and yellows — creating a strong contrast between the vermilliad and the zebra plant behind. By leaving areas of the paper's white, especially in the veining of the leaves, she increased the feeling of transparency and brilliant sunlight. The lines of white paper around the forms are also important in giving the areas of opaque color "breathing space" so they don't become too dense.

The intense blue ground and cloud pink background — symbolizing water and sky — were painted last because they were potential problems. Seligsohn used a wide sable brush to apply the gouache and worked quickly to establish a relatively smooth surface. She wanted these areas to be simply a setting for all the activity in the plants and shells.

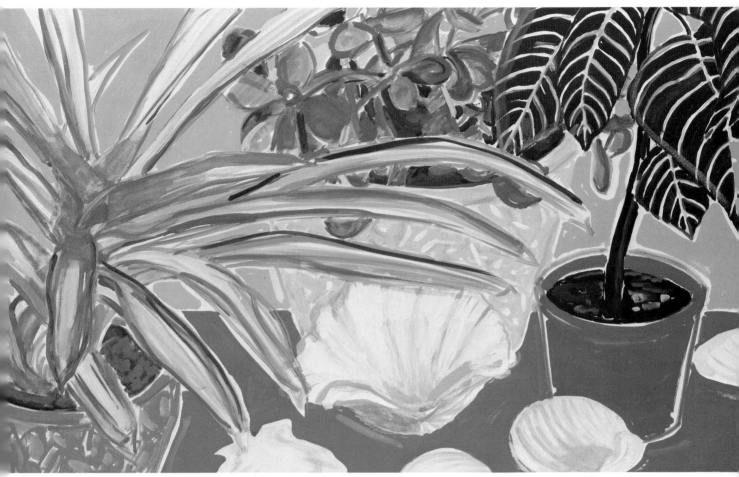

VERMILLIAD WITH SHELLS
15" × 26" (38 × 67 cm)
Gouache on Fabriano hot-pressed paper
Collection of Mr. and Mrs. James Korein
Photograph courtesy of Gross McCleaf Gallery,
Philadelphia

After doing the strongly vertical Vermilliad
and Shells *(see facing page), Seligsohn de-
cided she wanted to use the same objects
and colors in a more horizontal format.
She took the same narrow sheet of paper,
but this time she made the width the longest
dimension. She likes using "extreme" for-
mats, where one side of the rectangle is
much longer than the other, because it
allows her to present her still life as simply
a slice of a much larger view, a part of a*
*landscape. To augment this effect, she cuts
off the view of her objects at the edges so
they seem to extend beyond the painting.*

*Although the objects and colors are simi-
lar, this painting has a much different
feeling from the earlier vertical one. Notice
how the vertical lift of the vermilliad is
deliberately cut off here, so that the horizon-
tal reach of its leaves predominates. In
addition, Seligsohn shows us a much nar-
rower space, with the objects arrayed
frontally, side by side. The jade plant in the
center, with its rounded brushstrokes, then
provides an almost rolling transition from
the vermilliad to the zebra plant. All this
expresses the image Seligsohn had in mind*
*— a long stretch of Caribbean shoreline
with tranquil waters.*

*A particular challenge for Seligsohn in
this painting was the large shell in the
center. She had some difficulty getting the
color she wanted and ended up applying
some five or six layers of paint in some
areas. The problem with gouache, of
course, is that in layering the paint you
may pick up the color underneath; there's
also the risk of the paint becoming too caky.
Here, however, the gouache does not look
overworked. Seligsohn found that by care-
fully controlling the density of the pigment,
she could apply several layers without
jeopardizing the surface.*

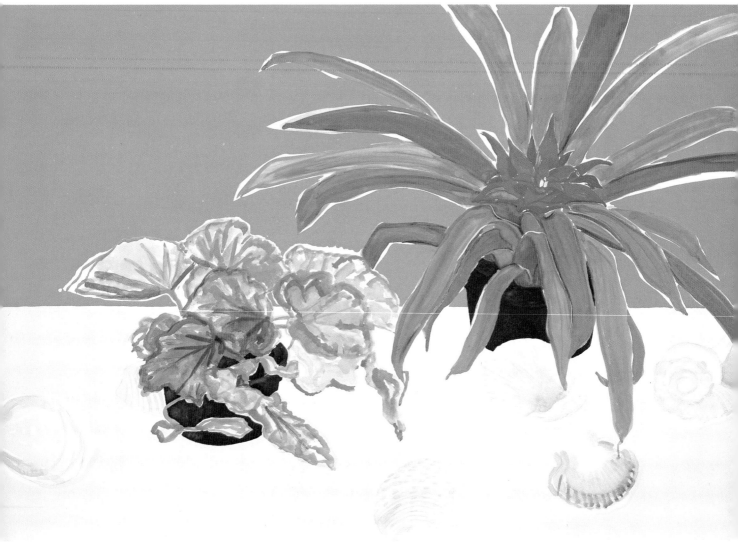

SHELLS AND PLANTS
24" × 36" (61 × 91 cm)
Gouache on Fabriano hot-pressed paper
Photograph courtesy of Gross McCleaf Gallery,
Philadelphia

To create an "icon for Tortola," Seligsohn arranged her objects frontally so that each would be prominent and serve as a symbol of tropical splendor. Because she wanted to evoke the openness of an island beach and sky, she chose a larger-size format than usual. In addition, she painted the objects relatively small in relation to the background and ground, which makes the sense of space more convincing.

Seligsohn first worked out her composition in a drawing. The one problem area was the background. Initially she thought of using a brocade fabric for the background, but after changing her drawing several times, she decided it wouldn't work. In her painting Seligsohn actually left the ground and background for last. She didn't know which colors she wanted until everything else was down. When she came to these areas, she experienced some trepidation because of the difficulty in rendering large areas smoothly with gouache. Three layers of paint were applied, each one quickly and without hesitation so that brushmarks would not be evident. As it turned out, she was pleased with the colors: the intensity of the blue offset the delicacy of the pink.

DETAIL

When she was ready to paint, Seligsohn started with the flower of the vermilliad. In fact, she studied this small painted section for weeks before moving on. She wanted to be sure this bright red flower really stood out, and that determined her handling of the pink and green areas in the rest of the painting. In the end, before she pronounced everything finished, she went back to add some revitalizing red brushmarks to the flower.

DETAIL

To capture the texture of these leaves, Seligsohn experimented with a variety of techniques. At points she used a lot of water with her gouache and allowed one color to bleed into another. Sometimes, after applying the paint, she blotted it and then laid more color on top. Occasionally she even loaded her brush with pure water and pulled away some of the paint to reintroduce the white of the paper.

SUGGESTED PROJECT

Creating a "place box" can help you evoke a particular location in a still life painting. First select a geographic area — a city, a country, or simply a special place that you feel strongly about. Then construct a plywood box, with a base measuring 18 × 24 inches, sides 4 inches high, and no top. To fill the box, begin collecting objects, fabric, photographs — things that are from or remind you of the place. As you collect these items, be conscious of their color, pattern, texture, and shape. How do these qualities fit into your mental image of the place?

Now it's time to arrange your collected material in the box. Decide whether you want a horizontal or vertical view and set the box up along either its longer or shorter side. Because the box space is fairly shallow, it should help you to see how your three-dimensional collage will translate onto a two-dimensional surface.

Once you've put everything together, study your collage and select three areas that you like. Develop them into three drawing compositions, using graphite, colored pencil, or charcoal on paper. Each drawing should measure 9 × 12 inches. From the three, select the best one.

Now stretch a canvas two or three times as large as the final drawing (making it 18 × 24 or 27 × 36 inches). Using oils or acrylics, paint your composition. Try to emphasize the patterns, colors, textures, and shapes in a way that will convey your feelings about the place involved.

Robert Treloar
Setting a Stage for Storytelling

Robert Treloar chooses his objects for their textural and color appeal, as well as for their storytelling potential. How he juxtaposes these objects is essential in terms of the feelings and mysteries that are expressed. Treloar used to make abstract paintings, and he admits that in depicting realistic subjects he is always aware of their abstract shape and structure. For him, what matters is the layering of different systems of patterning and different meanings. Technique is not something that he really thinks about. He doesn't have set rules for how he paints; instead, he relies on a close observation of his subject and an intuitive feel for his medium, acquired through experience.

Treloar is fascinated by how objects connect and relate in space and time. Every day he notices scores of still life setups everywhere around him. In juxtaposing objects, he attempts to accentuate their connection, establishing tension between them and movement from one to the next. He also invariably chooses to include reflective and transparent surfaces because they offer layers of abstract patterning and meaning — "worlds within worlds." Mirrors, glass vases, and sheets of mylar all enliven his canvases, as well as richly patterned fabrics and assorted plastic and ceramic figurines. All play a major role in narrating the story of the painting.

WORKING METHODS

Watercolor, oil, and pastel are all used by Treloar, depending on the effect he wants to achieve. Pastel, for instance, has a softer look; at the same time, because it is pure pigment, it allows for highly vibrant color. Watercolor, on the other hand, can enhance a sense of tightness and fragility through its transparency. Yet, whichever medium Treloar chooses, he builds his painting in much the same way: he applies layers of color all over the surface. Gradually, these layers of pigment accumulate and define the image.

For his watercolors, Treloar uses both cake and tube paints, which he applies with sable brushes and a good amount of water. First, he sketches the composition lightly on the paper; later, when he has put enough color on the paper to reveal the various forms, he goes back and erases the pencil marks. Before he starts to paint, however, Treloar determines where the white and very light areas of the painting will be so that he can work around them. Sometimes he uses a masking liquid — for instance, if there's a light area in the middle of a wash, which would be difficult to lay down evenly if he had to paint around it. As Treloar lays in broad wash areas, he works from the top of the paper to the bottom, carrying a well-loaded brush at a slight angle. At this early stage he keeps his colors very light — providing only a hint of what will ultimately appear. Treloar also begins to lay in the shadows, which will help to define the forms and create the illusion of three dimensions. He keeps his marks as bold and as carefree as possible, bleeding colors, gradating them, and blotting with tissue as he goes along. Fine details are reserved for the focal points. If the work were too "finished," it would look overworked and lose the appeal of watercolor, with the glow of the paper beneath the pigment.

With his pastels, Treloar uses a mid-toned warm or cool gray paper, which he tries to match up with the overall tone of the setup. He first covers the entire surface with a loose, light layer of pastel, blocking in the picture. Sometimes, however, he leaves bare areas of the paper if he thinks he may want the paper's color in that area. Next he blends or rubs the pastel into the paper, almost staining it; he may even blow or brush away any excess pigment. What emerges is a full-color "map" of the picture, on which needed changes can be dealt with fairly easily and even erasing is possible. He then starts layering on top of this map, refining shapes and colors. Fingers, brushes, as well as the pastel sticks, are all used to define the image and capture the texture he wants. Treloar finds the process a very sensual one, something in between finger painting and drawing. Once the pastel is finished, he sprays it with fixative — with extreme care because the fixative dissolves some of the pastel.

SNOW WHITE
(For caption, see page 134)

Preceding page
SNOW WHITE
27¹/₂″ × 19¹/₂″ (70 × 49 cm)
Pastel on paper
Collection of Mr. and Mrs. R. C. Treloar

How Treloar uses the still life as a stage for storytelling is well represented by this pastel work. One of his favorite ceramic figurines — Snow White — becomes the star in a world of reflective surfaces, which provide a theatrical, magical setting. To create his swirling, sparkling composition, Treloar worked carefully with the placement of the objects, the wrinkles of the mylar in the background, and with the lighting. The result is a kind of fantastic fairytale, in which reality and illusion intertwine. Although Treloar has rendered the objects realistically, they become almost unrecognizable as our attention is drawn to the abstract patterns of reflection in the mylar in the back and the mirror in front.

In planning his composition, Treloar gradually realized that the main subject of his picture was light and the way it was reflected. To make this interest clear, he withheld colors, restricting himself to a variety of grays, subtle yellows, and whites. He felt that the reflective surfaces that intrigued him could best be rendered in pastel, where the layering of color has a density that is different from watercolor. He finds that by manipulating the powdery pastel with his fingers, he can arrive at a smooth transition from color to color and re-create the glossy look of a material like mylar. Watercolor would have had a much crisper look.

STEP 1

Treloar started this painting by drawing with charcoal directly on a light gray gessoed canvas. Although he concentrated on the contours and positioning of the objects, he did indicate the strong darks he wanted on the left and at the top and bottom of the calendar.

STEP 2

Once his composition was established, Treloar loosely blocked in the areas of color with thinned paint. In this way he set up a map to help him keep track of the final patterns he wanted. Gradually he built up the painting with many thin layers of paint, refining as he went along. His brushes were mostly rounds, of varying sizes, but he also used blending brushes and even his fingers to create smooth transitions.

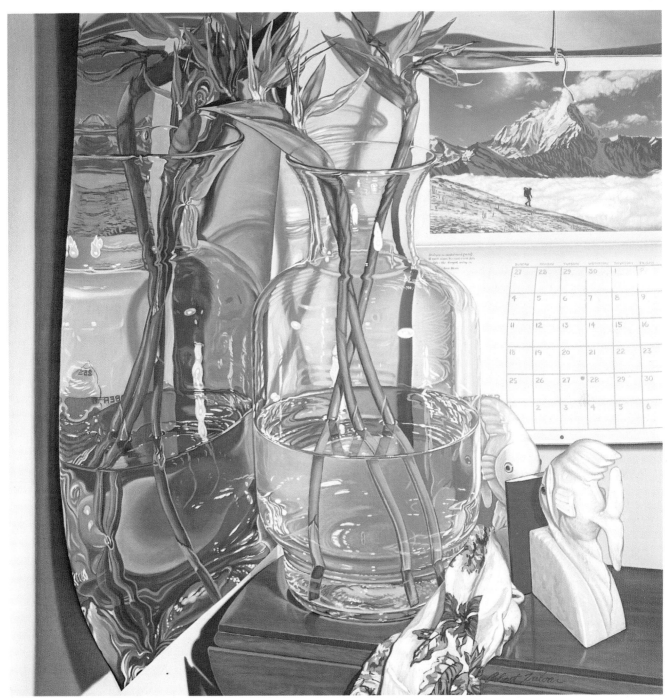

BIRDS OF PARADISE
36" × 36" (91 × 91 cm)
Oil on linen
Collection of Jim and Carroll Dillahunty

When a trip to the Himalayas fell through, Treloar decided to create a contemplative, yet vibrant painting expressing his disappointment. The calendar photo and passport, huddled between the bookends, refer to the trip directly. The firelike flowers were chosen to contrast with the snow and the fish bookends to relate to the water in

the vase. The way Treloar likes to layer meanings, questioning our notions of reality, is evident here. Although we connect the fish to the water, we are aware that they are not "real" fish but man-made representations. But, then, the flower in this painting is also a depiction, as is the painted "photograph." As a further commentary on his story, Treloar added the sheet of mylar on the left. Its distorted reflection of the whole suggests things not turning out as expected.

Treloar's use of color is important to establishing this painting's mood. Although the colors are based on the objects' real color, he keyed them to the color around them. The orange of the flower, for instance, stands out because of the cool whites and grays behind it. Treloar admits that the calendar photo dictated many of his choices. In the end, the painting took on a cold but delicate quality — much as he imagines the pictured mountains to be.

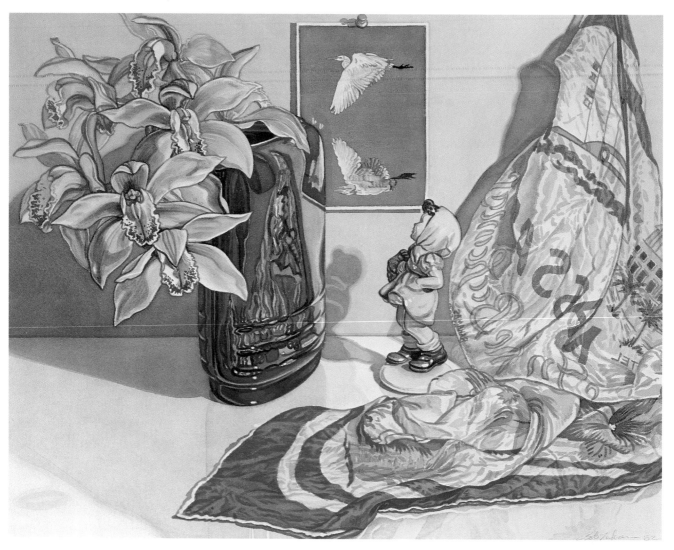

WHITE CRANE WITH ORCHIDS
17⁷/₈″ × 22⁷/₈″ (45 × 58 cm)
Watercolor on d'Arches 140-pound semirough
paper

This painting started with the orchids. As Treloar chose the other objects, he began layering levels of meaning and pattern into the painting. The postcard, with its depiction of a crane and its reflection, was brought in to express his fascination with mirroring and different levels of reality. To complement this and to increase the story-telling possibilities with a "human" interest, he added the ceramic figurine, who is re-flected in the vase.

The storytelling potential of the objects is augmented by Treloar's composition. All the objects have a similar movement — the orchids cascade, the scarf flows, the figur-ine's dress is wind-swept, and, of course, the crane glides. A circular motion is estab-lished in the painting, beginning with the figurine who gazes, through her reflection in the vase, up at the crane, who flies into the cascading orchids, whose movement takes our eyes down and up along the scarf.

DETAIL

To paint a complicated reflection like this one, with its distorted image, Treloar focuses on the abstract shapes. Essentially he copies the patterns of shape and color that he sees. It is by his careful attention to all the shapes, both positive and negative, that he creates the illusion of the reflection.

Here Treloar began with a light pencil sketch of the forms and then blocked in each distinct shape in light colors. He also decided where the highlights were going to be and blocked out the areas where he wanted the white of the paper to appear. After getting the basic colors down, he ran a light wash of blue over the whole vase to give it a sense of solidity. He then went back to bring up the colors and later added another blue wash, working in this way until he had achieved the right texture.

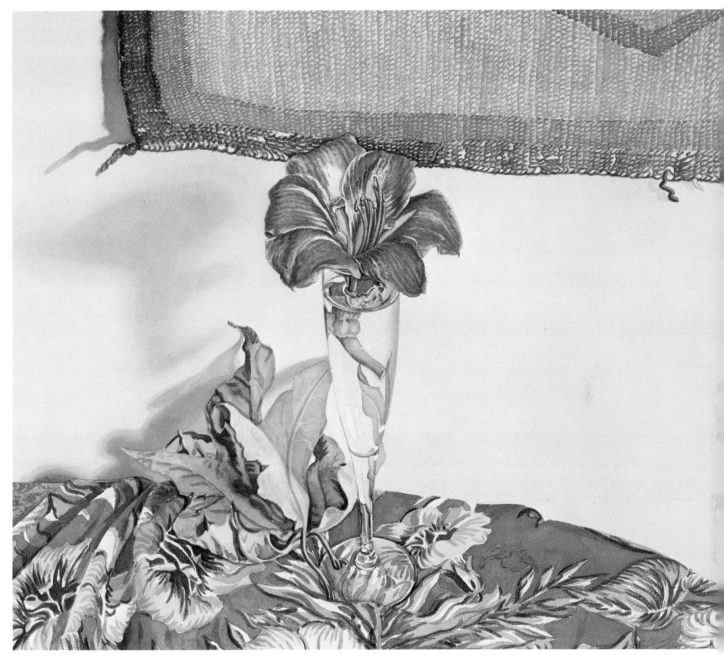

LILY WITH NAVAJO RUG
17⁷/₈″ × 21″ (45 × 53 cm)
Watercolor on d'Arches 140-pound semirough
paper

*Here Treloar was inspired by the beautiful
lily and its relation to the patterned table-
cloth. He was especially drawn to the
similar colors and the interplay between the
real flower and the represented fabric one.
He arranged the flower and "dead" leaves
so that they almost seem to spring to life
from the fabric. They are then topped off by
the very ordered version of the same colors
in the Navajo rug.*

*Because Treloar was using a very shal-
low space with a lot of patterning, he left
the white of the paper for the wall in much
of the background. Its simplicity provides a
relief from the depicted patterns. At the
same time this large flat area helps to tie
the abstract design of the composition to-
gether. It's important, for instance, in
establishing tension between the subtle
curve of the fabric and the wavy line of the
cut-off rug above so that our eyes are pulled
both up and down.*

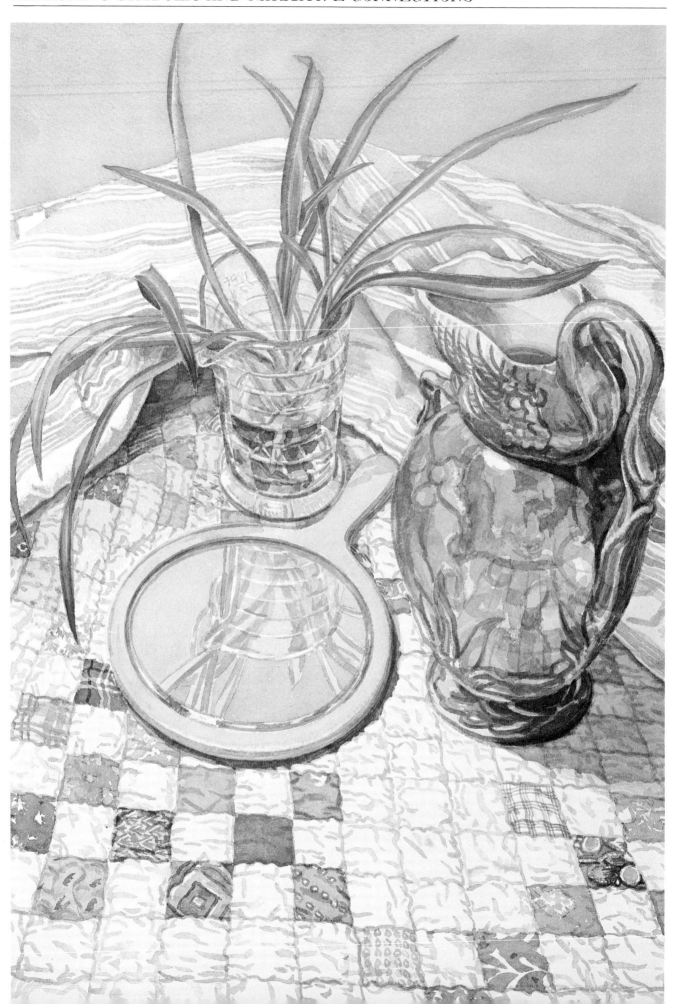

Left
QUILT AND BIRD PITCHER
18⁷/₈" × 12⁷/₈" (48 × 33 cm)
Watercolor on d'Arches 140-pound rough paper

The quilt and the name of its pattern, "Rocky Road," reminded Treloar of a country landscape. So in this painting he decided to evoke thoughts of an intimate place, rendering almost a miniature landscape. In arranging his objects, he was concerned with moving the viewer's eye through the painting and conveying a sense of distant space within the narrow confines of the setup. Notice, for instance, how the pattern of the quilt becomes smaller and smaller as it recedes into the background. Yet our eyes are stopped by the grassy stems and their reflection in the pool-like mirror. Treloar's choice of color is important here. The sky blue of the mirror draws our attention to the blue plane in the background. The wavy horizontal stripes of the sheet augment the landscape feeling, while the curve at the top leads us back into the central grouping.

It is through these back-and-forth tensions in the arrangements of his objects that Treloar gives vitality to his still life. His handling of the varied textures also contributes to this. By paying close attention as he paints to the different feel of each object's surface, he makes them separate characters, so to speak, in the drama of the still life.

DRAWING FOR DIVER'S WATCH
6" × 7" (15 × 18 cm)
Pencil on paper

This drawing was done by Treloar "on the spot," in the room where he was staying in the Caribbean. Later, when he got home, he used it to set up the still life again for his painting. Often Treloar will sketch his setup first to see how it translates onto a two-dimensional surface. Sometimes he cuts a viewing hole from paper in the proportions of his painting surface. Most recently, he has begun taking Polaroids, which is a quick way of testing the advantages of different viewing angles.

DIVER'S WATCH
5³/₄" × 6³/₄" (15 × 17 cm)
Watercolor on d'Arches 90-pound rough paper

While vacationing in the Caribbean, Treloar was intrigued by the colors of the beach in the small bay where he was staying. To evoke the place, he arranged the scarf and reflective surface in a miniature re-creation of the bay. Then he placed the other objects, a fishing spear and the diver's watch, to give a sense of movement and to establish space. He also carefully adjusted the lighting to get the reflections and shadows he wanted. Making sure that the composition is right is especially important when Treloar uses watercolor. Once he starts laying in his washes, it would be difficult to change anything.

139

MOSES AND SNOW WHITE
17⁷/₈" × 22⁷/₈" (45 × 58 cm)
Watercolor on d'Arches 140-pound semirough
paper
Courtesy of Sherry French Gallery, New York City

As a child, Treloar acquired these charming figurines and the postcard of Michelangelo's Moses at just about the same time and in the same place — Italy. In doing this painting he wanted to acknowledge the different, but equally strong influences of Michelangelo and Walt Disney. The mood swings back and forth between humor and a more serious point of view. Most of all it recalls for Treloar his childhood experiences in Italy.

The expression of the figurines determined their placement and the direction of their gazes. Treloar added the orange glass for color and focus. Indeed, without the glass, the painting would be almost black and white like the photograph. As usual, Treloar chose to include a reflective surface — the black "ground" on which the objects stand. By making this dark base reflective, he kept the bottom of the painting "light," almost weightless. Surprisingly, the yellowish white wall in the background seems heavier, in part because of its texture. Here Treloar experimented with a blockout solution after he had already laid in a preliminary wash of color. He applied it in little dabs and then continued to build his washes. By adding this texture, he created a greater sense of intimacy; a solid plane might have looked too harsh.

DRAWING
6" × 8" (15 × 20 cm)
Pencil and prismacolor on paper

After he did this sketch, Treloar decided to add the scarf in the lower left corner to mirror the shape of the orange cast shadow. In addition, the scarf helps to establish a sense of space by defining the foreground. By the way, Treloar often uses a grid, like the one you see here over the drawing, to help in transferring the composition to his painting surface.

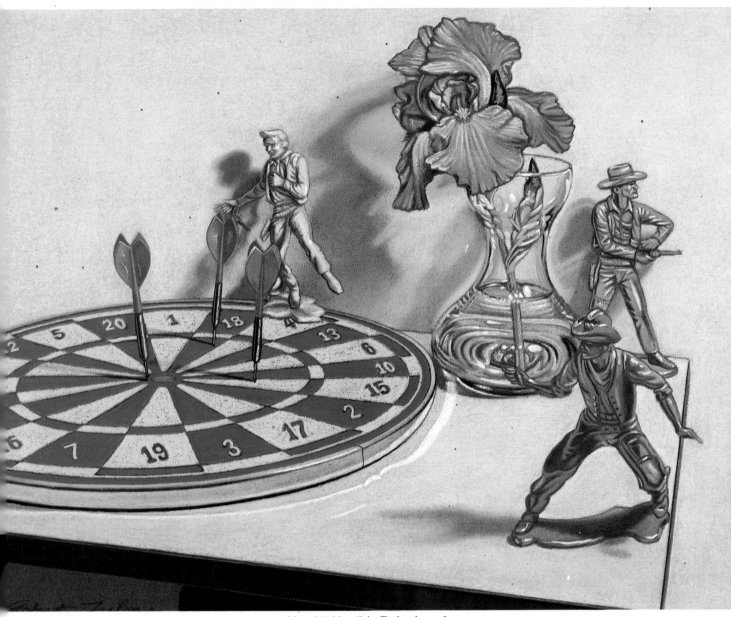

DARTBOARD

18¼" × 20¼" (46 × 51 cm)
Pastel on paper
Courtesy of Sherry French Gallery, New York City

Treloar's concept for this still life began with the plastic cowboys, which carried a built-in vitality and tension. Color, shape, and impact determined his selection of the yellow and blue dartboard, green vase, and contrasting red flower with its droopy petals. As always, in arranging his objects Treloar was interested in underlining the connections between them. The tension between the three darts, for instance, reinforces that between the cowboys. Even the cast shadows in the background become compositional "objects" in Treloar's work and add to the tense balance of the whole.

Treloar decided that pastel was the best medium for rendering the plastic feel of the cowboys as well as their almost garish color. He looked carefully for the dark lines that cut out the plastic form and for the pattern of highlights that create the sense of a glossy surface. Even though Treloar's work looks very realistic, it is based on a kind of abstract vision: instead of focusing on the object per se, he concentrates on the different patterns of shapes, darks and lights, and colors.

Biographical Notes

Toni Arnett, who holds a B.S. degree from Texas Tech University, studied under Frank Gervasi, Daniel Greene, Helen Van Wyk, Dick Goetz, and Glenna Goodacre. Her work has been exhibited at the Diamond M. Foundation Museum (Snyder, Texas), Beijing Exhibition Center (People's Republic of China), Kaiser Center Art Galleries (Oakland, California), and Society of American Impressionists (Scottsdale, Arizona), among other places.

Catherine Behrent grew up in a small Texas town, and her mother drove her every week to the nearest art teacher, 30 miles away. Later, at age 13, she studied in an adult evening class with Mrs. Elizabeth Simpson, who taught her the basics of oil painting that she still draws upon. After receiving her B.F.A. from the University of Texas, she studied in Paris and the Middle East. She has had one-person shows at the DuBose Gallery and Meredith Long & Company in Houston.

Nell Blaine was born in Richmond, Virginia, and came to New York to study with Hans Hofmann. She served as art director of the United Jewish Appeal and designed the original *Village Voice* newspaper. Her work is included in the collections of the Metropolitan Museum of Art, Whitney Museum of American Art, Hirshhorn Museum and Sculpture Garden, Brooklyn Museum, Virginia Museum of Fine Arts, and Corcoran Gallery of Art. In addition to Guggenheim and National Endowment for the Arts grants, she has received the Virginia Governor's Award for painting and an honorary doctorate from Moore College of Art in Philadelphia.

Barbara E. Bohler, a self-taught artist who was born in Seattle, Washington, now lives in Mesa, Arizona. A member of the National Watercolor Society and Watercolor West, she has exhibited at the Gammage Center for the Performing Arts at Arizona State University and the National Academy Galleries in New York. Her *White House Egg* (1983) is included in the Smithsonian Collection.

Peter Eichner-Dixon (PED) comes out of a family of painters: his grandfather was a fresco painter and watercolorist; his father, a watercolorist. Born in West Germany, he studied literature, art history, and philosophy at the University of Erlangen/Nuremberg and University of Boulder, and received a Ph.D. His work is included in the Wichita Art Museum and Heritage Museum (Denver), as well as private collections. A member of the Royal Institute of Painters in Watercolours (London), he recently received a Copeland Fellowship at Amherst College in Massachusetts.

Robin Eschner-Camp received her Bachelor's degree from the University of California, Davis, where she studied under Cornelia Schulz (whom she considers to be her mentor) and Wayne Thiebaud. Her work has been exhibited in many shows and is included in private collections in both the U.S. and Europe. At present she is represented by Allport Associates Gallery (San Francisco) and Stone Press Gallery (Seattle).

David Fertig earned his B.F.A. from the Philadelphia College of Art and M.F.A. from the Chicago Institute of Art. In recent years his paintings have appeared in group exhibitions in the Philadelphia-New Jersey area, as well as in one-person shows at the Marian Locks Gallery in Philadelphia. His work is featured in the book *Painting the Landscape* by Elizabeth Leonard (Watson-Guptill Publications).

Iona Fromboluti, who was born in New York, received her B.F.A. from the Tyler School of Art. Her work has been included in a variety of group shows, and she recently had a solo exhibition at the Gross McCleaf Gallery in Philadelphia. Fromboluti is the recipient of the 1983 Tobeleah Wechsler Award from the Cheltenham Art Center and the 1972 Drawing Award from the Skowhegan School of Painting and Sculpture.

Eileen Goodman, who received her B.F.A. from the Philadelphia College of Art, has been an instructor there since 1967. Currently represented by the Gross McCleaf Gallery (Philadelphia), she has shown in both one-person and group exhibitions. In 1978 she received the Purchase Award from Beaver College. Her work appears in the book *The Art of Watercolor* by Charles LeClair, as well as several corporate collections.

Penelope Harris, born in New York City, studied at the Pennsylvania Academy of the Fine Arts. Among other honors, she is the recipient of the 1976 Thomas Eakins Memorial Prize for Figure Painting, the 1978 Eleanor S. Gray Prize for Still Life, and the 1978 Catherine Grant Memorial Prize for Still Life. She recently had a solo exhibition at the Gross McCleaf Gallery (Philadelphia) and her work has appeared in various group shows.

Polly Kraft, who was born in Spokane, Washington, and now lives in Washington, D.C., studied at the Corcoran School of Art and the University of Maryland. Her work has appeared in numerous exhibitions and is included in the De Menil Collection, Corcoran Gallery of Art, and Santa Barbara Museum of Art, as well as private and corporate collections. She is currently represented by Fischbach Gallery (New York) and Osuna Gallery (Washington, D.C.).

Robert M. Kulicke, educated in both Philadelphia and Paris, describes his art as an attempt at a "personal continuation" of aspects of the work of four artists from four different centuries: Vermeer, Chardin, late Manet, and Morandi. He wants his art to reveal "an intimate, serene order; at the same time it must look easy, as effortless as Hals or Velasquez." Kulicke aspires to what he calls "that 'sense of the absolute' which we find in Mondrian or a 14th-century Siennese Madonna." "Impossible, of course," he admits. "Still, living in the attempt is what I do with my life."

Harriet Martin graduated from the Pennsylvania Academy of the Fine Arts after also studying at the University of Virginia. In addition to participating in group shows, she has had a solo exhibition at the Butcher and Moore Gallery in Philadelphia and is currently represented by the Gross McCleaf Gallery there.

Jane Piper, educated at the Hans Hofmann School, the studio of Arthur B. Carles, and the Pennsylvania Academy of the Fine Arts, currently teaches at the Philadelphia College of Art. She has shown in numerous group and solo exhibitions, and in 1982 received the Saltus Gold Medal from the National Academy of Design. Piper's work is included in the Allentown Art Museum, Museum of Art of the Carnegie Institute, Corcoran Gallery of Art, Pennsylvania Academy of the Fine Arts, Philadelphia Museum of Art, and other collections.

Barnet Rubenstein, who studied with the Expressionist painters Karl Zerbe and Oskar Kokoschka, lived for 15 years in France, mostly near Aix-en-Provence. At present he teaches at the Boston Museum School. His work has been shown in many exhibitions, including a one-person show at the Boston Museum of Fine Arts in 1979, and appears in the collections of Graham Gund, Stephen Paine, the Cabot Corporation, and others.

Valerie Seligsohn (née Jesraly), who is of Armenian descent, earned her B.F.A. from Cornell University and her M.F.A. from the University of Pennsylvania. Currently represented by the Gross McCleaf Gallery (Philadelphia), she has work in the Reading Public Museum, Herbert F. Johnson Museum of Cornell University, Community College of Philadelphia, and Yale University. "To a great degree," Seligsohn states, "my work is a reflection of the joy and well-being generated by my family—my husband Mel and my children Abigail and Zachary."

Robert Treloar, born in Newport, Rhode Island, received his B.F.A. and M.F.A. from San Diego State University. In addition to several one-person exhibitions, he has shown in a variety of group exhibitions, most recently at the Sherry French Gallery (New York), Hunter Museum (Chattanooga, Tennessee), and Modernism Gallery (San Francisco). His work appears in the Laguna Museum of Art (Laguna Beach, California), as well as various private and corporate collections.

Susan Headley Van Campen, educated at Moore College of Art and the Pennsylvania Academy of the Fine Arts, received the 1983 Marsha Moss/Rose Graff Award from the Cheltenham Art Center. She has had solo exhibitions across the country, most recently at the Gross McCleaf Gallery (Philadelphia), Maine Coast Artists Gallery (Rockport, Maine), and Allport Associates Gallery (San Francisco). Her work is included in the collections of the Delaware Art Museum, Millersville State College, and Rutgers University.

Paul Wonner, born in Tuscon, Arizona, holds a B.A. and M.A. from the University of California at Berkeley. In 1981-82 a retrospective of his work toured the San Francisco Museum of Modern Art, Marion Koogler McNay Art Institute (San Antonio, Texas), and the Los Angeles Municipal Art Gallery. Wonner, who has participated in exhibitions throughout the U.S. and abroad, is currently affiliated with Hirschl and Adler Modern Gallery in New York. His work is in the Solomon R. Guggenheim Museum, Hirshhorn Museum and Sculpture Garden, Metropolitan Museum of Art, Museum of Modern Art, National Museum of American Art, San Francisco Museum of Modern Art, and Boston Museum of Fine Arts.

Index

Concept by Mary Suffudy
Edited by Sue Heinemann
Designed by Areta Buk
Graphic production by Hector Campbell
Text set in 9-point Century Old Style